LESSONS IN LANDSCAPE

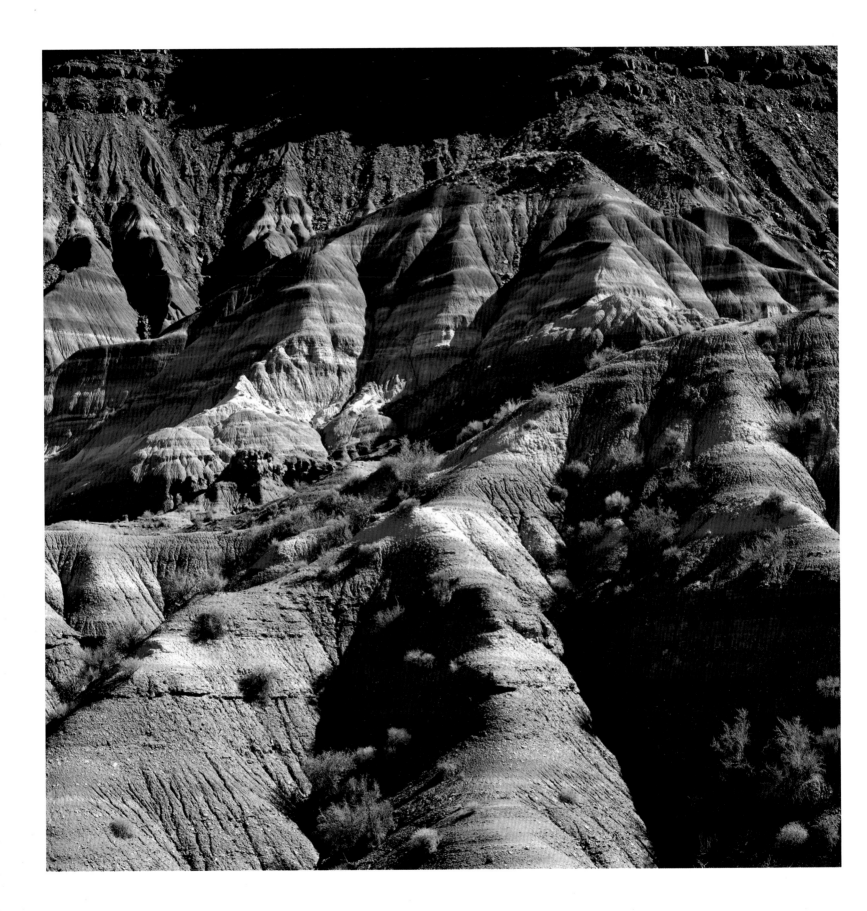

LESSONS IN LANDSCAPE
80 TECHNIQUES FOR TAKING BETTER PHOTOGRAPHS

PETER WATSON

AMMONITE
PRESS

First published 2016 by Ammonite Press, an imprint of AE Publications Ltd, 166 High Street, Lewes, East Sussex, BN7 1XU, UK

Text and photographs © Peter Watson, 2016
Copyright in the Work © AE Publications Ltd, 2016

ISBN 978 1 78145 144 1

Publisher: Jason Hook
Production Manager: Jim Bulley
Senior Project Editor: Wendy McAngus
Editor: Stephen Haynes
Designer: Robin Shields

Colour origination by GMC Reprographics
Printed and bound in Turkey

PAGE 1

NEAR KOLOB CANYONS, UTAH, USA

Camera: Mamiya 645 AFD II with Mamiya digital back

Lens: Mamiya 150mm telephoto

Filter: None

Exposure: 1/6sec at f/20, ISO 100

Waiting for the light: Immediate

Post-processing: Curves adjustment, Color Balance adjustment (warming), cropping to panoramic format

PAGE 2

PARIA CANYON WILDERNESS, UTAH, USA

Camera: Mamiya 645 AFD II with Mamiya digital back

Lens: Mamiya 80mm standard

Filter: Polarizer, fully polarized

Exposure: 1/6sec at f/18, ISO 100

Waiting for the light: 40 minutes

Post-processing: Curves adjustment

RIGHT

NEAR CONISTON, CUMBRIA, ENGLAND

Camera: Mamiya 645 AFD II with Mamiya digital back

Lens: Mamiya 35mm wide-angle

Filter: 2-stop ND grad

Exposure: 1/2sec at f/22, ISO 100

Waiting for the light: 1 hour

Post-processing: No adjustments

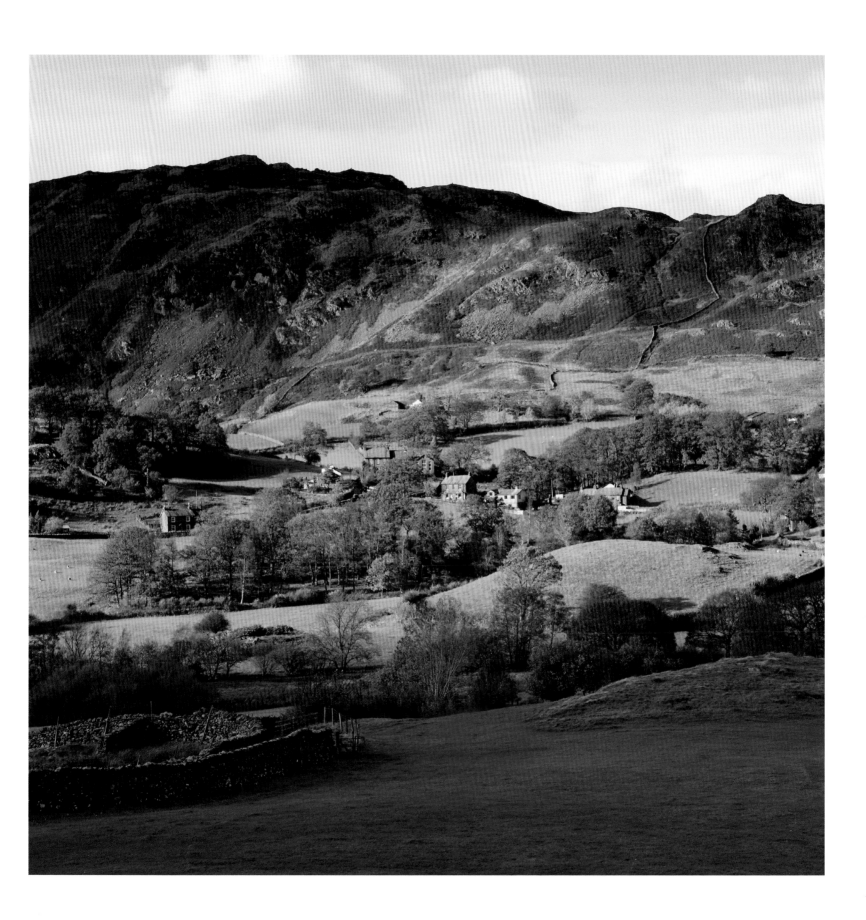

CONTENTS

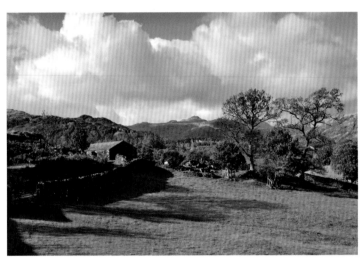

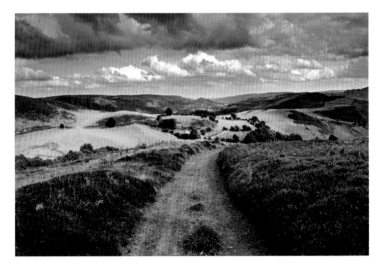

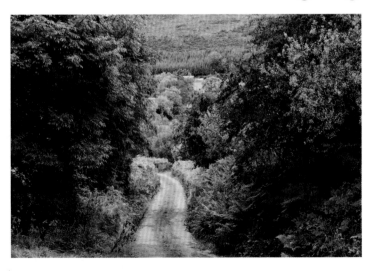

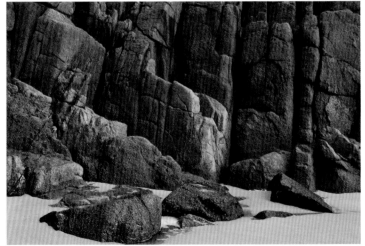

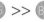
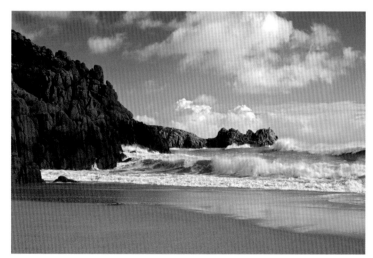
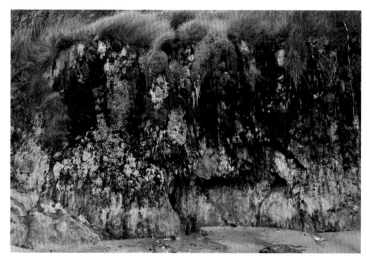

INTRODUCTION

We have all seen them – images with so much vibrancy and impact that they almost leap
off the page. Have you ever wondered how the top photographers manage to produce
such stunning pictures? You need wonder no longer, because the techniques and working
practices employed by the world's leading professionals are revealed in this book. Inside
is a collection of eighty practical tips which have been tried and tested in the field. They will
– and I speak from my own experience – enable you to master the art of capturing images
of a distinctive quality that stand out from the crowd.

Tips are given that will help you choose the right equipment and then use it correctly in
every type of situation. You will learn the art of composition and be shown how to use
light to maximum effect. Also included is advice on practising the methods relied upon by
professionals to observe the landscape creatively, with a photographer's keen eye. Adopt
these methods and you will see the world in a different way – and images which would
previously have gone unseen will become apparent. In the final chapter a small number
of simple post-processing adjustments are explained. They are easy to undertake and will
enable you to fine-tune your photographs and boost their appearance without spoiling their
integrity. Your processed images will have impact, yet remain authentic.

Put the tips in this book into practice and you will build the skills and the confidence
to make the most of every image-making opportunity you encounter in the landscape.
You will then be able to take your photography to the next level – and even beyond.

The landscape awaits you!

Peter Watson

COT VALLEY, CORNWALL, ENGLAND

Camera: Mamiya 645 AFD II with Mamiya digital back

Lens: Mamiya 35mm wide-angle

Filter: None

Exposure: 1/2sec at f/22, ISO 100

Waiting for the light: 20 minutes

Post-processing: Color Balance adjustment (warming)

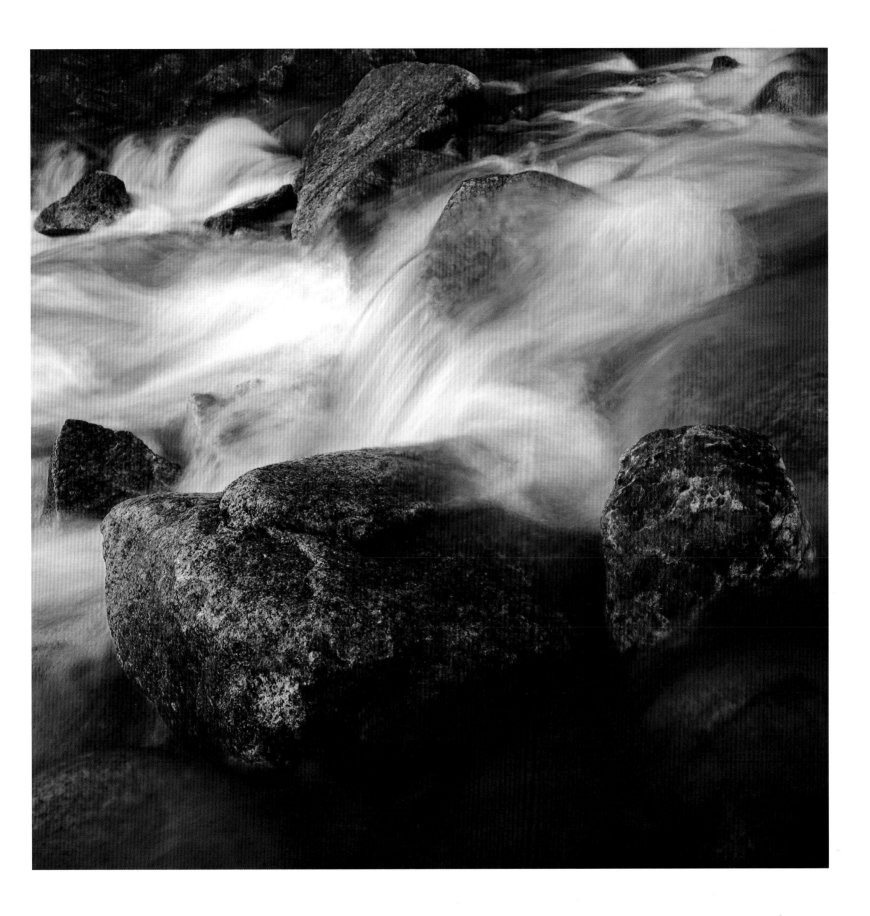

EQUIPMENT AND ACCESSORIES

LESSONS

Despite the advances in technology, there is no camera that can capture images for you. This remains your domain as the photographer; you still have the key role and success depends on you, not your equipment. You cannot buy quality images but you can – and should – buy quality equipment, because using the correct tools will help your photography and improve your enjoyment of it. The following pages will help you to choose, and use, the right cameras, lenses and accessories.

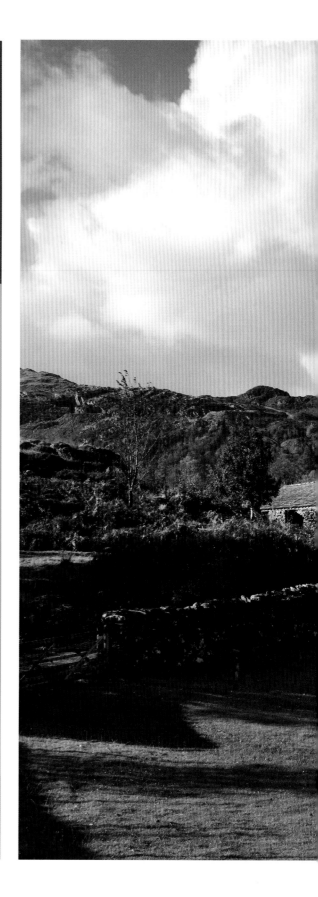

NEAR SKELWITH BRIDGE, CUMBRIA, ENGLAND

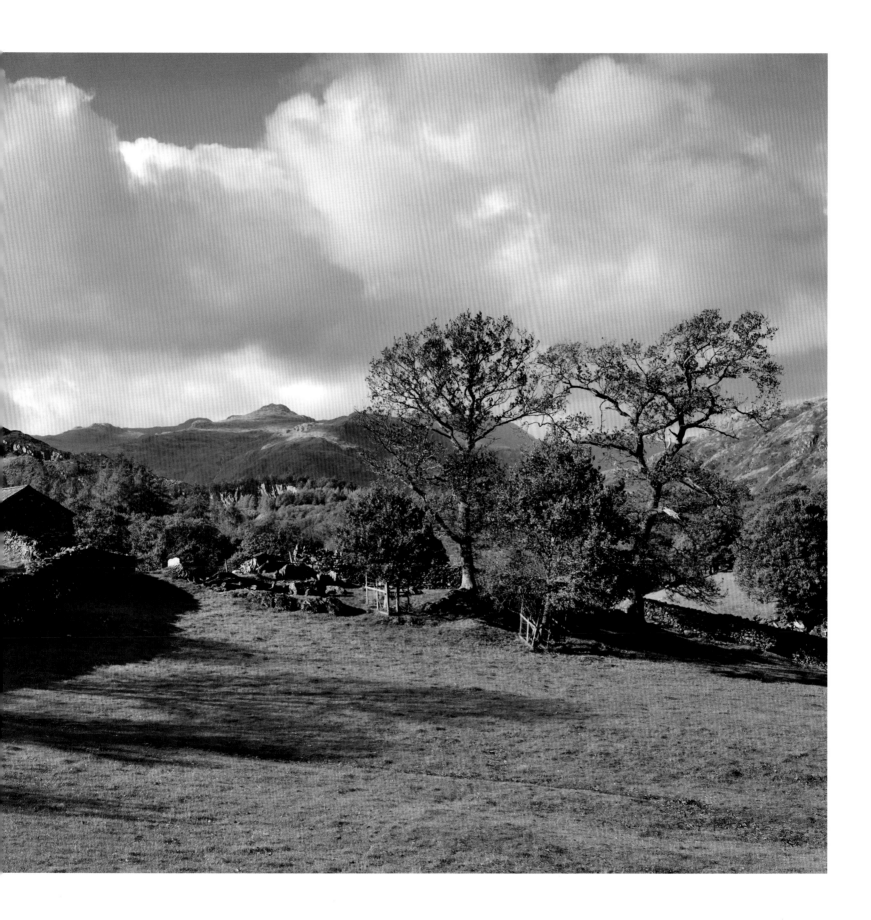

01 CHOOSE THE RIGHT EQUIPMENT

Landscape photography requires a specific type of equipment, the key factors being image quality, speed/practicality of use and portability. It is important to choose with care because the wrong type of equipment can be a hindrance to success and might also affect your enjoyment of photography. Size and weight of equipment is an important consideration and there is a fine line between carrying too much and too little. If you overburden yourself with lenses and accessories it can impede your movement and deter you from making long treks across the landscape. If, on the other hand, you are under-equipped then your ability to realize the full potential of picture-making opportunities will be compromised.

The equipment shopping list isn't long. For digital photography the essential items are a camera body, two or three lenses, filters, filter holder, cable release/remote control, lens cleaning cloth and brush, memory cards, spare batteries and a tripod. With the exception of the tripod everything should fit comfortably into a medium-sized backpack and will probably weigh no more than 11lb (5kg).

My personal choice of equipment has evolved over the years and I now have two kits. My Mamiya medium format camera is my long serving workhorse but I am increasingly using smaller, more portable APS-C equipment. Many of the photographs in this book have been captured with this kit because I like its combination of compact size, speed of use and high image quality. Camera systems, lenses and accessories are discussed in more detail throughout the book.

PORTH NANVEN, CORNWALL, ENGLAND

COMPOSITION
Coastal areas display an enticing array of subjects but finding the right composition can sometimes be difficult because a rocky terrain can restrict your choice of camera position. In these situations I prefer to use a zoom lens and a small camera and tripod as they provide more options when searching for a viewpoint.

VIEWPOINT
Because of shortage of space I struggled to compose this picture of Porth Nanven but eventually used an APS-C camera and compact tripod to capture it from a low position on uneven and unstable ground.

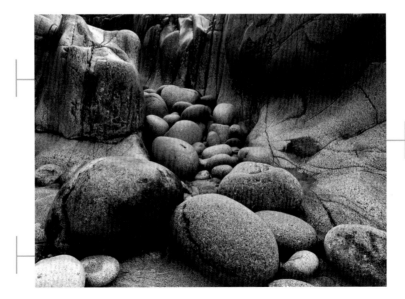

FOCAL POINT
The height of the camera was important. Too low and the view of the receding boulders would have been impaired, too high and foreground interest would have been weakened.

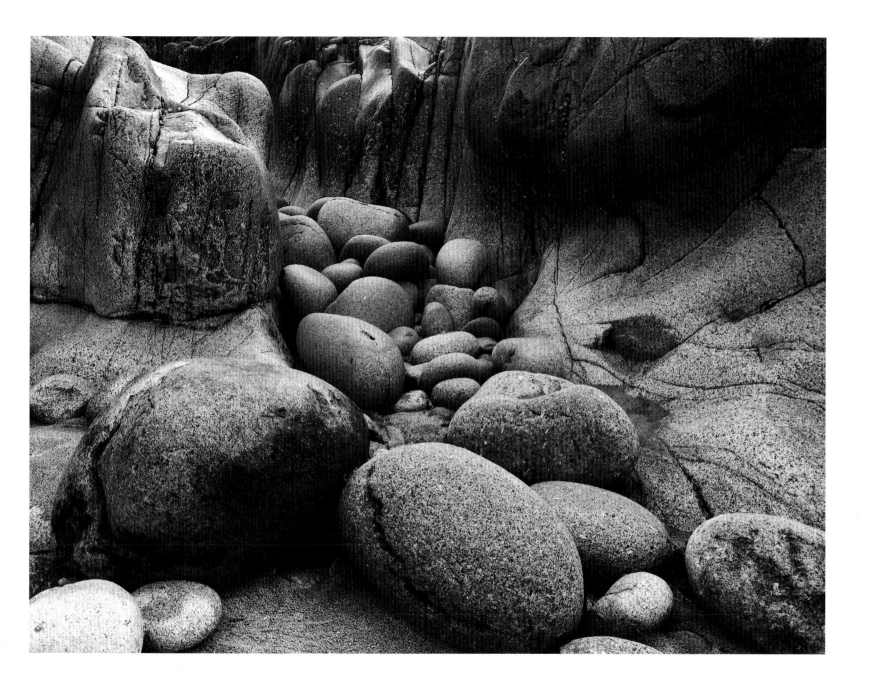

Camera: Nikon D7100

Lens: Nikon 16-35mm VR

Filter: None

Exposure: 1/10sec at f/11, ISO 100

Waiting for the light: Immediate

Post-processing: Slight adjustment to contrast

PACK YOUR EQUIPMENT SAFELY

The capture of landscape images entails exposure to the elements in what is often a challenging environment. The weather can take its toll, and the packing of your equipment is therefore an important consideration. It should be safely packed in a weatherproof bag or case which is easy to carry and allows ready access to the contents. From my experience, the most practical solution that meets these requirements is a backpack.

The size of your backpack should be appropriate for the size of your equipment. It should be large enough to allow you to pack everything securely, with each item being readily available. A bag that is too small will be a hindrance if you have to grab an item quickly — you don't want to waste time unpacking your kit to search for your spare battery as you are suddenly presented with the shot of a lifetime. Seconds lost can mean pictures lost, so every piece of equipment should be in its designated place and immediately accessible. For this reason an oversized bag should also be avoided. It's not a pretty sight if you open your backpack to find everything in disarray, with the contents taking on the appearance of a chaotic jumble-sale counter. Buy a good-quality, correctly sized backpack and it will repay its cost many times over.

WHITE POCKET, ARIZONA, USA

EQUIPMENT SELECTION
This picture was taken deep in the Vermilion Cliffs National Monument at White Pocket, a remote expanse of the most striking rock formations. Reaching it requires a long, arduous trek but it is worth the effort. Lightweight equipment eased the journey and also helped when I was scrambling over the rocks looking for the best compositions.

When travelling over difficult terrain I prefer to use my small camera and tripod. This conserves energy, which means that when I arrive at my destination I still have the stamina to make a comprehensive search for the best pictures.

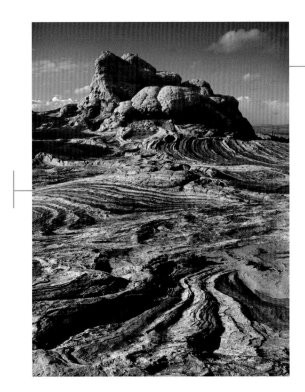

POLARIZER, FULLY POLARIZED
A polarizer was used to darken the sky and deepen its colour. A grey graduated neutral-density filter could have been used instead, but it would also have darkened the upper rock formation, which would have been undesirable.

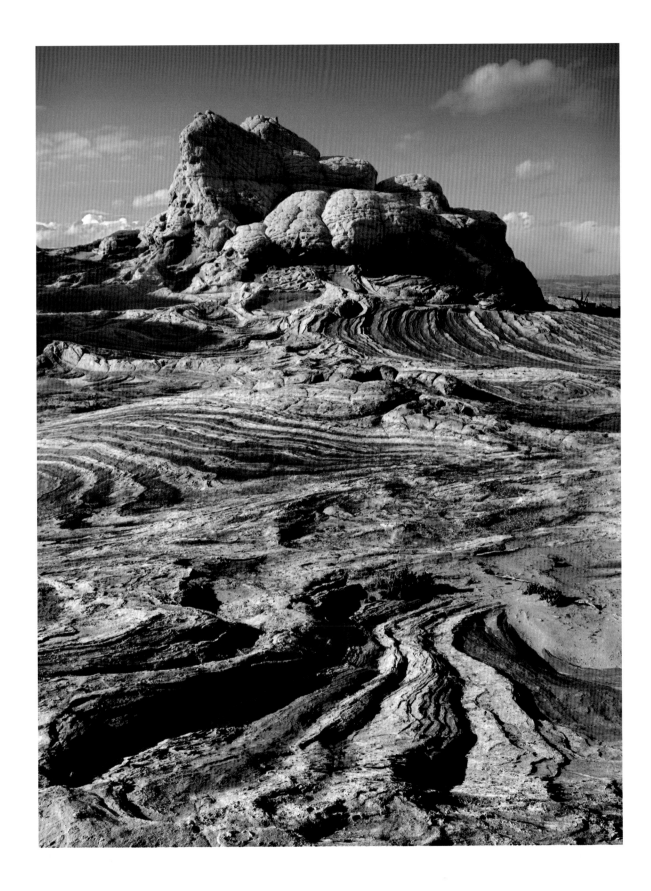

Camera: Canon EOS 7D

Lens: Canon 24–105mm L IS

Filter: Polarizer

Exposure: 1/15sec at f/11, ISO 100

Waiting for the light: 4 hours

Post-processing: Curves adjustment

03 USE A TRIPOD AND CABLE RELEASE

In most cases, the capture of a successful landscape image requires a meticulous, thoughtful approach. Therefore, unless you are working against the clock, your camera should be mounted on a tripod, not held in your hands. Freeing yourself from carrying your camera will allow you to consider your options without feeling the compelling need to press the shutter. You will be free to think about composition, sky and – most importantly – light. Unburdened by your camera, you will be able to watch as the light plays across the landscape, and release the shutter at the precise moment when light and shadow combine to show your subject at its best. This is the technique used by all successful landscape photographers. Get into the habit of using a tripod every time you make an image, and it will have a noticeable effect on the quality of your photography.

Choose a tripod that has been designed for the landscape environment and, for speed and convenience, add a ball-and-socket head. To reduce the possibility of camera shake, a cable release or a wireless remote control should also be used. Carrying a tripod can be a burden, but carbon fibre or aluminium models are both relatively lightweight and sturdy. A good tripod can last a lifetime, so it's worth investing in a good-quality model – it should provide you with many years of reliable service.

FISHER GILL, CUMBRIA, ENGLAND

EQUIPMENT SELECTION
Blurring water requires a shutter speed of 1/2sec or longer, so the use of a tripod is essential. Rivers are not the easiest subjects to navigate, and finding a camera position and erecting a tripod can be difficult (the best images always seem to be in the worst places!), so a tripod with independently movable legs is particularly useful.

POLARIZER, FULLY POLARIZED
A polarizer was used to reduce reflections on the wet rocks and also to absorb light. This enabled a slow shutter speed to be selected to blur the water surface.

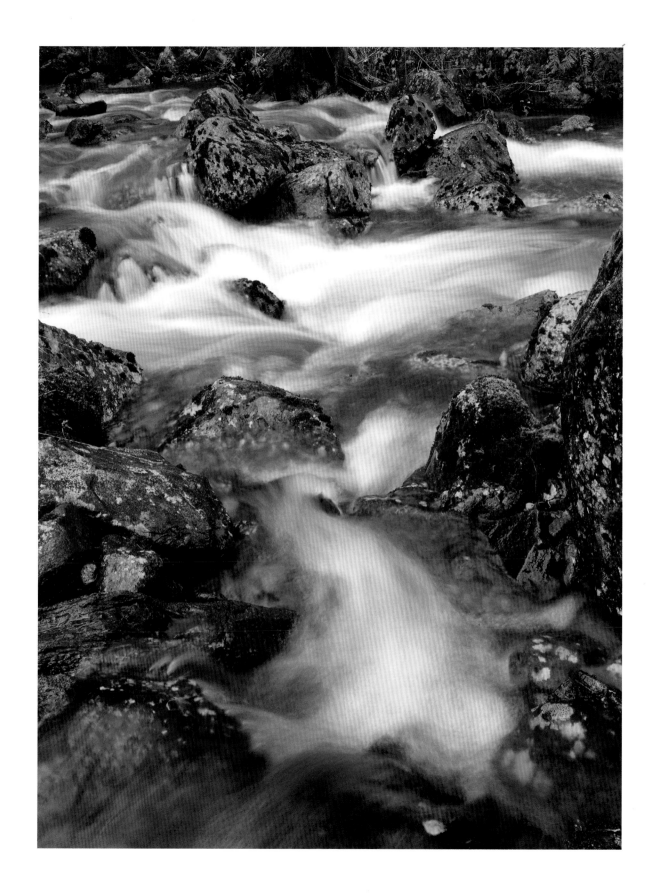

Camera: Mamiya 645 AFD II with Mamiya
digital back

Lens: Mamiya 35mm wide-angle

Filter: Polarizer

Exposure: 1/2sec at f/22, ISO 100

Waiting for the light: Immediate

Post-processing: Highlight reduction

04 ELIMINATE CAMERA SHAKE

A perfectly still camera is a prerequisite for a sharp photograph. Even a minute degree of movement will become apparent when the image is scrutinized, and it is therefore important to have the ability to spot any hint of camera shake at the time of capture.

A spirit level mounted on the camera's hot shoe is a commonly used tool. Its primary function is to help you ensure the horizon is straight, but it is also a very effective means of indicating vibration. Even the tiniest movement will be revealed if you look closely at the centre bubble. It is very sensitive, and by observing it you will be able to release the shutter during moments of perfect stillness and be confident that camera shake will not spoil your photograph. A spirit level is a permanent fixture on my camera and I would encourage you to use one. Tripods sometimes have them built in, but these are not as responsive to movement as a camera-mounted level.

Image stabilization (or the equivalent – different manufacturers use different names) is now a common feature in lenses, and sometimes in camera bodies. It is a big step forward because it makes handheld shooting possible when the use of a tripod is impractical. However, as a means of preventing camera shake it should not be considered as an alternative to a spirit level, as it can sometimes soften a photograph when used on a rigid support. There is also a risk of it causing damage to the camera when it is mounted on a tripod, particularly if the stabilization is built into the camera body. Image stabilization should be switched off when using a tripod.

NEAR THWAITE, SWALEDALE, NORTH YORKSHIRE, ENGLAND

EQUIPMENT SELECTION
It is not apparent in the picture, but there was a gale blowing at the time the exposure was made. A spirit level mounted on the camera's accessory shoe enabled the shutter to be released in a rare moment of perfect stillness, which was indicated by the spirit level's bubble being, for a split second, vibration-free. Fortunately this coincided with a favourable splash of light falling across the hillside.

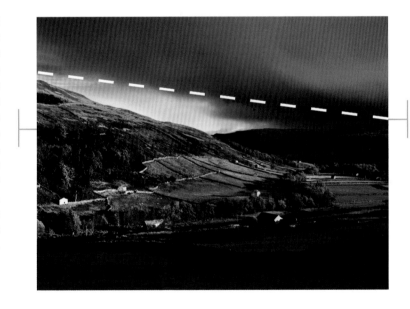

2-STOP (0.6) ND GRAD
A 2-stop ND graduated filter was used to darken the sky and prevent it from being overexposed.

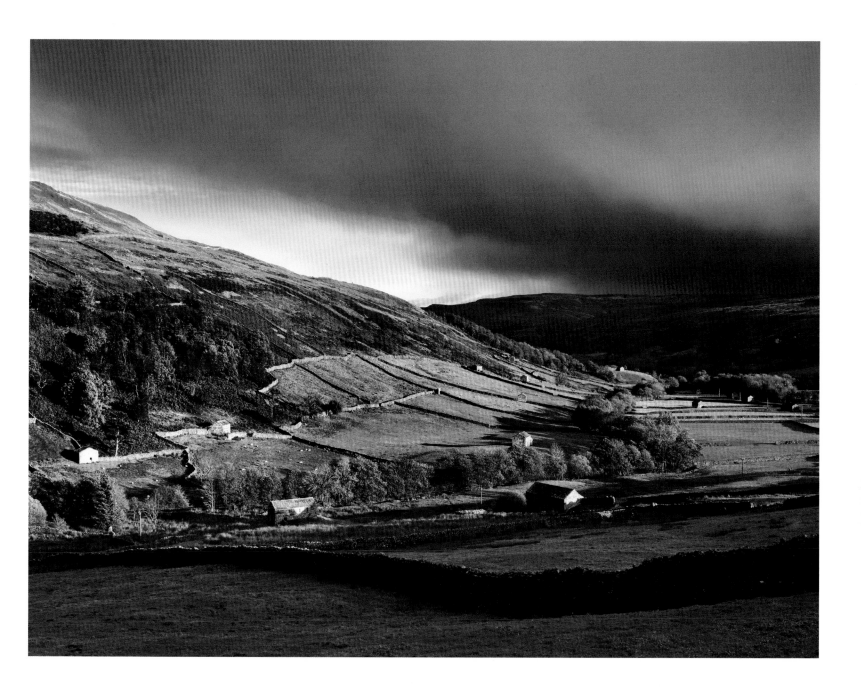

Camera: Mamiya 645 AFD II with Mamiya digital back

Lens: Mamiya 35mm wide-angle

Filter: 2-stop ND grad

Exposure: 1/8sec at f/16, ISO 100

Waiting for the light: 45 minutes

Post-processing: Curves adjustment

05 USE A GRADUATED NEUTRAL-DENSITY FILTER

The sky is, with rare exceptions, always brighter than the landscape, sometimes by as much as three or more stops. An exposure based on the land will therefore render the sky too bright, which will cause detail to be lost in the highlights. Though it is possible to adjust this in post-processing, it is preferable to darken the sky at the time of capture as this usually produces better results.

The method adopted by virtually all landscape photographers is to use a graduated neutral-density filter (also known as an 'ND grad' or 'grey grad'). This filter is designed to absorb excess light from a specific part of the image and, being a neutral colour, it has no other effect on the photograph.

Therefore, placing the grey part of the filter over the sky will darken it and enable all parts of the picture to be correctly exposed.

The filters are available in various densities. I generally use a 2-stop filter (known as an ND 4 or ND 0.6). The graduation from light to dark can be hard (fairly abrupt) or soft, which is more subtle. I usually prefer the hard graduation.

The graduated neutral-density filter is an extremely useful tool and if you carry just one filter in your kit bag then this should be it. It will bring a noticeable improvement to the appearance of your skies.

NEAR SKELWITH BRIDGE, CUMBRIA, ENGLAND

EQUIPMENT SELECTION
Having taken separate meter readings of the sky and landscape, it was apparent that, on average, the sky was 3 stops brighter than the land. There was also a wide tonal range within the sky itself so, in order for every part of the image to be correctly exposed, careful control of contrast was going to be required.

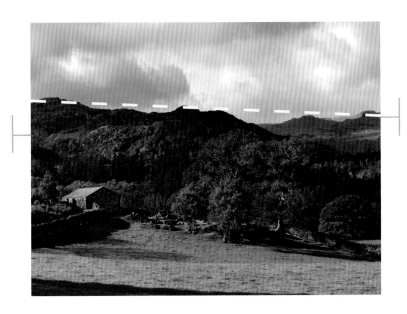

2-STOP (0.6) ND GRAD
After considering various options I decided to use a 2-stop graduated ND filter to lower the overall brightness of the sky, and then further reduce the highlights in post-processing. This combination of filter and post-exposure adjustment brought out the best in the sky, with subtle tones being present across the wide range of light values.

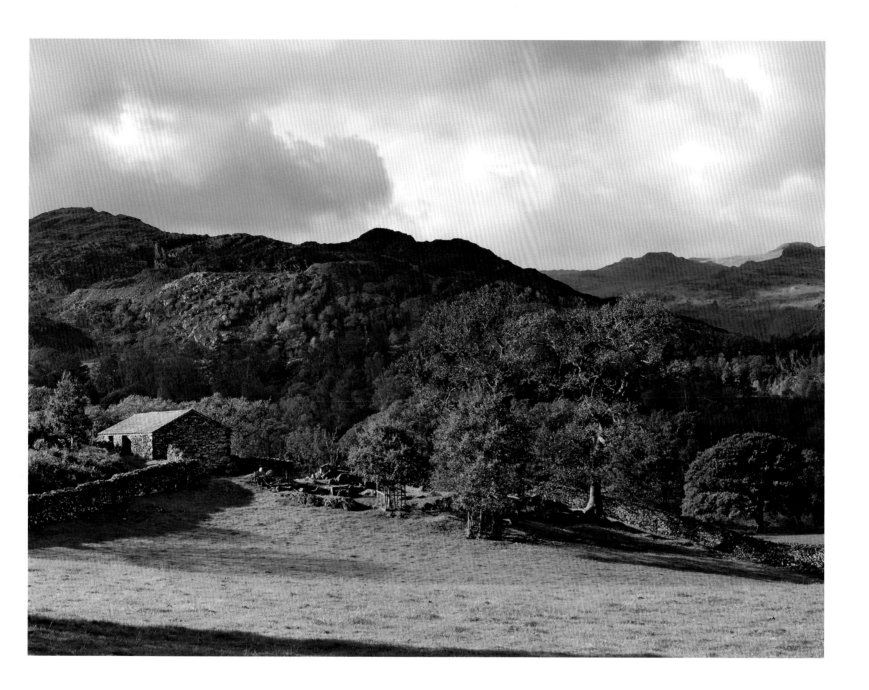

Camera: Mamiya 645 AFD II with Mamiya digital back

Lens: Mamiya 35mm wide-angle

Filter: 2-stop ND grad

Exposure: 1/5sec at f/22, ISO 100

Waiting for the light: 45 minutes

Post-processing: Curves adjustment and highlight reduction

06 USE A POLARIZING FILTER

In terms of usefulness the polarizer comes a close second to the graduated ND filter. It is effective because it absorbs polarized light, and this can have a magical effect on the appearance of landscape images. It is most commonly used to darken only the blue part of skies. This can boost the appearance of a sky and give it impact, particularly when a scattering of white cloud is present.

The polarizer also has another property: it has the miraculous ability to improve the transparency of water, and this can have a quite marvellous effect on, for example, the surface of a lake. Submerged stones near the edge of the lake will suddenly reveal themselves, which solves the problem of what to use for foreground interest when photographing an expanse of water. All surface reflections will be reduced and this will saturate colour and strengthen visual interest in the middle and far distance.

The amount of polarization can be controlled by rotating the filter. Sometimes fully polarized light can be too severe, resulting in over-darkened, or unevenly darkened, skies (this is particularly noticeable if there is little cloud present), so a cautious approach is necessary when using this filter. If correctly used, however, it can bring many pictures alive and is a very useful accessory.

LOUGH FEE, CONNEMARA, IRELAND

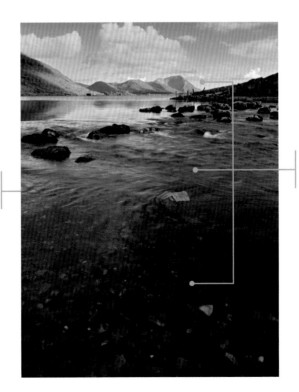

FORMAT
Portrait format was used to maximize the impact of the foreground and also enhance depth in the picture.

POLARIZER (FULLY POLARIZED)
The combination of the partly clouded sky and shallow foreground water made this a perfect image for polarizing. I therefore didn't hesitate to attach my polarizer to the camera lens and rotate it to the maximum position.

The beneficial effect of the filter can be seen across the entire picture. Starting with the foreground, the pebbles at the edge of the lake have been revealed to provide an eye-catching feature that leads the eye to a textured, colourful middle section and then on to the far mountains and sky. All parts of the image have a vibrancy and visual appeal which is solely the result of using a polarizer.

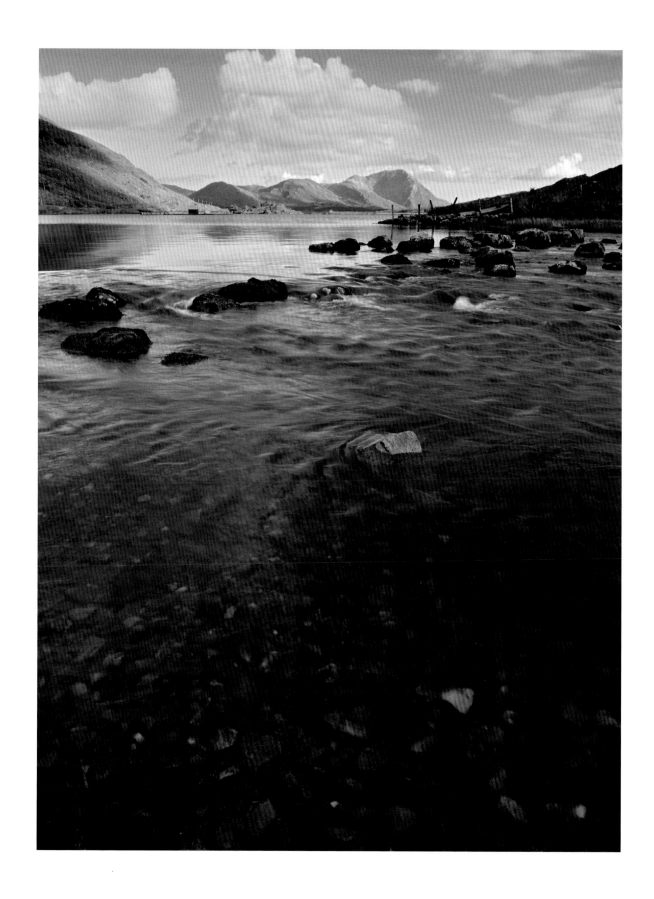

Camera: Mamiya 645 AFD II with Mamiya
digital back

Lens: Mamiya 35mm wide-angle

Filter: Polarizer

Exposure: 1/2sec at f/22, ISO 100

Waiting for the light: 40 minutes

Post-processing: Curves and Color
Balance adjustment (warming)

07 USE ZOOM LENSES

In recent years the optical quality of zoom lenses has steadily improved, and in terms of image resolution the better ones are now on a par with prime lenses. I, like many photographers, use them more and more frequently because they offer a number of advantages over their fixed-focal-length counterparts. These can be summarized as follows:

Portability One zoom lens can replace two or three fixed lenses. You can therefore reduce weight and bulk by carrying just two zooms in your bag and still have the ability to shoot from wide-angle all the way through to long telephoto.

Composition Your compositional choices are not restricted by the fixed focal lengths of prime lenses. All angles of view are available.

Creativity Having the ability to zoom in and out of subjects encourages experimentation and acts as a catalyst for creativity.

Versatility You are not restricted to one type of subject. Extreme wide-angle, macro and long telephoto images can all be captured without having to invest in additional equipment.

Economy The cost of two zoom lenses is a lot less than the equivalent in prime lenses.

Convenience You will spend less time changing lenses. This will also help to keep your camera sensor clean.

NEAR PHOENICIA, NEW YORK STATE, USA

COMPOSITION
Composing this subject took some time. I paced forwards, backwards, to the left, to the right, and considered different camera heights. I knew there was a picture to be had, but finding it was proving elusive.

VIEWPOINT
After an hour of experimenting, I chose a distant viewpoint which, with the benefit of a long telephoto zoom lens, enabled the photograph to be constructed by flattening the perspective and using a tightly framed arrangement. The effect of this is that the image has a graphic quality, consisting largely of irregular shapes, curves and angles.

FOCAL POINT
Sometimes the sky has no role to play and can therefore be excluded. The narrow angle of view of a long-focal-length lens makes this easy to achieve (see page 104).

Camera: Canon EOS 7D

Lens: Canon 100–400mm L

Filter: None

Exposure: 1/30sec at f/13, ISO 100

Waiting for the light: Immediate

Post-processing: No adjustments

08 CARRY AN UMBRELLA

It has happened to everybody: the weather forecast makes no mention of rain, so you go out without an umbrella – and, of course, it rains and you get a drenching. When you are not prepared for it, it rains – that seems to be one of the immutable laws of nature, and landscape photographers are as susceptible to nature's whims as everybody else. The solution is simple: in order to minimize disruption to your shooting and, importantly, keep your equipment dry, carry an umbrella with you – always.

The best light often occurs in periods of changeable weather and, rain or no rain, the image-making opportunities that arise on such days should never be missed. Rain might be in the air, but provided you have an

umbrella with you this should be no deterrent to setting up your camera and tripod, because you will be able to protect your equipment from any sudden showers. With practice you might even be able to assemble and operate your equipment as you hold your umbrella; it's a little tricky but, as a last resort, it can be done.

BALLYNAKILL HARBOUR, GALWAY, IRELAND

EQUIPMENT SELECTION
There was very fine drizzle falling as I made this image. Clouds were gathering and the weather seemed to be on the verge of deteriorating. The light was, at that moment, favourable and, not wishing to miss the opportunity, I quickly set up camera and tripod while holding an umbrella and rapidly made three exposures. The task was simplified by using a zoom lens and autofocus.

FOCUS
To create maximum depth of field, the point of focus was placed 6ft (1.8m) from the camera. This works better than the traditional rule of focusing one-third of the way into the picture.

2-STOP (0.6) ND GRAD
Although cloudy, the sky was still two stops brighter than the landscape. Therefore, to ensure detail was retained across the tonal range of the clouds, a 2-stop graduated ND filter was used. To minimize my camera's exposure to the elements, I attached the filter in advance, inside my car.

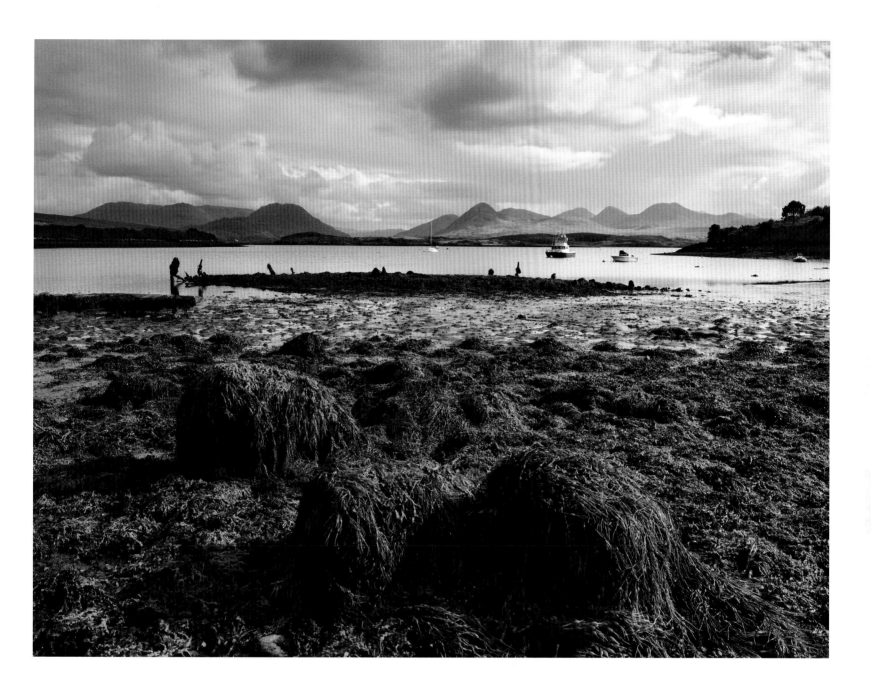

Camera: Nikon D7200

Lens: Nikon 16–35mm VR

Filter: 2-stop ND grad

Exposure: 1/20sec at f/11, ISO 100

Waiting for the light: Immediate

Post-processing: Highlight reduction

09 USE IMAGE STABILIZATION

Pin-sharp resolution is, with just a few exceptions, a prerequisite for successful landscape images. Until recently this meant that your camera had to be mounted on a sturdy tripod. Now, with the advent of image stabilization (or vibration reduction), the shackles of the tripod have suddenly been removed. This new technology makes handheld exposures a viable option, and this has opened up new opportunities for the landscape photographer. Now those fleeting, unexpected moments when a not-to-be-missed image suddenly appears can, almost literally, be grabbed with both hands. Seconds matter, and the time saved by dispensing with a tripod can be decisive. Shots which would previously have eluded you can be captured, and there is no doubt that image stabilization has a role to play in landscape photography.

However, I must at this point sound a cautionary note. The tripod is not yet redundant. It is still an essential piece of equipment and should be used whenever possible. A tripod-mounted camera still produces the sharpest pictures and, as discussed earlier, freeing yourself of the burden of holding your camera gives you thinking time — and a thinking photographer is more likely to be a successful photographer. Image stabilization is, however, a huge leap forward and your investment in this technology will open up new picture-making opportunities. Use it at the right time and its benefits will be apparent. (*See also page 18.*)

SHEEFFRY HILLS, CONNEMARA, IRELAND

TIMING
Sun rays bursting through a stormy sky are an arresting, but often short-lived, sight. If you are suddenly presented with a heaven-sent display, then to avoid missing the moment you have to move with lightning speed.

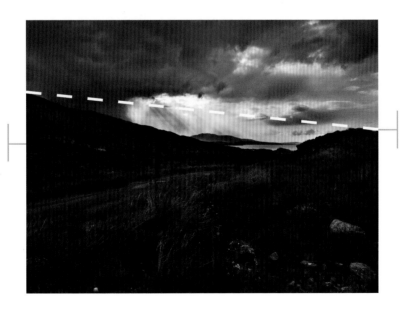

2-STOP (0.6) ND GRAD
Driving through the Sheeffry Hills in Connemara, I rounded a bend and immediately saw this opportunity. Screeching to a halt, I grabbed my camera, fitted a graduated ND filter, switched on autofocus and image stabilization, focused on a point at a distance of approximately 7ft (2m) and quickly made three exposures before the light faded. Capturing this photograph would not have been possible without image stabilization.

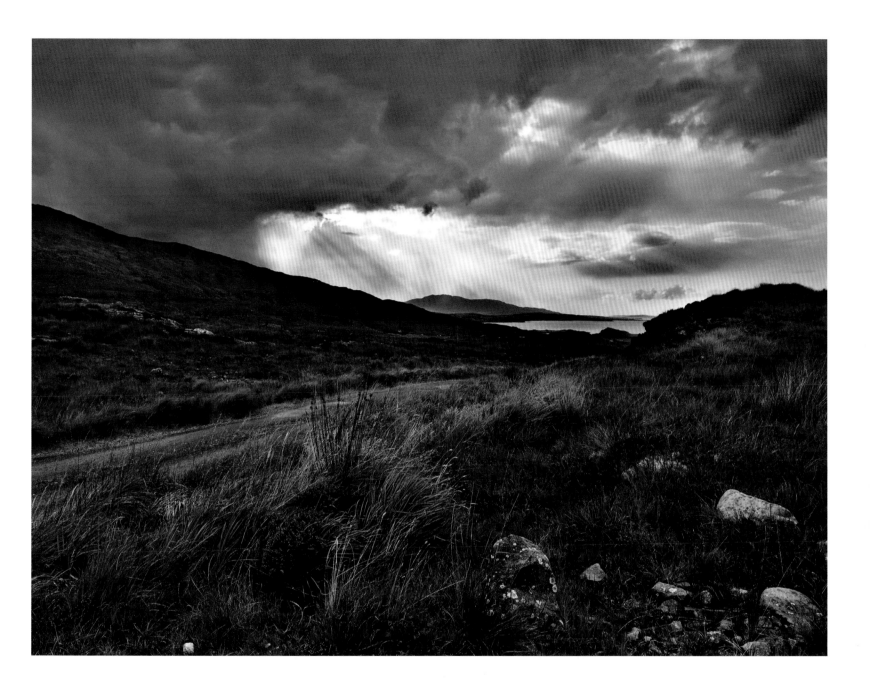

Camera: Nikon D7200

Lens: Nikon 16–35mm VR

Filter: 2-stop ND grad

Exposure: 1/20sec at f/10, ISO 100

Waiting for the light: Immediate

Post-processing: Highlight reduction

UNDERSTAND YOUR CAMERA

Cameras aren't as simple as they used to be. Even the most basic digital SLRs (DSLRs) have what appears to be a baffling array of menus and options, many of which you might never need to access. There are, however, a number of basic functions which it is wise to become familiar with. The most important ones are the shooting modes, exposure adjustment and focusing. These should be practised and experimented with until their operation becomes second nature. It is also useful to familiarize yourself with the information displayed in the viewfinder and rear screen. An understanding of the symbols shown and what causes them to start flashing (it is always disconcerting when something starts flashing for no apparent reason!) will enable you to react to what your camera is telling you, and it might just be the difference between capturing and missing that once-in-a-lifetime picture-making opportunity.

Hands-on experience is invaluable, so handle the camera, and practise changing lenses and inserting and removing the memory card and battery until you no longer need to think about these things. Sometimes you have to have lightning-quick reactions and any uncertainty or hesitation will slow you down – often with disastrous results. Get to know your camera as well as you know your mobile phone or any other appliance, and you will greatly increase your chances of success.

UPPER ANTELOPE CANYON, ARIZONA, USA

TIMING
The Antelope Canyon is a magnificent sight and a popular tourist attraction. Tours are regulated and time is limited, and because of its popularity there is also a constant danger of passers-by wandering into your shot. Time is therefore of the essence, and you have only a limited opportunity to capture images. In these pressurized situations you have to work quickly and a deep working knowledge of your equipment is essential. Get to know your camera like the back of your hand, and you will have the confidence to make the most of every opportunity.

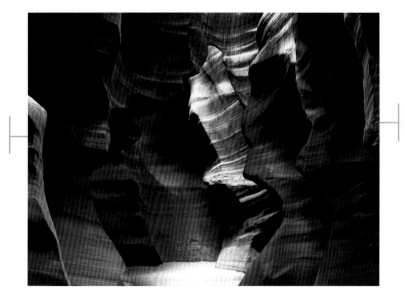

POSITIONING
Contrast was high in many parts of the canyon. This picture was taken in an area where the lighting was softer and more subdued, which allowed detail to be retained across the range of highlights and shadows.

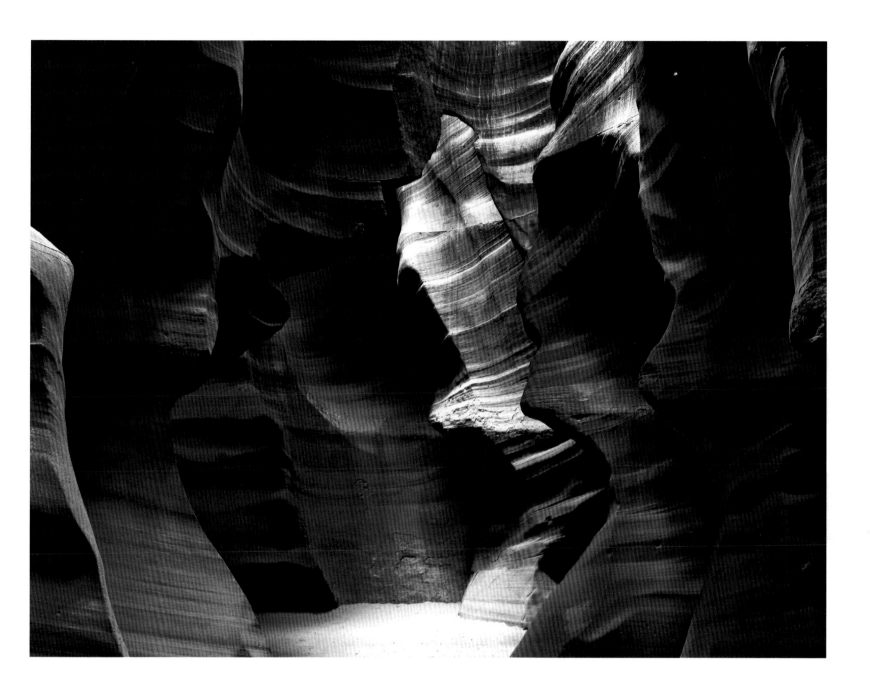

Camera: Canon EOS 7D

Lens: Canon 24–105mm L IS

Filter: None

Exposure: 1sec at f/13, ISO 100

Waiting for the light: Immediate

Post-processing: Curves adjustment and highlight reduction

TECHNIQUE

LESSONS

The top landscape photographers share a common attribute: their method of working is based on a sound and proven technique. They were not born with it; they have developed it to the point where success is virtually guaranteed every time they reach for their cameras. They learned their technique and you can learn it too. This chapter will outline the methods the top professionals use, and show you how to consistently produce stunning, high-quality landscape images.

LLANTYSILIO, DENBIGHSHIRE, WALES

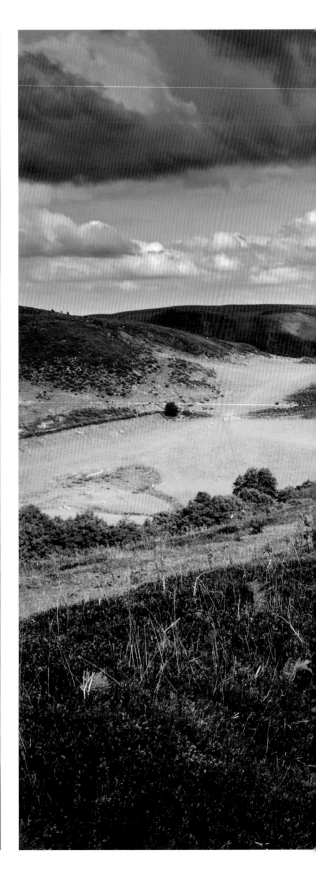

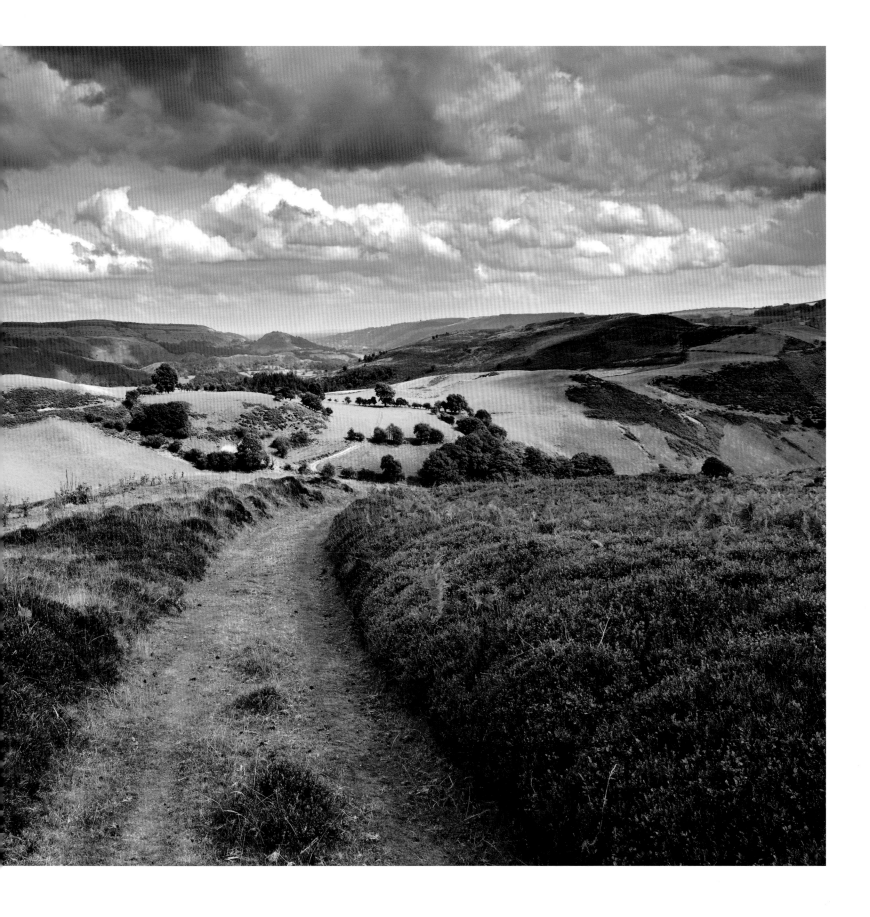

11 USE THE RIGHT CAMERA SETTINGS

Successful landscape photography requires high-quality images that show fine detail and front-to-back sharpness. To achieve this your camera has to be set up correctly, and for landscapes the best settings are generally considered to be:

Exposure mode: aperture priority. This will enable you to select your preferred aperture while the camera determines the appropriate shutter speed. You therefore have control over depth of field, which is an important requirement for image sharpness.

Metering mode: evaluative or multi-zone. In this mode, exposure is based on several points across the frame. On many cameras this is the default setting, as it usually gives the most reliable results.

Focus mode: manual. This will enable you to determine the point of focus, which again is important for overall sharpness. Autofocus can be used, but you need to be aware of what the camera is focusing on. When capturing open views there is a possibility that the camera will focus on a distant point, which might result in an out-of-focus foreground.

ISO: 100. Unless there is a reason not to, I suggest you use ISO 100 (or slower). This will render the finest, noise-free detail.

Image quality: Raw or Raw + Jpeg. Raw files capture more information and higher dynamic range than Jpegs. They also enable a wider range of post-processing adjustments to be made. However, Jpegs can also be useful and your camera will probably give you the option of saving images simultaneously as both Raw and Jpeg.

ZION NATIONAL PARK, UTAH, USA

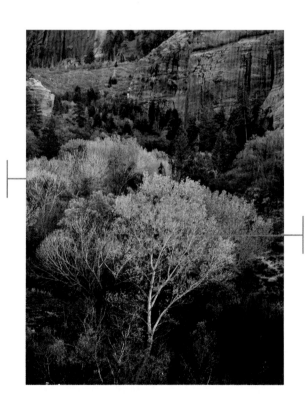

TONE
A faithful rendition of fine detail and tonal range was the priority in the making of this photograph of Zion National Park. This was achieved by using a mid-range aperture and precise manual focusing, with the image captured in Raw format at ISO 100.

COLOUR
When colour is a prominent feature, it is best captured under diffused lighting. I had to wait over an hour for passing cloud to soften the light, but there was no alternative because highlights and shadows would have obscured the subtle tones of the autumn foliage.

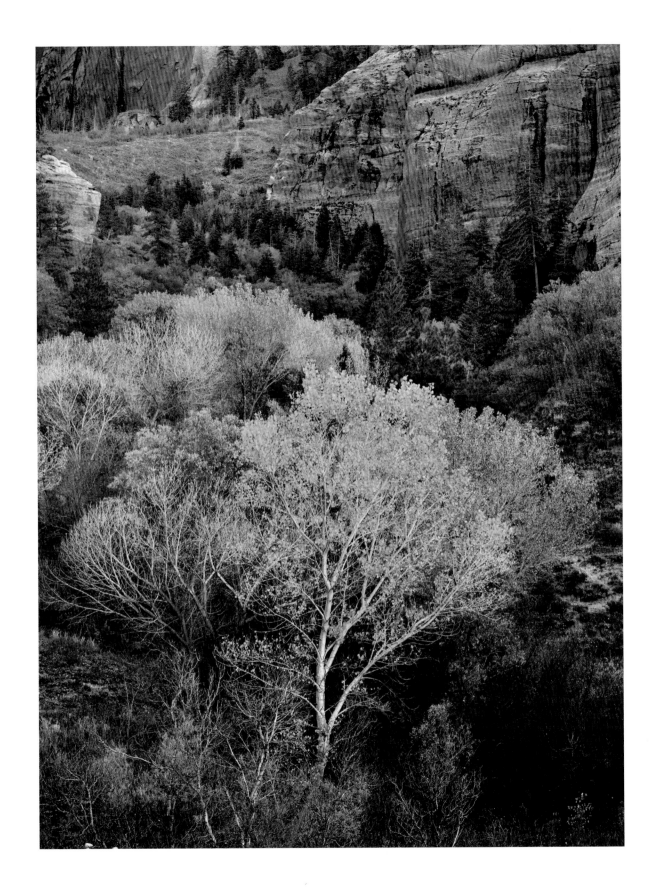

Camera: Mamiya 645 AFD II with Mamiya
digital back
Lens: Mamiya 150mm telephoto
Filter: None
Exposure: 1/15sec at f/18, ISO 100
Waiting for the light: 1 hour 20 minutes
Post-processing: No adjustments

12 ESTABLISH A PROCEDURE

Once you are familiar with your camera, you should get into the habit of putting into practice the knowledge you have gained. In the excitement of suddenly being presented with a shooting opportunity it is easy to overlook the basic requirements. To avoid disappointments I suggest you establish a procedure and follow it each and every time you switch on your camera. Check that you are:

1 capturing Raw (or Raw + Jpeg) images
2 using ISO 100, or the ISO of your choice if a higher value is required
3 using aperture priority, and have the aperture of your choice selected
4 not using vibration reduction or image stabilization if you are using a tripod
5 aware of the point of focus (and therefore the extent of your depth of field).

If you follow these five simple steps – they will take only a matter of seconds – then you can be confident that the basic requirements are in place, and you can from now on concentrate on the creative aspects of capturing the photograph. I have seen cases of cameras being inadvertently set to capture small, low-resolution Jpegs, and the resulting images, though technically perfect, were too small to be usable. Follow the procedure and you will avoid this, or other costly errors.

LANGDALE VALLEY, CUMBRIA, ENGLAND

TIMING
A sudden beam of light bursting through a cloudy sky gave me an unexpected image-making opportunity. Seconds mattered, but there was just time to find a viewpoint, attach a graduated ND filter and capture the picture handheld, using image stabilization. The camera settings were also checked. There was no reason why they should have changed since the last time the camera was used – and indeed they hadn't – but the procedure was still followed. It is the only way to ensure that mistakes are avoided.

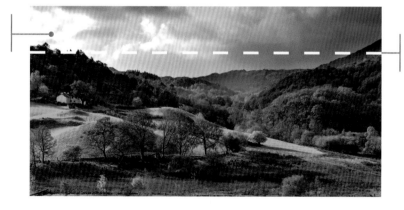

2-STOP (0.6) ND GRAD
A 2-stop graduated neutral density was used to darken the sky and enable all parts of the image to be correctly exposed.

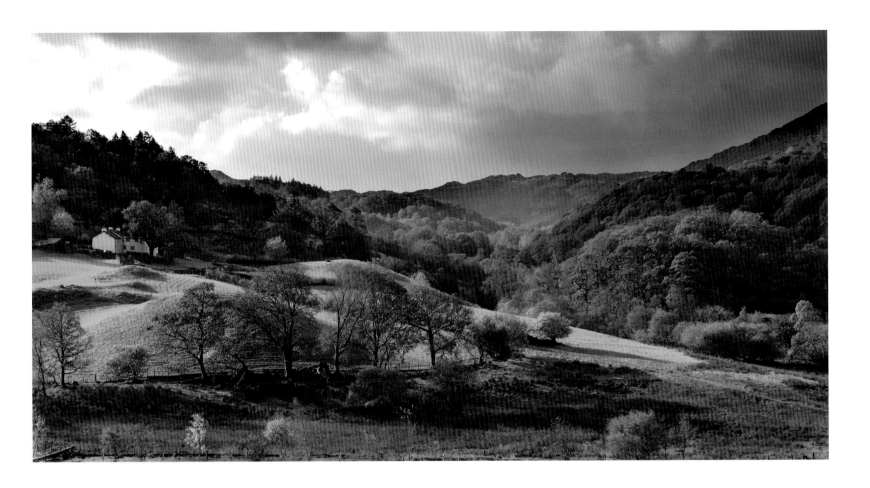

Camera: Canon EOS 7D

Lens: Canon 24–105mm L IS

Filter: 2-stop ND grad

Exposure: 1/50sec at f/13, ISO 100

Waiting for the light: Immediate

Post-processing: Curves adjustment and highlight reduction

13 KNOW YOUR SHARPEST APERTURE

The creation of pin-sharp images is the objective for most landscape photographers. To achieve this everything must be in focus, and this often requires deep depth of field, from as close as 2–3ft (0.6–0.9m) from the camera to infinity. Extensive depth of field requires the use of a small aperture – the smaller the aperture, the greater the depth of field – and a simple solution is to set your camera lens to its minimum aperture, typically f/22 or smaller. This, however, has its drawbacks, and despite the long depth of field it can produce soft images. The reason for this is an optical effect called diffraction.

Diffraction occurs when light passes through a small opening. Light rays begin to disperse (or 'diffract') as the size of the opening (i.e. the lens aperture) decreases. Smaller camera lenses are particularly susceptible to diffraction, and image sharpness tends to peak in the middle of the aperture range, with softening starting to become noticeable from about f/13 or thereabouts. You can determine your sharpest aperture by mounting your camera on a tripod, capturing the same photograph at different aperture settings and then viewing the resulting images at 100%. Depth of field is, of course, reduced by using a larger aperture, but this isn't really a problem because the short focal lengths of APS-C lenses compensate for this. For example, a 20mm lens set at f/11 and focused on a distance of 6ft (1.8m) produces a depth of field from 3ft (0.9m) to infinity. This covers most situations, and when using my smaller cameras I use between f/8 and f/11 for the majority of my exposures.

NEAR AMBLESIDE, CUMBRIA, ENGLAND

EQUIPMENT SELECTION
Obtaining the sharpest possible reproduction of this rock face was my main concern when capturing this picture. I would have preferred to use my Mamiya medium-format camera, but access was difficult and it was therefore taken with a Nikon D7200. The lens aperture was set at f/10 and this has produced a perfectly sharp image.

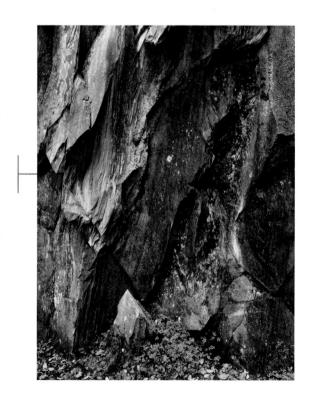

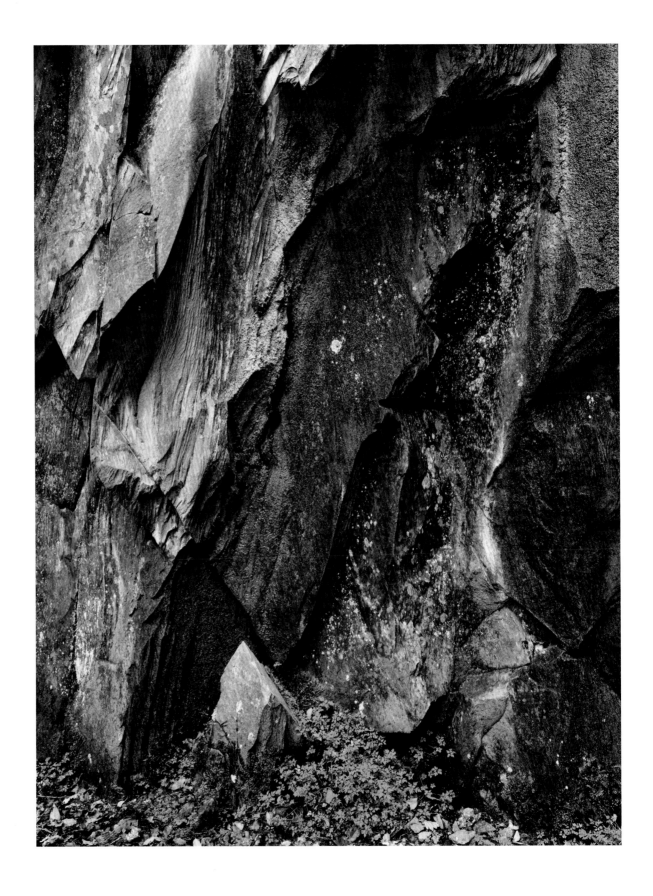

Camera: Nikon D7200

Lens: Nikon 16–35mm VR

Filter: None

Exposure: 2sec at f/10, ISO 100

Waiting for the light: Immediate

Post-processing: No adjustments

LOOK AT THE HISTOGRAM

Accurate exposure requires the precise measurement of light, and with modern cameras this happens automatically every time the shutter is released. In-camera metering systems have come a long way since the days of using handheld exposure meters but, while in most cases they give good results, they are not foolproof. They only measure reflected light, and are calibrated to render the average tone in a scene as the equivalent of middle grey. If your subject is lighter or darker than this, you will therefore need to adjust the exposure. When shooting film, this can be achieved by bracketing (taking several images at slightly different exposures), but with digital imaging bracketing is no longer really necessary. By looking at the histogram you can accurately assess the brightness and adjust it by changing exposure as required.

The histogram is a graphical representation of the distribution of pixels across the tonal range of an image. The horizontal scale indicates exposure latitude and the vertical scale shows pixel quantity. The darkest pixels are normally shown on the left, and they become progressively lighter as they move to the right. A histogram with pixels stacked to the left will therefore indicate a dark, possibly underexposed photograph, while stacking to the right shows a predominance of light tones, or possible overexposure. By viewing the histogram you will therefore be able to adjust exposure and produce the tonal range you require.

ZION NATIONAL PARK, UTAH, USA

EXPOSURE
This image consists of a wide range of tones, so to ensure detail was recorded in both highlights and shadows, accurate exposure was essential. The first attempt was a little underexposed. This was caused by the large expanse of sky, which lowered the average exposure value calculated by the camera's metering system. Looking at the histogram, the underexposure was apparent because the pixels were grouped predominantly to the left. Exposure was increased and a second photograph captured, the histogram of which (*right*) indicated an even distribution of pixels across the full spectrum of tones.

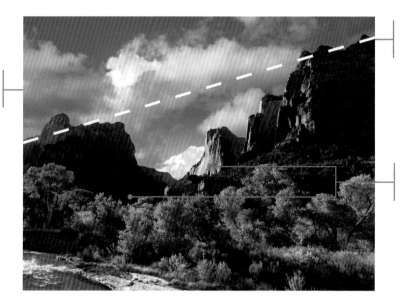

2-STOP (0.6) ND GRAD
Bright sunlight produced a wide range of contrast. Correct exposure of the highlights and shadows was achieved by paying close attention to the histogram.

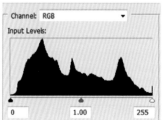

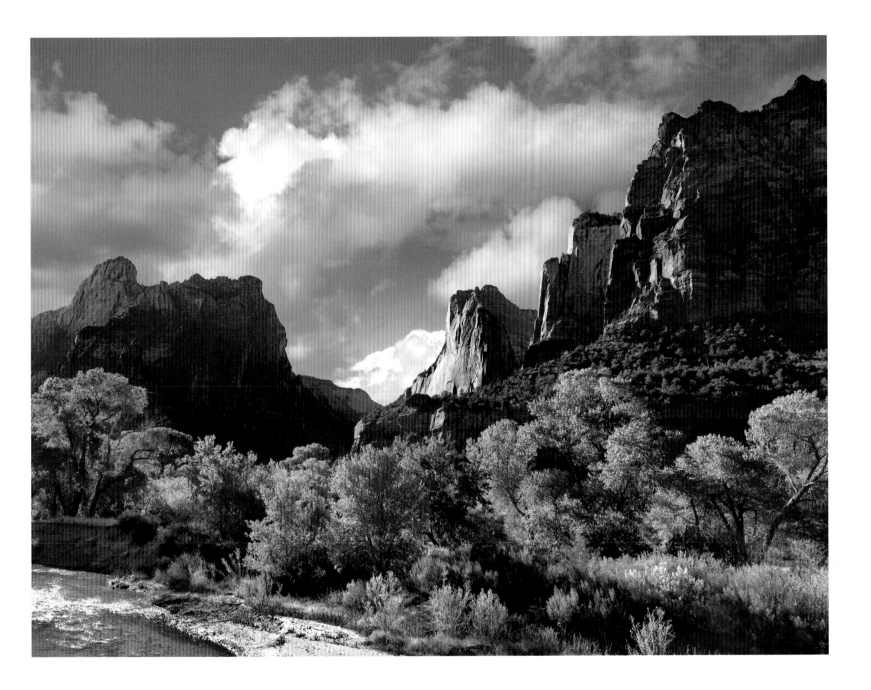

Camera: Mamiya 645 AFD II with Mamiya digital back

Lens: Mamiya 35mm wide-angle

Filter: 2-stop ND grad

Exposure: 1/30sec at f/22, ISO 100

Waiting for the light: 45 minutes

Post-processing: Curves and Shadows/Highlights adjustment

⑮ ASSESS CONTRAST

Your histogram will, as previously explained, show both exposure and contrast levels. High levels of contrast are indicated by pixels clipping the sides of the histogram. This shows that the camera sensor is unable to capture the extreme highlights or shadows, or both. This will result in blown-out (pure white) highlights and/or blocked (pure black) shadows with no detail visible in these areas. The histogram shows 256 levels of brightness, 0 being the darkest and 255 the lightest.

Waiting for soft lighting is one way to control contrast, but filtration is sometimes another option. Whenever you have a clearly defined area that is too bright and it is adjacent to an edge of the image, you could consider darkening it with a graduated neutral-density filter. This filter, as discussed on page 20, is mainly employed as a means of darkening the sky, but it can also be used to darken other parts of a picture. It is an effective method of reducing contrast, and is quicker and simpler than making adjustments in post-processing. It also gives better results, because highlights and shadows look more natural if they have been correctly exposed at the time of capture. Adjusting high levels of contrast or compensating for incorrect exposure in post-processing should be avoided if possible; the use of a graduated neutral-density filter can, in this respect, be very helpful.

PORTO DE BARCAS, PORTUGAL

EXPOSURE
There was, on average, a 3-stop difference in the exposure values of the sand and rock. This is similar to an image of landscape and sky, only inverted, so by positioning the dark portion of the filter over the sand the exposure value was equalized across the picture.

2-STOP (0.6) ND GRAD

HISTOGRAM
The histogram of this image shows that although there is a wide range of tones, with the filter in place there are no extremes of contrast. Detail across all tonal values has therefore been fully captured by the camera's sensor.

Channel: RGB
Input Levels:
0 1.00 255

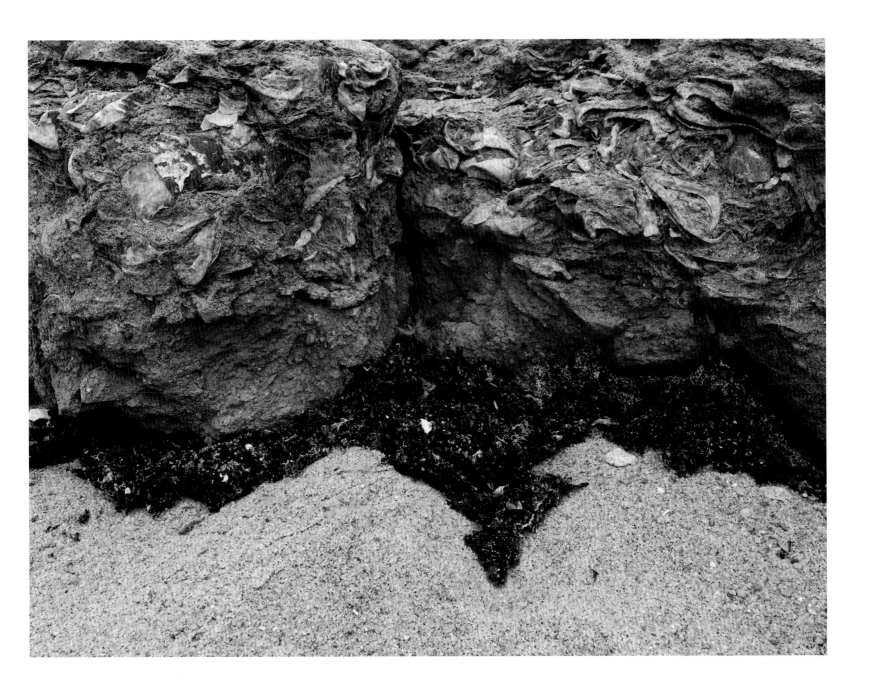

Camera: Mamiya 645 AFD II with Mamiya digital back

Lens: Mamiya 35mm wide-angle

Filter: 2-stop ND grad

Exposure: 1/2sec at f/13, ISO 100

Waiting for the light: Immediate

Post-processing: Color Balance adjustment

16 USE LIVE VIEW

Autofocus systems have steadily improved over the years and, for wildlife and sports photographers, have now virtually eliminated the need for manual focusing. If an awareness of the extent of depth of field is not essential to your photography, then your camera can be left permanently in autofocus mode. Landscape photography, however, normally requires front-to-back sharpness, and manual focusing is therefore often the better option. To assist in determining depth of field, many cameras have a preview button that enables you to see the extent of sharpness at any given aperture, but when using a small aperture the image in the viewfinder can be so dark that it is difficult to see anything in detail. This can cause focusing errors.

But nowadays there is another option. If your camera has a live view mode, this can be used to obtain sharp focus. Live view is sometimes considered to be primarily a video-recording function but, while it is indeed very useful for that, it can also be utilized in the capture of still images. Live view not only enables you to see in real time what the camera sees, but you can also look at the live photograph at 5x or 10x magnification. This gives you the ability to focus manually with great accuracy, because you can see the changes in depth of field as you select different apertures. You can therefore check sharpness from foreground to background and focus precisely on the point that creates maximum depth of field.

PORTH NANVEN, CORNWALL, ENGLAND

DEPTH OF FIELD
As the distance from subject to camera reduces, so does depth of field. Close-up images require, therefore, accurate focusing, even when using a small aperture. In these situations live view is of great help in determining depth of field and focusing on the point of maximum sharpness.

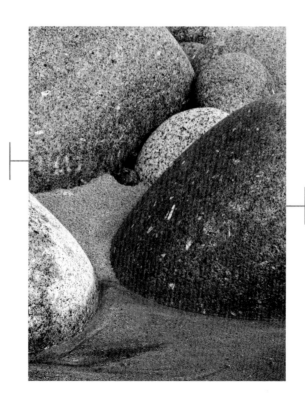

POINT OF FOCUS
There was no room for error as I focused on this close-up picture of rocks. Using live view removed the guesswork because, seeing exactly what the camera saw, I was able to select a point of focus in the knowledge that all parts of the image would be sharp.

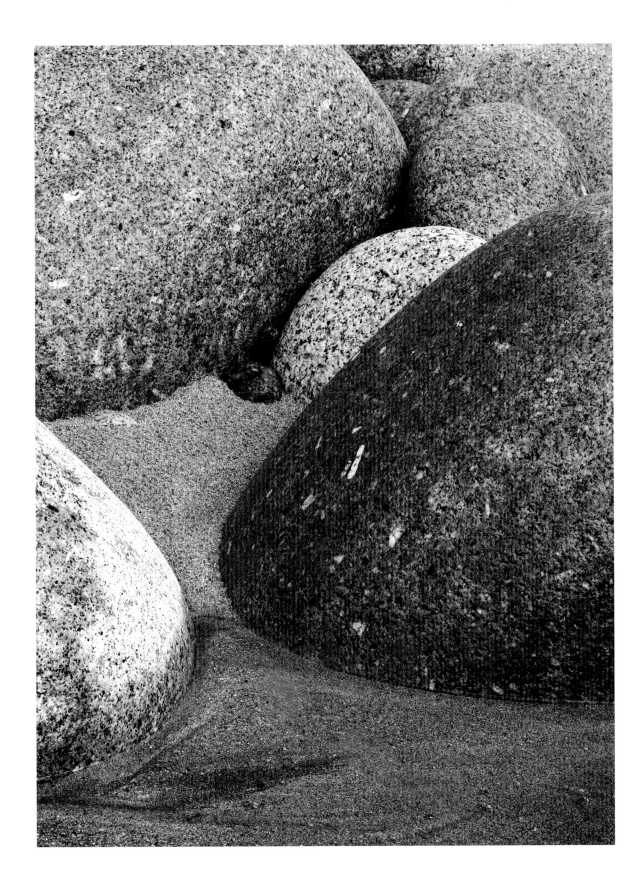

Camera: Canon EOS 7D

Lens: Canon 24–105mm L IS

Filter: None

Exposure: 1/50sec at f/10, ISO 100

Waiting for the light: Immediate

Post-processing: No adjustments

FIND THE HYPERFOCAL DISTANCE

The hyperfocal distance is the closest distance at which details are recorded sharply when the lens is focused on infinity. Therefore, if you focus your lens on the hyperfocal distance you will create maximum depth of field, with everything being sharp from the closest possible point all the way to infinity. This becomes relevant when you are shooting a distant view with foreground close to the camera, because extensive depth of field will be required. Accurate focusing will be necessary, so it is preferable to use manual focus, rather than rely on your camera's autofocus system. You will then be certain that you are focusing on the optimum distance.

There are two variables which determine the hyperfocal distance: these are lens aperture and focal length. The shorter the focal length and the smaller the aperture, the closer the hyperfocal point (and the greater the depth of field). An APS-C 18mm lens set at f11 will, for example, produce a hyperfocal distance of 5ft (1.5m) with a depth of field that extends from 2.5ft (0.8m) to infinity. This is, as you can see, very large and, unless your foreground is extremely close to the camera, allows for a degree of error in the calculation of hyperfocal distance.

The simplest way to find hyperfocal distance is to refer to charts that are available online. A useful website is www.dofmaster.com, which calculates it for any combination of focal length and aperture. For reference purposes I carry a list of these distances in my kit bag, but I find it unnecessary to refer to it constantly as I use a fairly limited number of focal lengths and apertures, and instinct tells me where the point of focus should be. With time you should also be able to estimate the distance without too much difficulty.

PONT MELIN-FACH, POWYS, WALES

SHUTTER SPEED
There was a strong wind at the time this picture was captured. To prevent the swaying grass and reeds from blurring during exposure I used a fast shutter speed, and as a result a relatively large aperture. This reduced depth of field and careful focusing was therefore required. I found the hyperfocal distance on my chart, paced out the distance (5.4ft/1.6m) and focused on the precise spot. This produced a depth of field of 3ft (0.9m) to infinity.

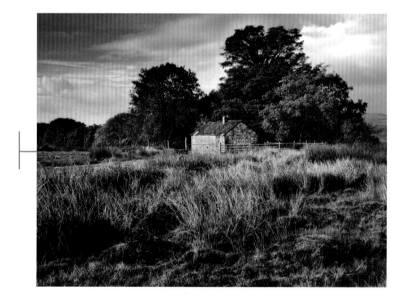

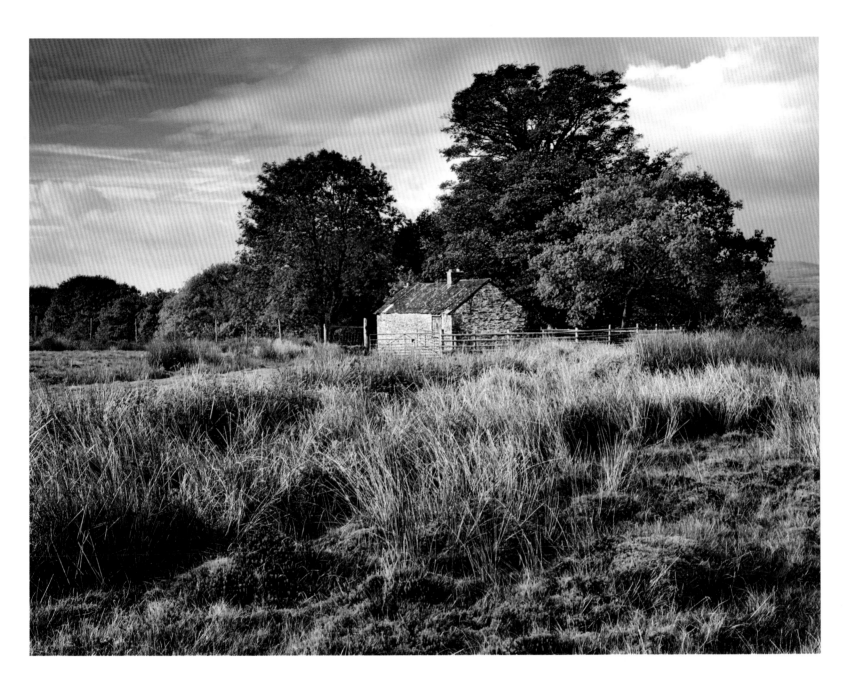

Camera: Mamiya 645 AFD II with Mamiya digital back

Lens: Mamiya 35mm wide-angle

Filter: None

Exposure: 1/30sec at f/8, ISO 100

Waiting for the light: 30 minutes

Post-processing: Curves and Shadows/Highlights adjustment

 # RESEARCH AND PLAN IN ADVANCE

Before you make a photography trip it pays to undertake advance research and planning. Some places are naturally more photogenic than others and, with just a little investigation, you can pinpoint the locations where the odds of making successful images are stacked in your favour. There is now a wealth of information available on the Internet to help you make your choice. Google Earth enables you to look at photographs from all over the world; the quality can be variable but they give you an idea of what to expect from an area. Image-hosting websites such as Flickr are also a useful resource and have literally millions of pictures for you to peruse. You can find the places which are popular with other photographers and see how they approach their subjects (I'm not suggesting you replicate their pictures – that helps nobody – but they can point you in the right direction).

'When' is as important as 'where', since both light and landscape can change dramatically throughout the year. The softer, lower-angled light of winter can be captivating, as can the colours of autumn, but other times of year also have their advantages, so think about the type of subject you like to capture and time your trip to coincide with the peak time of year. Visit the right place at the right time, and you will be a very big step closer to capturing successful photographs.

WHITE POCKET, ARIZONA, USA

PLANNING
You don't find places like this by chance encounter. White Pocket is an isolated and difficult-to-reach patch of sandstone lying deep in the Paria Canyon Wilderness. To visit it requires a long drive across a rough, and at times impassable, track followed by an arduous trek. Advance research and close scrutiny of maps were necessary to make the trip to this breathtaking part of Arizona possible.

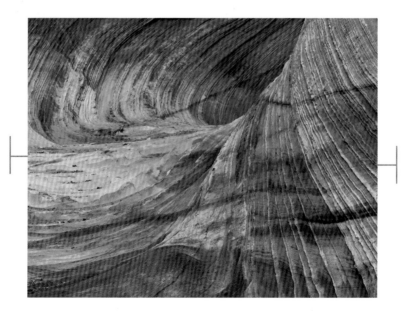

POSITIONING
The patterned limestone of White Pocket provides an endless variety of images. Here I have used an abstract arrangement in an attempt to reveal a specific characteristic of the rock formation. The absence of scale heightens the abstract quality but also, to my eye, weakens the picture slightly.

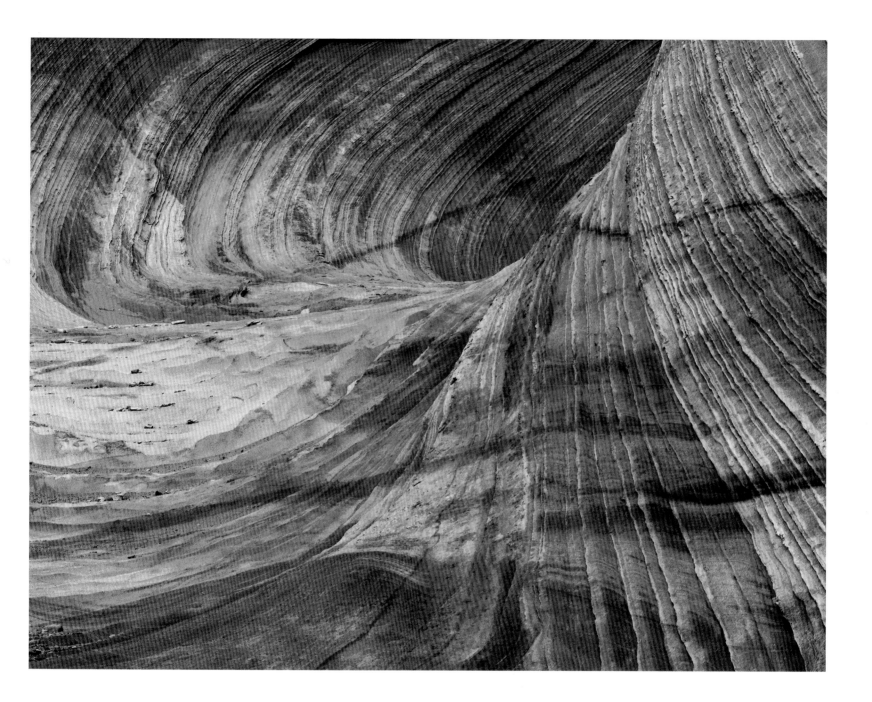

Camera: Canon EOS 7D

Lens: Canon 24–105mm L IS

Filter: None

Exposure: 1/60sec at f/10, ISO 100

Waiting for the light: Immediate

Post-processing: Color Balance adjustment (warming)

19 USE LARGE-SCALE MAPS

Maps are an invaluable source of information and an indispensable tool for the landscape photographer. Large-scale maps – such as the 1:50,000 Ordnance Survey Landranger series for Great Britain – reveal a lot about a location and help you pinpoint areas that, on paper at least, hold the most potential. By studying the contour lines on a map you can assess the shape of the land and search for the most photogenic areas. Mountainous and hilly terrain is always worth investigating, as are those places with lakes, rivers and forests. The size of these features is not that critical. You don't, for example, need to visit Windermere in the English Lake District to capture a good shot of a lake. Small expanses of water which are relatively unknown and largely ignored can be just as captivating, and rewarding, as their more prominent counterparts. Rivers and waterfalls can also be found which, although they might be diminutive, can be the source of many fine images.

Look at a map carefully and you will be able to time your visit to see a location at its best. If, for example, there are deciduous forests, then autumn would be a colourful time of year to make the trip. If the land is largely arable, then the growing season might be of interest and a spring or summer visit might be productive. Mountains and lakes might be at their best during winter, when snow and frost and low winter sunlight bring an added quality to the landscape.

Large-scale maps also contain additional information such as the presence of farm buildings, churches and bridges. These can add interest to a photograph and can be used as focal points so, by studying the detail, maps really can point you in the right direction. Make it a habit to refer to them, and wasted journeys can be avoided.

KELD, SWALEDALE, NORTH YORKSHIRE, ENGLAND

RESEARCH
The Yorkshire Dales are a delight to visit at any time of year, but the autumn weeks are undoubtedly the highlight of the photographer's calendar. With the aid of a large-scale map I was able to discover this group of deciduous trees and estimate the time of day when the sun would be in the best position. The map was therefore an essential aid to planning my trip.

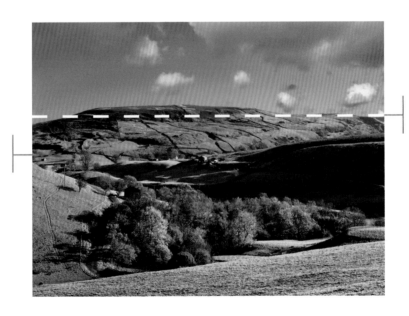

1-STOP (0.3) ND GRAD

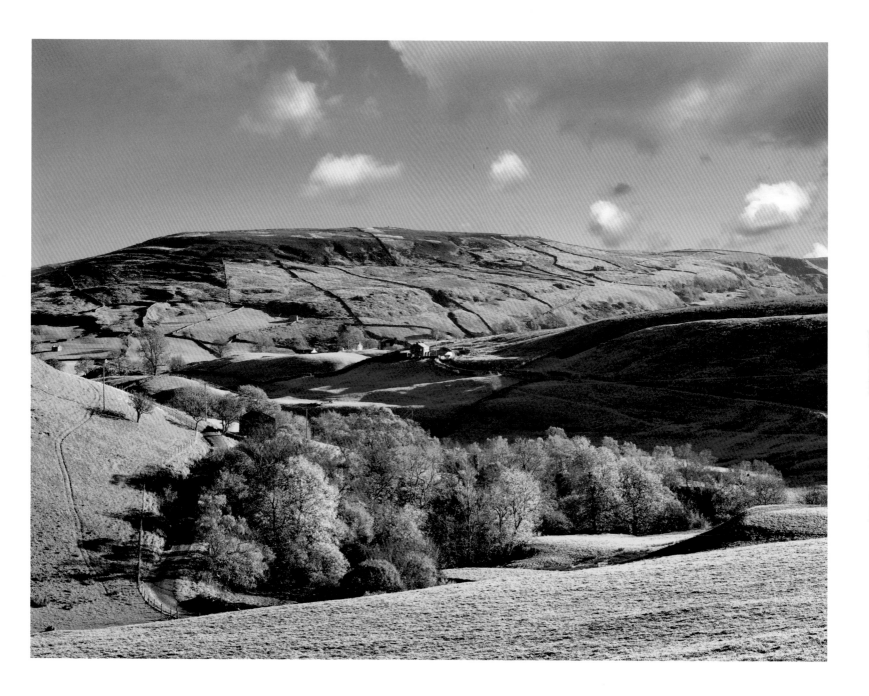

Camera: Mamiya 645 AFD II with Mamiya digital back

Lens: Mamiya 35mm wide-angle

Filter: 1-stop ND grad

Exposure: 1/30sec at f/22, ISO 100

Waiting for the light: 1 hour

Post-processing: Curves adjustment

20 MAKE REPEAT VISITS

It is an inescapable fact that success is linked to effort. Like most things in life, the more you put in, the more you get back; in practical terms, when photographing the landscape this means making repeat visits, sometimes many of them, to a location. You might be lucky and capture a stunning picture at your first attempt. It can happen – but realistically you should be prepared to make several trips before you can feel satisfied that you have seen, and photographed, a place at its best.

Timing is all-important. The time of year, the time of day and of course the weather all combine to change – sometimes quite dramatically – the appearance of the landscape. The simple fact is that *when* you make

the visit affects what you see, and the wider the variety of conditions you experience, the greater the chance of capturing that moment when the elements combine to magical effect.

Gaining experience of the impact light can have on a subject is an important part of the learning curve, and by making repeat visits to a place you will become familiar with the role light plays in the making of a photograph. Persevering with a location will therefore be both instructive and rewarding.

NEAR SKELWITH BRIDGE, CUMBRIA, ENGLAND

PREPARATION
Light was the key ingredient in the making of this image. Having visited the location several times, I knew that late afternoon in October was the time when the angle of light would be most favourable. The weather was poor on the day of my arrival but there were breaks in the clouds, so with camera and tripod set up I began to wait. It didn't look promising but, as the day was drawing to a close, a piercing beam of sunlight suddenly played across the hills and I was able to make several quick exposures before darkness returned. Without the benefits of having made previous visits, this picture would not have been possible.

2-STOP (0.6) ND GRAD

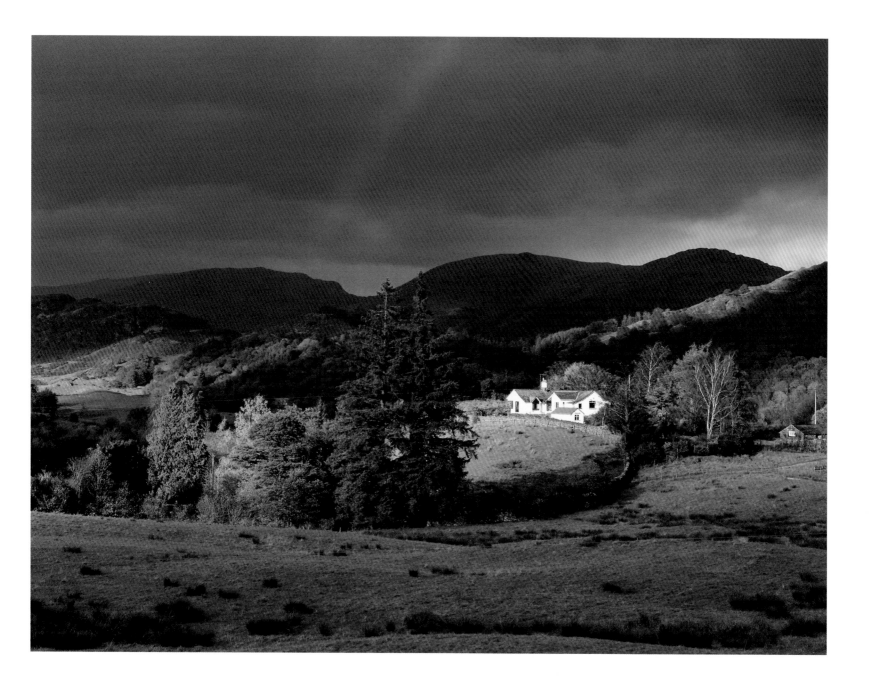

Camera: Mamiya 645 AFD II with Mamiya digital back

Lens: Mamiya 35mm wide-angle

Filter: 2-stop ND grad

Exposure: 1/8sec at f/22, ISO 100

Waiting for the light: 1 hour 30 minutes

Post-processing: Curves adjustment

21 BE PREPARED

One of the attractions of the pursuit of landscape photographs is that no two days are ever the same. The unexpected always happens; you don't know when or where, and it might not be every day, but at some point you will experience a surprise encounter with an image-making opportunity. Such moments can be exhilarating, but you have to be able to react immediately. A matter of seconds can be the difference between exhilaration and despair, so it pays to be ready.

Image-stabilized cameras have made the capture of unplanned photographs a lot easier, because there is often no time to set up a tripod. It is usually a matter of grabbing your camera, pointing it at your subject and making an immediate exposure. Speed of response is important, so ensure your equipment is easily accessible and keep an eye on what is happening in the sky. Unexpected opportunities are usually the result of developments in cloud formations and light, and sometimes by studying the sky you can anticipate what is going to materialize. This can save precious time, so remain vigilant and be aware of what is happening around you.

JOHNSON CANYON, UTAH, USA

TIMING

The sky had been clear on the day this picture of the Grand Staircase-Escalante National Monument was captured. It had been frustrating because a cloudless sky is not to my liking, but as the light began to fade it was apparent that clouds were beginning to develop. As the day drew to a close the sky continued to improve, but time was ebbing away and the sun was now hidden behind a blanket of cloud. It didn't look promising, but suddenly a distant mountain was bathed in the most glorious warm sunlight. On its own that would not have made a picture, but the glowing summit was sandwiched between a perfect sky and a colourful, sprawling forest. All the ingredients were there and I wasted not a second in taking the shot. There was no time to erect a tripod, so it was taken handheld, using image stabilization. Moments after the exposure had been made, the light faded and the opportunity vanished.

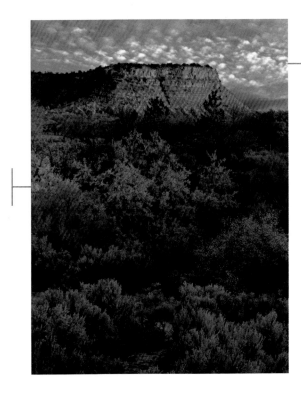

POLARIZER, FULLY POLARIZED

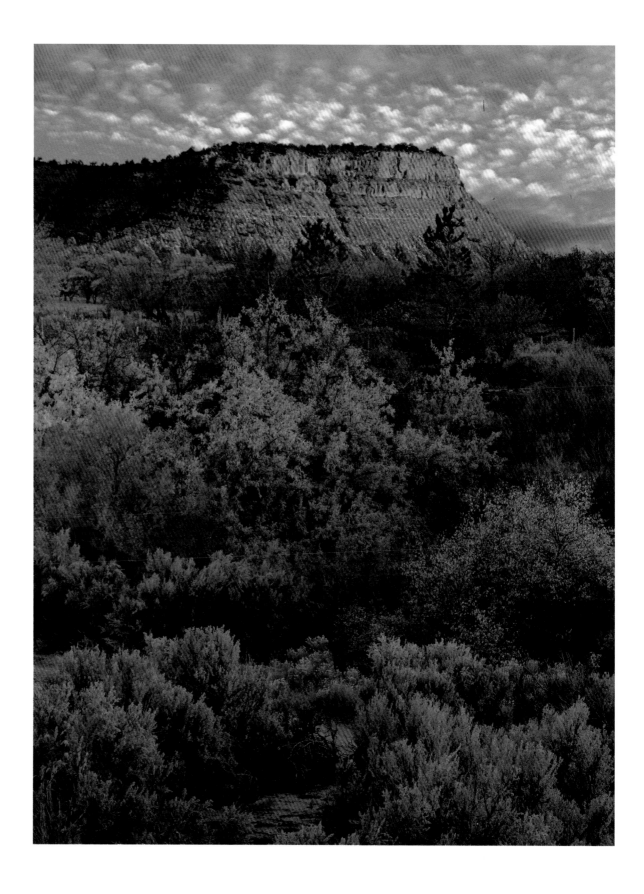

Camera: Nikon D7200

Lens: Nikon 16–35mm VR

Filter: Polarizer

Exposure: 1/30sec at f/8, ISO 100

Waiting for the light: Immediate

Post-processing: Color Balance
adjustment (warming)

22 WATCH THE SKY

A landscape photograph, no matter how spectacular its subject, will fail if the sky is poor. The effect the sky has on an image is not always recognized, and a common error made by inexperienced photographers is to pay too little attention to what is happening above them. Avoid this pitfall by remaining aware of changes to the cloud formation as they occur. If you are spending the day photographing, then watch the sky continually and allow yourself to be governed by it. You cannot change what is happening, so you must make the best of the prevailing conditions and remain vigilant for fleeting opportunities. Consider the sky and landscape as a single entity, as equal partners in the structure of your compositions, and you will avoid images being spoiled by an inferior cloud structure and possibly also poor light.

Skywatching can, as mentioned on the previous page, also help you to anticipate what is about to happen. By monitoring wind direction and movement in the clouds it is often possible to predict imminent lighting conditions, which can give you time to prepare yourself and be in the right place to capture an image. Be ready to react to developments in the sky, and you will produce photographs that would otherwise have been missed.

SILVEIRA, ALTO ALENTEJO, PORTUGAL

TIME OF DAY
The group of buildings and trees have the makings of an attractive photograph, but in order for their full potential to be realized it was important that they should be captured in the right conditions. In order to give shape and depth to the landscape, sidelighting was necessary, and to complete the arrangement an attractive sky would also be needed.

Because of the lighting requirements there was a relatively short period each day during which the photograph could be made. After several days of skywatching, I arrived at the location late one afternoon as a scattering of cloud hovered above the horizon. The sky complemented the landscape and together they made a complete picture.

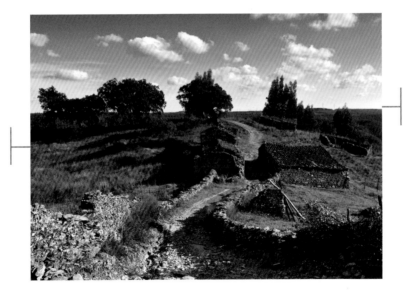

POLARIZER, FULLY POLARIZED
A polarizer was used to darken the blue part of the sky and enhance the appearance of the clouds.

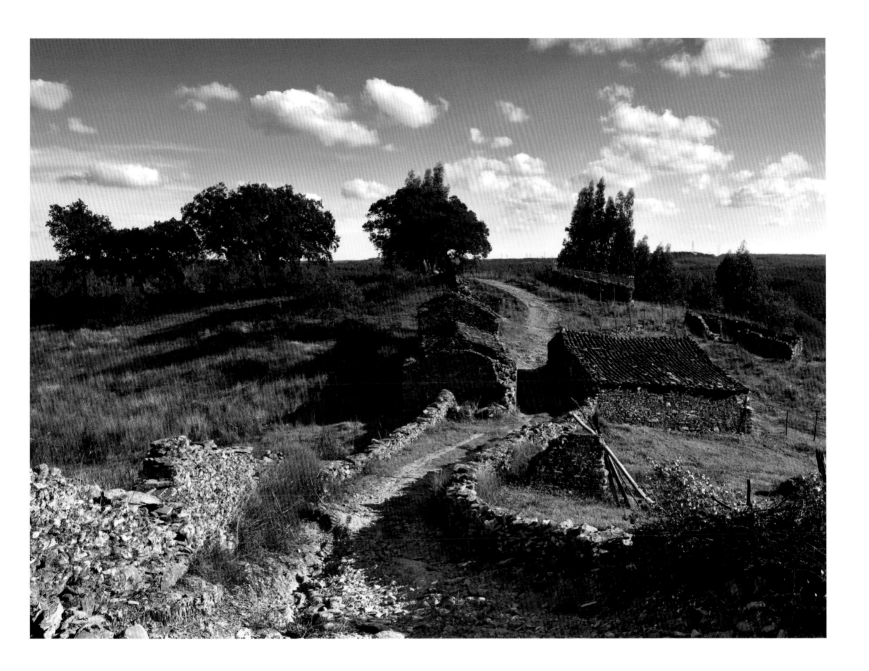

Camera: Mamiya 645 AFD II with Mamiya digital back

Lens: Mamiya 35mm wide-angle

Filter: Polarizer

Exposure: 1/8sec at f/22, ISO 100

Waiting for the light: 4 days

Post-processing: Curves adjustment and highlight reduction

23 USE A VIEWFINDER

For many years I captured photographs with a 5 x 4in view camera. There is no viewfinder in this type of camera; instead, the picture appears on a ground-glass screen. It is upside down and reversed left to right, and it is not very bright. Lenses are all of fixed focal length, so composing images by zooming in and out is not possible. The camera is also bulky and slow to set up. Add all this together and it means that when you prepare to make an exposure you have to know exactly where to place the camera, what lens to use and how the picture is going to be composed. For these reasons I used – and still do – a handheld Linhof viewfinder* to search for and compose potential subjects. This results in the viewing and assessment of a scene and the photographing of it being undertaken as two completely separate actions – and, whether you use a large-format view camera or not, there are a number of advantages to this.

Searching for images while your camera is out of reach allows for a more contemplative approach. There is no temptation to make an exposure simply because it is convenient to do so. Unencumbered by your camera, you will have more thinking time, and with the aid of a viewfinder you will be able to search for the best viewpoint and consider various compositions. Adopt this method and the likelihood is that you will take fewer photographs – but of a higher quality.

As an alternative some people use a piece of card with the middle cut out to act as a frame. It's not as convenient and doesn't produce the same effect, but it is of course a lot cheaper.

SOUTH COYOTE BUTTES, UTAH, USA

OBSERVATION
Abstract images do not leap out in front of you. They are often hidden away in the fabric of the landscape, and eventually emerge in the mind of the photographer by a process of keen observation and creative interpretation. Because of the nature of an abstract arrangement, the compositional choices are endless and a thoughtful, considered approach is necessary if the potential for making the most of the options available is to be realized.

EQUIPMENT
The picture was the result of much searching and deliberation. Deciding on its content and composition was a slow process which was greatly eased by my not being burdened with carrying any equipment – apart, that is, from my Linhof viewfinder.

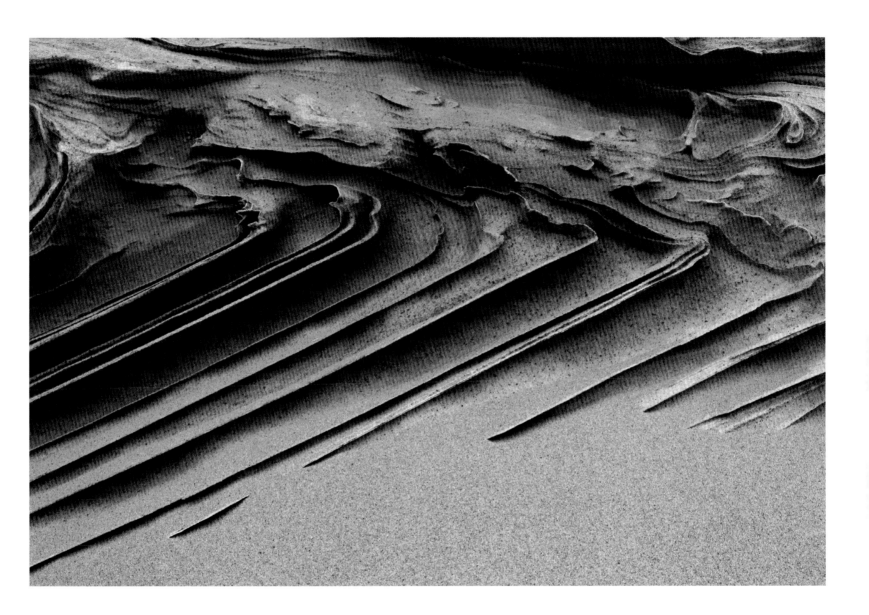

Camera: Canon EOS 7D

Lens: Canon 24–105mm L IS

Filter: None

Exposure: 1/80sec at f/10, ISO 100

Waiting for the light: Immediate

Post-processing: No adjustments

 # KEEP AN OPEN MIND

Potential images are everywhere. There are times when you can literally be surrounded by picture-making opportunities, and it can be overwhelming. The easy solution is to capture the obvious – but sometimes the photograph that leaps out at you might not be the only, or indeed the best, option. A good location can yield several, often quite different, possibilities so, having captured the subject that first caught your attention, it can pay dividends to start searching for more. Keep an open mind: you might see something which is completely different from the photograph you have just taken. Keen observation is the key to success; look all around you and consider close-ups as well as distant views.

Coastal locations can be particularly fertile hunting grounds, and close inspection of the shoreline can be productive. Look for patterns and repetitive shapes, and think creatively. The options can be limitless, so experiment and try different subjects and compositions. This will help in the development of your ability to visually isolate objects from their surroundings and create images which at first glance are not obvious. This is the photographer's way of viewing the landscape, and it is a skill that can be acquired with practice. Persevere, and you will be able to capture pictures which you would previously not have seen.

LETTERGESH BEACH, CONNEMARA, IRELAND

OBSERVATION

There are some places that seem to have an inexhaustible supply of images hidden away, waiting to be discovered. Lettergesh Beach is one of those places and this picture is one of several quite different photographs (*another one appears on page 67*) I captured during a rewarding day spent foraging through its nooks and crannies. Careful observation was needed to discover this group of partly buried rocks, but once found they made an enticing subject.

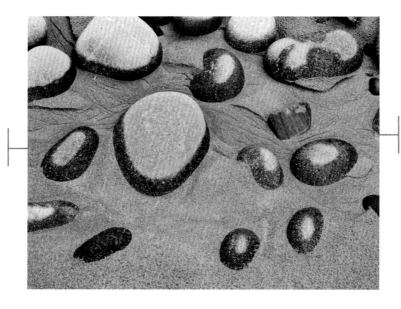

VIEWPOINT

By photographing them from above and moving in close I was able to isolate the rocks from the surrounding boulders and form, in my opinion, a pleasing arrangement. This, I believe, has produced an image that captures a small but interesting detail of the beach.

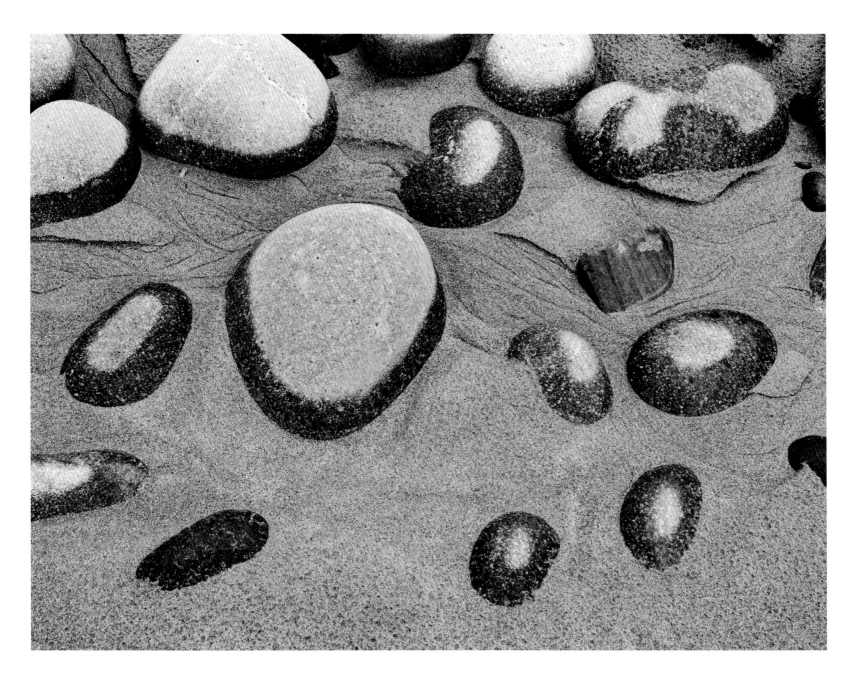

Camera: Mamiya 645 AFD II with Mamiya digital back

Lens: Mamiya 35mm wide-angle

Filter: None

Exposure: 1/4sec at f/22, ISO 100

Waiting for the light: Immediate

Post-processing: Curves and Color Balance/Saturation adjustment

25 AVOID FOOTPRINTS

This might seem to be an obvious precaution and hardly worthy of discussion. Normally the problem of footprints doesn't arise, but when photographing the coast it can be more difficult because sand is very easily disturbed, and I have in the past ruined pictures because of my own carelessness.

The delicate surface of a beach often prevents you from searching for viewpoints as thoroughly as you would in other locations. You cannot stroll around experimenting with different compositions; instead you have to stand back and visualize potential images. A degree of self-control is required because one's instinct, when seeing the makings of a picture,

is to immediately investigate further. Having made the investigation, you may suddenly find that the best viewpoint now has a foreground covered in footprints. Take care in sand, and tread only where you know it is safe to do so.

Along the shoreline, human footprints are not the only concern. Dogs are the scourge of pristine sand and can lay waste to a foreground in a matter of seconds! If the beach is well trodden, the best solution is to visit it as the tide is receding. You will then be able to capture freshly washed, glistening sand and, as an added bonus, you might also be able to build a picture around reflections on the sand itself or in rock pools.

GLASSILAUN BEACH, CONNEMARA, IRELAND

CAUTION
A cautious approach was called for as I contemplated this view of Glassilaun Beach. The ripples in the sand were an essential feature and footprints had to be avoided at all costs. Fortunately I had seen the potential for making the image before walking across the area, and was able to avoid leaving a trail of footsteps.

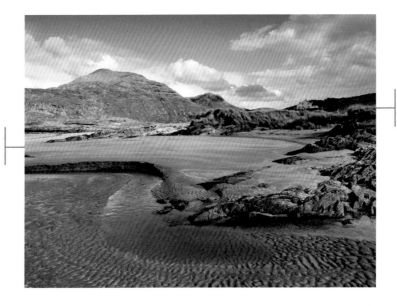

POLARIZER, FULLY POLARIZED
A polarizing filter was used to boost the appearance of the sky and improve the colour and transparency of the water. In addition to this it has deepened the shadows slightly, which has helped to reveal the ripples and patterns in the foreground sand.

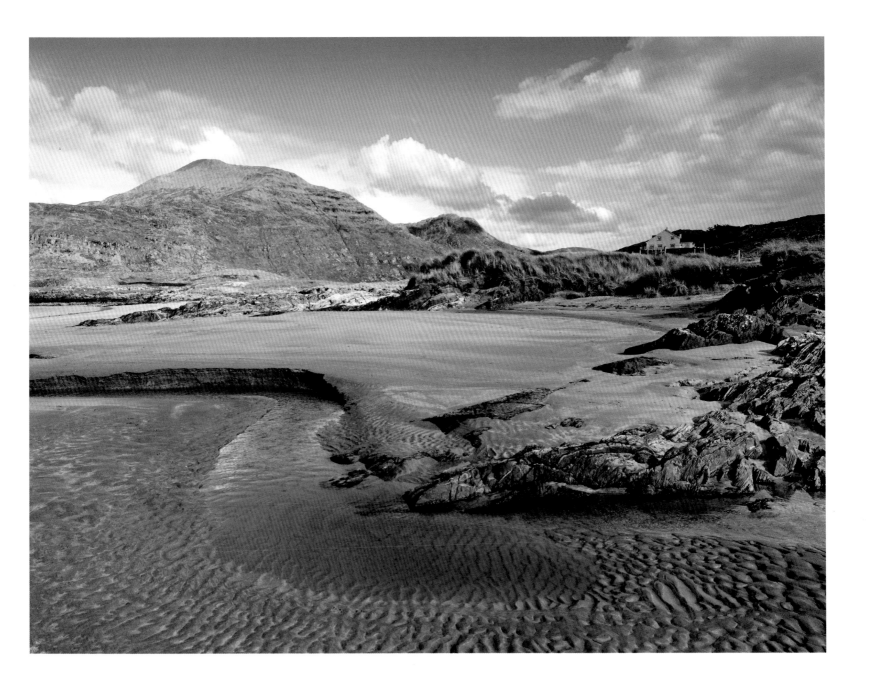

Camera: Mamiya 645 AFD II with Mamiya digital back

Lens: Mamiya 35mm wide-angle

Filter: Polarizer

Exposure: 1/15sec at f/22, ISO 100

Waiting for the light: 2 hours

Post-processing: Highlight reduction

26 TIDY THE SUBJECT

Urban environments and tourist attractions are unlikely to be completely free of litter. It might not be particularly noticeable at the time, but once photographed it will become a starkly apparent distraction. The presence of litter in an image looks careless and unprofessional and is also unsightly, so it should always be removed. Small amounts can be taken out in post-processing by using the cloning tool, but ideally it should be removed before the picture is taken.

Tidying up the landscape before you photograph it is sometimes necessary in both urban and rural locations, and should be considered whenever you feel there is anything present that spoils the picture or detracts from its purity. Train your eye to scan every part of your subject before you make your exposure. It will save you a lot of time in post-processing and the image will be more authentic.

ÓBIDOS, CENTRO, PORTUGAL

DISTRACTION
The ancient town of Óbidos is a national monument and a well-preserved example of medieval architecture. It is, not surprisingly, also a tourist magnet and its narrow, cobbled streets are often crowded. The town is clean and well maintained, but with hordes of people it is inevitable that some litter will fall.

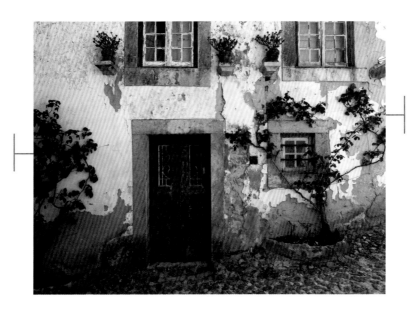

CLEAN SWEEP
Wandering through the town's alleyways, I discovered this delightfully dilapidated house. It was situated in a quiet corner and fortunately there were few passers-by; it was not completely clear, though, because a small amount of debris had accumulated in the doorway of the attractive dwelling. A sweeping brush is not one of my accessories, but conveniently there was a besom standing against the wall behind me and I was able to tidy up the doorstep before taking the photograph. Picture taken, I waved at a smiling resident who had seen me sweeping the rubbish and departed, happy that I had been able to capture an image and meet with the approval of a local inhabitant.

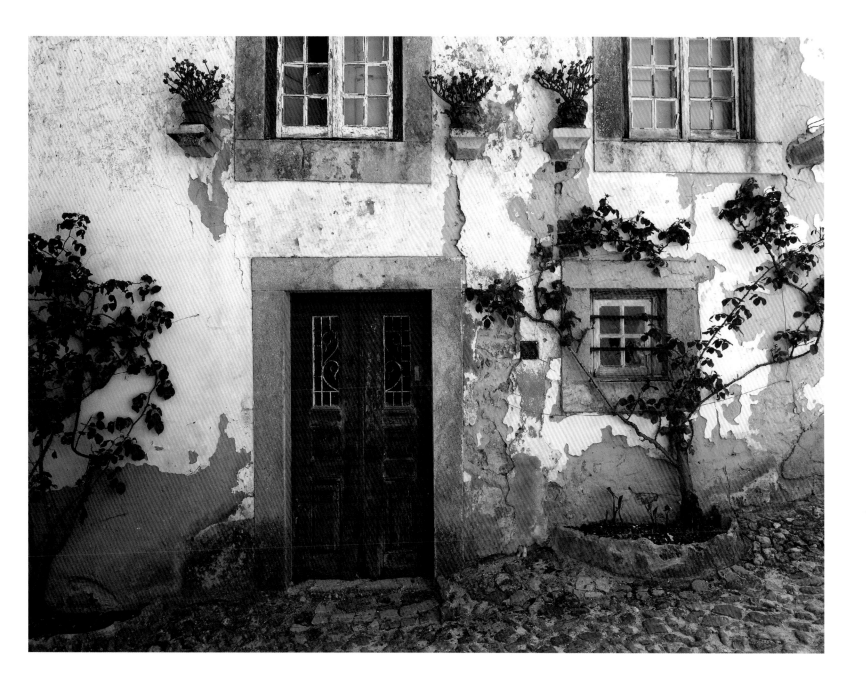

Camera: Mamiya 645 AFD II with Mamiya digital back

Lens: Mamiya 35mm wide-angle

Filter: None

Exposure: 1/10sec at f/18, ISO 100

Waiting for the light: Immediate

Post-processing: Curves adjustment and highlight reduction

KEEP YOUR TRIPOD LEVEL ON SOFT GROUND

A tripod is only as secure as the ground it is standing on. A soft surface can cause a tripod to be unstable and prone to movement when any weight is applied to it. When it is standing on sand you should push it firmly into the surface so the feet are partly buried, and test it to check that it is rigid. At the water's edge the sand is very soft and may be continually shifting. If water washes over the base of your tripod you can virtually guarantee that the wet sand will cause one or more of the legs to sink; you should therefore check that it is level every time you make an exposure.

The easiest, and most reliable, way to do this is to mount a spirit level onto your camera's accessory shoe. The double-axis type is the most useful as it indicates both vertical and horizontal tilting. Some tripods have a built-in spirit level, but this does not help when adjusting the camera with a ball-and-socket head. If your camera has an integral spirit level it can be used instead. The important point to remember is that when standing on wet sand, keep checking it before every shot.

LETTERGESH BEACH, CONNEMARA, IRELAND

EQUIPMENT
A sloping horizon will always stand out in this type of image. It can be adjusted in post-processing, but is best avoided by using a spirit level.

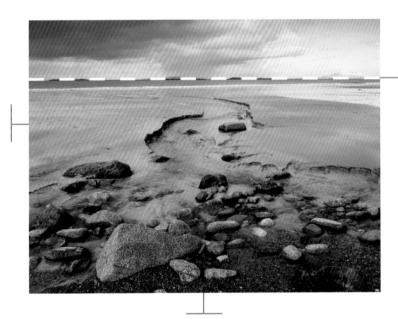

2–STOP (0.6) ND GRAD

CAMERA POSITION
The composition of this picture required a precise camera position. The foreground rocks were on the edge of a deep pool and I was forced to stand my tripod in 6in (15cm) of water. Apart from the danger of dropping accessories into the water, standing partly submerged on a soft, unstable surface is far from ideal. Add in a force 10 gale (OK, I exaggerate – but not by much!) and you have the perfect recipe for a tilting, moving camera. By paying close attention to the spirit level mounted on the camera's accessory shoe both before and during exposure, I captured level, pin-sharp images.

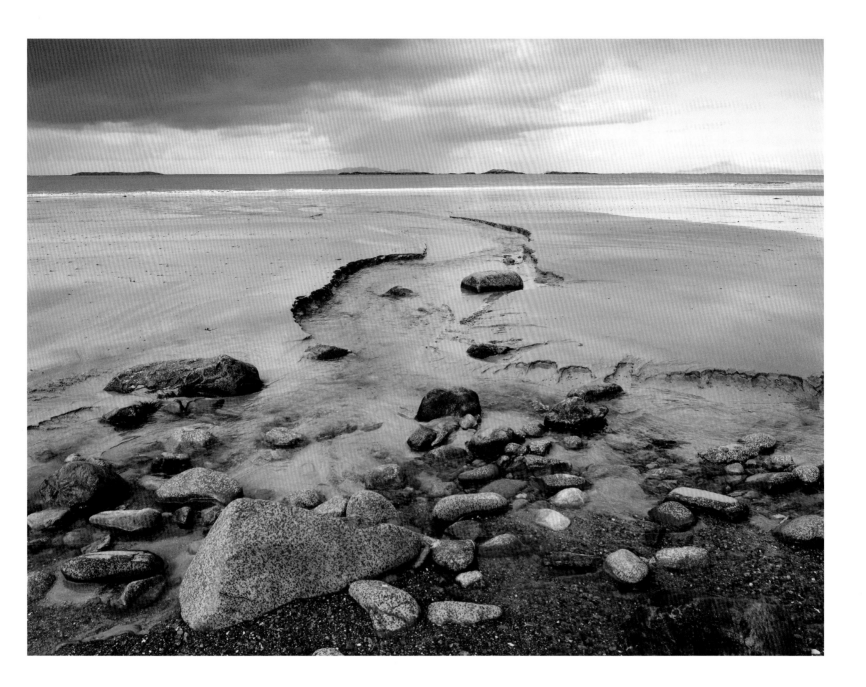

Camera: Mamiya 645 AFD II with Mamiya digital back

Lens: Mamiya 35mm wide-angle

Filter: 2-stop ND grad

Exposure: 1/30sec at f/18, ISO 100

Waiting for the light: 40 minutes

Post-processing: Curves and Color Balance adjustment (warming)

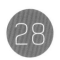 # AVOID CONVERGING PARALLELS

Converging parallels (or verticals), also known as keystoning, occur when a camera is tilted either upwards or downwards. This causes a distortion of perspective which results in parallel lines, such as the vertical lines of a building, converging towards the top (or the bottom, if the camera is pointing down). It happens frequently when photographing buildings, because it is often necessary to tilt the camera skywards in order to fit them into the frame. Corrections can be made during post-processing but this can affect image quality, particularly when large adjustments are made. It is therefore preferable to avoid the problem at the time of shooting.

A shortage of space is often the reason for converging parallels, because the viewpoint is too close to the subject. You can't step back, so to compensate for this you have to point upwards. One solution, therefore, is to search for an alternative position, preferably one which is elevated. With image stabilization it is now possible to shoot from confined spaces without the burden of a tripod. You might be able to find some steps or a balcony, or shoot through an open window.

Another option which is sometimes possible is to keep the camera perfectly level (a spirit level is essential for this) and use an ultra-wide-angle lens. This will leave unwanted space around your subject, but this can be cropped out later and you are then left with perfectly straight lines and no sign of distortion. This is my preferred method, because no manipulation of the picture is necessary and image quality is not compromised.

EGREMONT, WIRRAL PENINSULA, ENGLAND

CROPPING
This is a cropped version of a larger image of Egremont Promenade. It was captured using a wide-angle lens with the camera perfectly level, both horizontally and vertically. This resulted in the inclusion of an unwanted expanse of paving in the lower part of the picture. It could have been omitted by pointing the camera upwards, but this would have caused the parallel lines of the walls to converge. Instead, I chose to remove the excess foreground by cropping the photograph during post-processing.

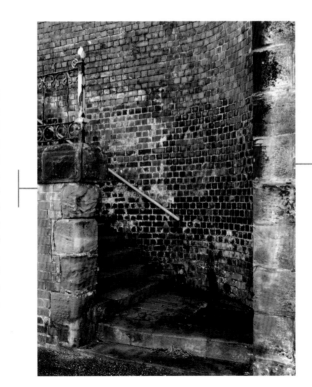

TONES
This picture was captured on an overcast day when the light was soft. Sunlight and shadows would have obscured the wide and varied tonal range.

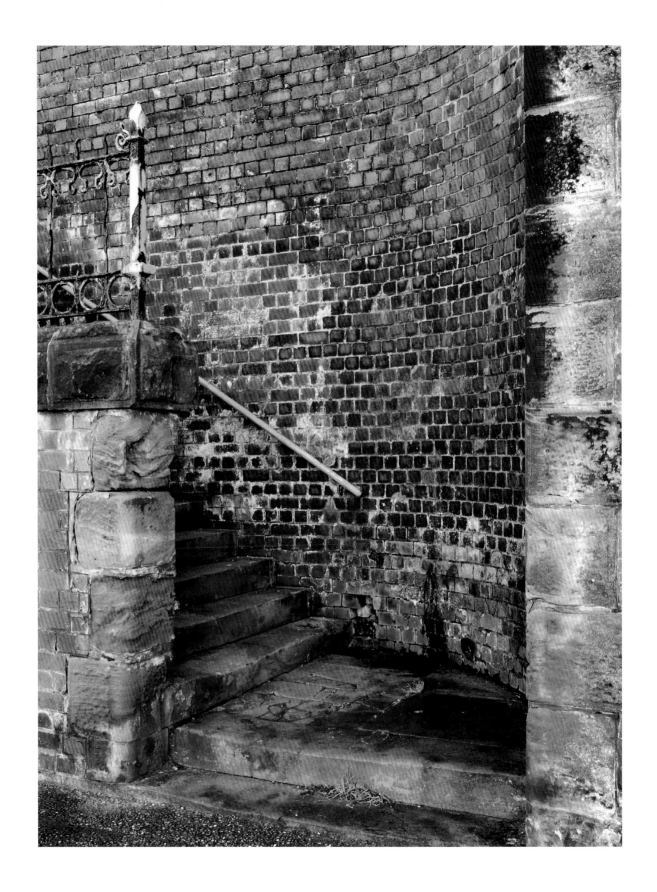

Camera: Mamiya 645 AFD II with Mamiya
digital back

Lens: Mamiya 35mm wide-angle

Filter: None

Exposure: 2sec at f/22, ISO 100

Waiting for the light: Immediate

Post-processing: Cropping

29 MAXIMIZE DEPTH OF FIELD

Depth of field reduces as the camera-to-subject distance shortens, so when photographing in close-up, or when your foreground is extremely close to the camera, you may find that even the smallest aperture will produce insufficient depth of field to render everything sharp. This will result in part of the image being soft, which can be disastrous; fortunately, there is a way this can be overcome.

With your camera firmly held on a tripod – this is important: there must be absolutely no change in camera position between exposures – you take two photographs which are focused at different points, one on the foreground and one somewhere between the middle and far distance. By doing this you have stretched the depth of field, because

you now have front-to-back sharpness split across two pictures. You can then merge them together in post-processing and create a single, fully sharp photograph.

Depending on your depth of field requirements and size of aperture, it might be necessary to capture more than two images, each with a small adjustment in the focus point. There is no limit to the number of exposures you can make, but the amount of work you need to undertake in post-processing will increase with each one and it can become quite exacting. Merging pictures isn't particularly difficult, but doing it successfully requires a certain level of expertise. The technique is known as 'focus stacking', and there are many tutorials available online to guide you through the process.

COT VALLEY, CORNWALL, ENGLAND

MERGED EXPOSURE
In this image the boulder in the foreground was little more than 1ft (30cm) from the camera. Because of its close proximity it was impossible to create sufficient depth of field to render both foreground and background sharp. The only solution was to make two exposures focused at different points. These were then merged to make a single image which was sharp across its entire depth.

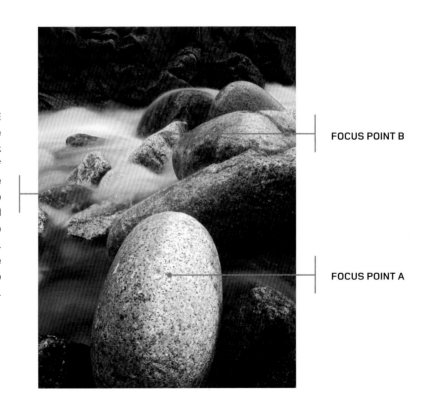

FOCUS POINT B

FOCUS POINT A

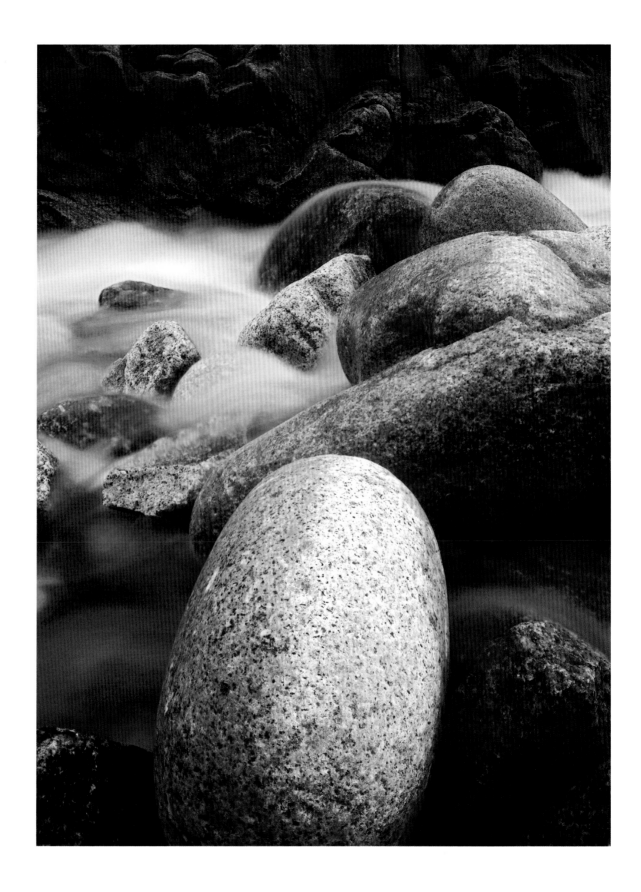

Camera: Nikon D7200

Lens: Nikon 16–35mm VR

Filter: None

Exposure: 2sec at f/11, ISO 100

Waiting for the light: Immediate

Post-processing: Merging of two images

30 CHECK TIDE TIMES

The meeting point of land and water can be a rich source of images. The combination of two opposites – perpetual movement and perfect stillness – is pure poetry in motion, and watching the continual ebb and flow of gently lapping waves can be mesmerizing. To the photographer, though, there is much more than the allure of the visual display because there is, of course, the opportunity to capture pictures.

With every lap of a wave and every pattern that emerges on a freshly washed beach, images will become manifest to the observant eye. However, as always, timing is important and a little advance planning can greatly increase your chances of success. The appearance of the coastline changes with the tide, so it is useful to refer to a tide timetable when

planning your journey. There is no rule that says high tide is better than low tide – it depends on the location. If you are familiar with a beach, or are able to visit it in advance, you might be able to determine what level of tide suits it best. Alternatively, it might be more productive to simply spend several hours at your chosen viewpoint and search for photographs as the tide flows in and out. By referring to your timetable you might be able to plan your shots in advance and then wait for the optimum level of water. With a knowledge of tide times you will also be able to ensure that you do not end up being cut off by rising water. It happened to me once and, believe me, it is not a pleasant experience – so keep one eye on the tide and the other on your watch!

LAMORNA COVE, CORNWALL, ENGLAND

PREPARATION
Violent storms were forecast on the day I visited Lamorna Cove in Cornwall. I planned my visit in the knowledge that, because of its aspect, it would be exposed to the full force of the wind, and by studying the tide timetable it was possible to time my visit to coincide with the peak of high tide. This might have been a little foolhardy because the ocean was raging and conditions were dangerous, but I lived to tell the tale and was able to capture this image before retreating to the safety of my car.

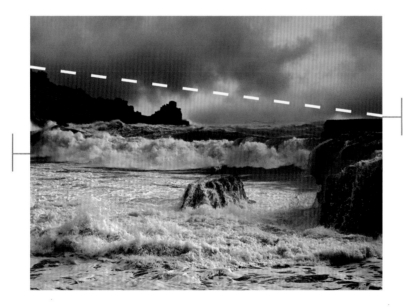

2-STOP (0.6) ND GRAD
An ND grad filter was necessary to prevent the sky from being overexposed.

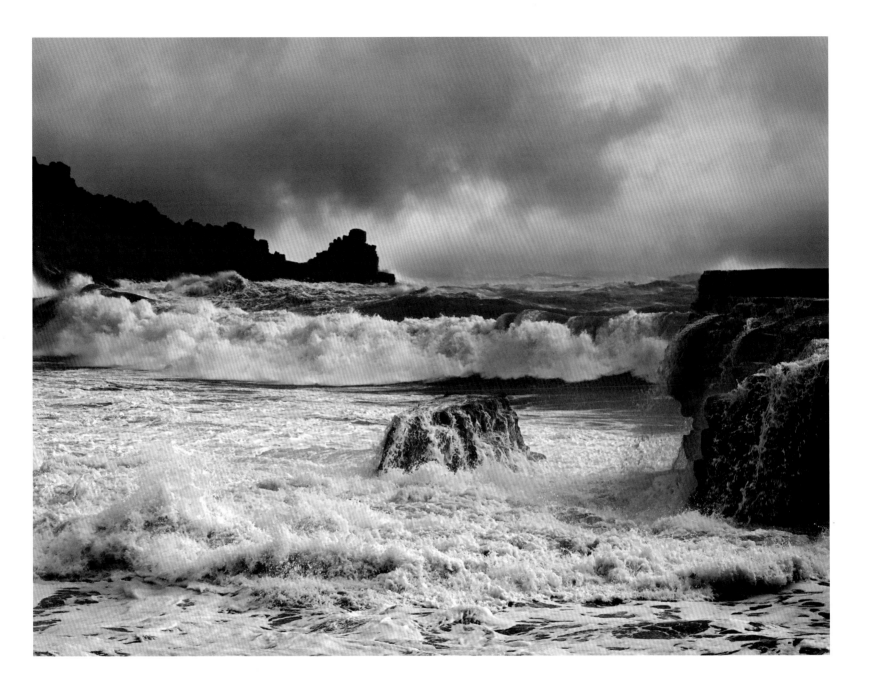

Camera: Mamiya 645 AFD II with Mamiya digital back

Lens: Mamiya 35mm wide-angle

Filter: 2-stop ND grad

Exposure: 1/250sec at f/11, ISO 400

Waiting for the light: Immediate

Post-processing: Highlight reduction

31 APPRAISE YOUR WORK

We landscape photographers love our subject. We have an emotional involvement with the landscape, and the capture of an image comes from the heart as much as the head. It can therefore be difficult to step back and take a detached and objective view of the pictures we create. Often the making of an exposure is the culmination of a lot of hard work and effort, the thrilling moment of success after many failed attempts. It is not surprising, then, that any imperfections which are present might not register quite as strongly as they perhaps should. The euphoria of the moment can act as a filter against reality, so we tend to dwell on the positives and overlook the negatives. This is understandable but, if a photographer's work is to improve, then at some point it will have to be appraised with a critical eye.

The method I use is that after the initial processing of new pictures (*see Chapter Six*) I forget about them for a week or so. By then the excitement (and often relief) of having captured them has faded a little, and I then reappraise them and compare them with other, older, images. I consider the more intangible qualities. What is special about the photograph? Does it stand out from the crowd? Does it have impact? If a picture still stands up to scrutiny it remains in my collection, but if it is flawed in any way it is either deleted or moved to a subfolder. I keep some of them because it can be useful to refer to inferior pictures from time to time, to (a) learn from past mistakes and (b) monitor progress and improvement.

If you adopt this practice it can only be to the benefit of your photography. Don't be too harsh on yourself, especially in the early days. The learning curve can be long and steep, but you will make progress if you persevere.

DENTDALE, NORTH YORKSHIRE, ENGLAND

SELECTION
This was the one photograph that passed muster from a number of exposures I made of this river. The others were either unbalanced or lacking in depth and were therefore discarded.

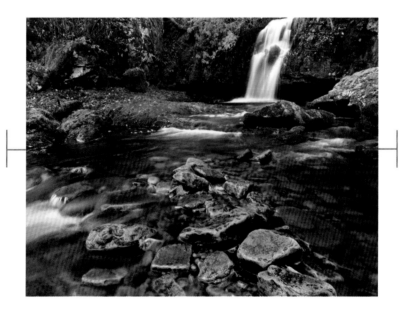

POLARIZER, FULLY POLARIZED
A polarizer was used to increase exposure time and to reduce reflections on the water and wet rocks.

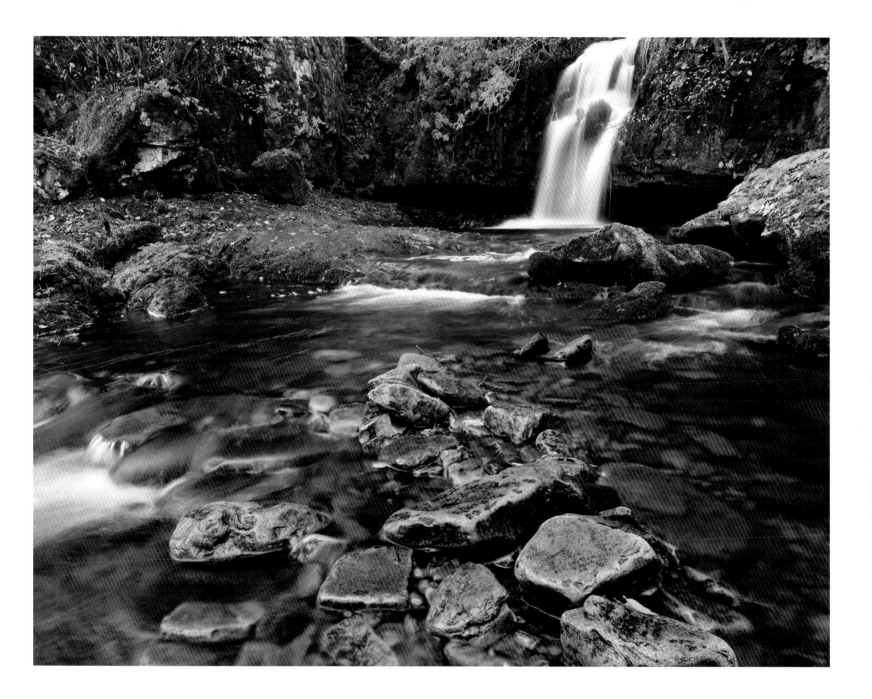

Camera: Mamiya 645 AFD II with Mamiya digital back

Lens: Mamiya 35mm wide-angle

Filter: Polarizer

Exposure: 2sec at f/22, ISO 100

Waiting for the light: Immediate

Post-processing: Color Balance adjustment

ESTABLISH A WORKFLOW

Establishing a routine in the handling and processing of your exposed images is almost as important as the technique you use in the capture of them. The absence of a system can, at the very least, slow down the processing and, more seriously, can lead to photographs being lost. Maintain a regime of working to a structured routine and you will avoid these problems. The system you adopt should be tailored to your own needs and circumstances, but here, for what it's worth, is my workflow:

1 Copy images to a computer After each day's shooting I remove the memory card from the camera and connect it to the computer via a card reader. I don't connect the camera, as it needlessly wastes the camera's battery. For every location or trip I make, I create a new folder named with the location and the month and year of the shoot.

2 Evaluate Raw images Daily, if possible – or, if time prevents this, at the end of the shoot – I open the Raw files in Capture One, which is my preferred software. The choice of software is a personal decision; many photographers use Adobe Photoshop Lightroom or Adobe Camera Raw, for example. I then assess each picture, viewing them at pixel level, i.e. 100%, as this is the only way to check that they are perfectly sharp. After very careful assessment, second-rate shots are deleted, borderline images are kept (you have to be absolutely certain before deleting anything), and I then start to process the remaining Raw files.

3 Assess Tiff images Once the Raw files have been processed and converted to Tiffs, they are then further assessed and if necessary fine-tuned in Photoshop.

4 Back-up images The folder, which now contains both original Raw files and Tiffs, is copied to two portable hard drives which are kept in separate locations. As an added precaution I also back up my images to a Cloud server. At this point the Raw files are deleted from the original memory card.

NEAR LLANLLYFNI, SNOWDONIA, WALES

SELECTION
A gale was blowing at the time this picture was captured, and I was concerned about the possibility of camera shake. I made several exposures and, after transferring the Raw images to a new folder on my computer, examined each one at 100%. Some were discarded and the remainder were processed; the folder was then copied to two portable hard drives.

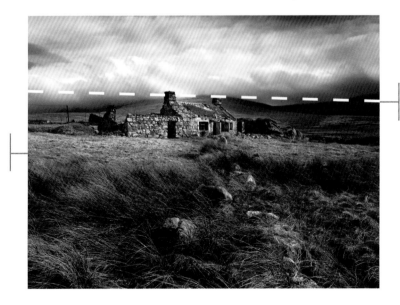

2-STOP (0.6) ND GRAD
An ND grad filter was necessary to prevent the sky from being overexposed.

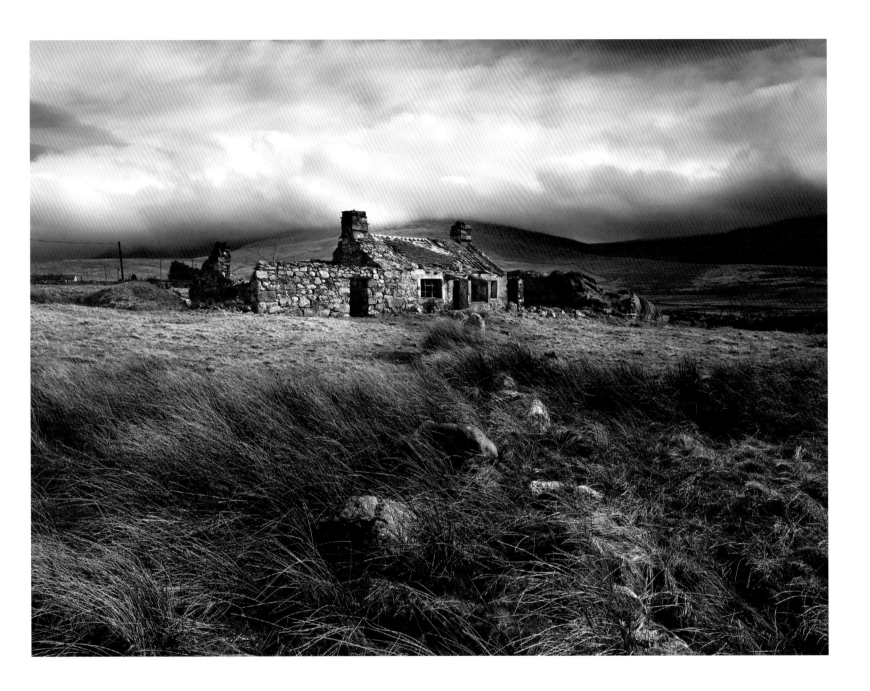

Camera: Nikon D7200

Lens: Nikon 16–35mm VR

Filter: 2-stop ND grad

Exposure: 1/50sec at f/13, ISO 100

Waiting for the light: 1 hour

Post-processing: Highlight reduction

COMPOSING THE IMAGE

LESSONS

 >> 50

There is no photographic subject as varied and challenging as the landscape. From intricate close-ups to distant vistas, images are out there waiting to be captured, but they can be structured in many different ways and it is you, the photographer, who must make the crucial decision: how to compose the picture successfully. The following pages will address the theories and practicalities of composing landscape images and show, by example, the best approach to adopt for every type of subject.

NEAR TINAHELY,
CO. WICKLOW, IRELAND

33 CREATE DEPTH

The depiction of depth is a basic requirement of a successful landscape photograph. It is important because a picture that looks flat will lack impact and will fail to engage the viewer. When images of large, open views prove to be a disappointment, lack of depth is the most common reason. Photographs can fail to capture the experience of being outdoors because they contain no sense of distance or scale. So, how do we perform the miracle of transferring a sweeping, three-dimensional vista onto a flat, two-dimensional surface?

Start by choosing the right vantage point. Look for a camera position that gives you a clear, uninterrupted view of the horizon. There should be no blind spots – the eye should be able to travel from foreground to horizon and take in the journey across every part of the landscape. The foreground should flow into the middle ground, which in turn should continue, unimpeded, into the distance. Constructing the image in this way creates an impression of depth and distance and allows the viewer to take in the scene in a way that replicates the experience of actually being there.

Depth can be further enhanced by the correct use of light. Flat lighting should be avoided; there should be a scattering of highlights and shadows, which will strengthen the presence of specific features in the landscape. A shaded or softly lit foreground combined with brightly illuminated distant features can be very effective, as it will draw the eye to the horizon and reinforce the impression of depth.

NEAR LARAGH, WICKLOW MOUNTAINS, IRELAND

VIEWPOINT
Capturing a successful image of this view of the Wicklow Mountains was, because of the large expanse of flat land, something of a challenge. Without undulations there seemed to be nothing for a viewer of the photograph to latch on to. Fortunately there were other options, and after a little searching I was able to choose a viewpoint that had as its foreground a rich fabric of variegated grass. The thickly textured surface has a wide tonal range that engages the eye, and then the brightly lit group of trees in the distance encourages the viewer to 'travel' across the landscape towards the mountains. The combination of these two elements gives the image a sense of depth and, I hope, of actually being there.

2-STOP (0.6) ND GRAD

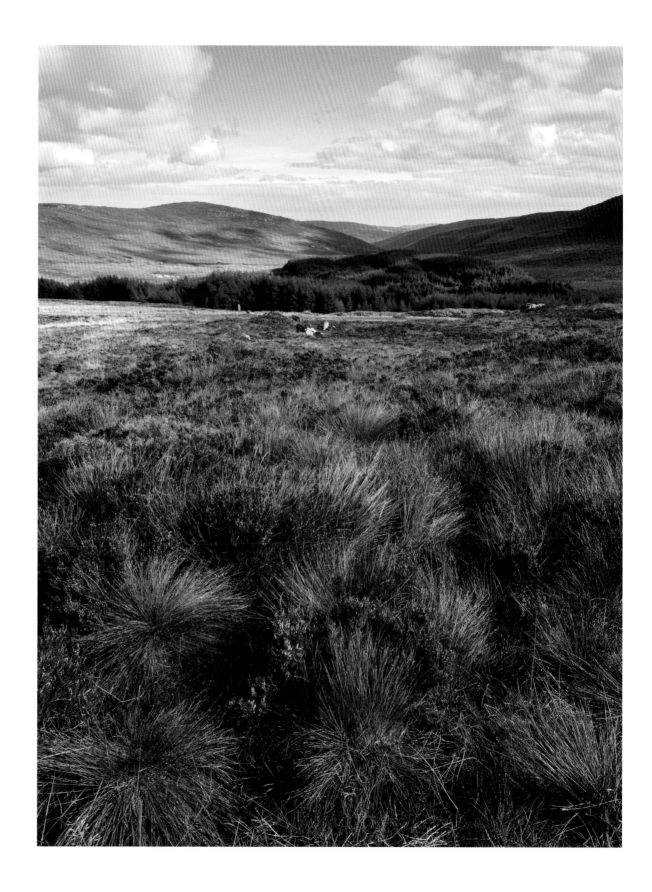

Camera: Mamiya 645 AFD II with Mamiya
digital back

Lens: Mamiya 35mm wide-angle

Filter: 2-stop ND grad

Exposure: 1/8sec at f/22, ISO 100

Waiting for the light: 30 minutes

Post-processing: No adjustments

34 INTRODUCE A SENSE OF SCALE

Flat-looking images can be avoided by the introduction of a sense of scale. This can be achieved when objects of a similar size are shown in a picture to be receding into the distance; as they grow smaller and smaller, their diminishing scale will then convey depth and distance. Trees can be useful for this, as can buildings, but what you use isn't important, as long as the objects are appropriate to the image and aesthetically attractive.

Diminishing scale is most apparent when an elevated shooting position is used, as this gives a clear view of objects as they taper away into the distance. A high viewpoint also enables the eye to sweep unimpeded over

a scene, and this in itself will also help to give a three-dimensional quality to the photograph. For maximum effect, keep the composition simple; an image with a wide variety of features will confuse the viewer and the effect will be lost. Repetition of similar shapes of reducing size is the objective – achieve this and your picture will have depth.

VILA VELHA DE RÓDÃO, CENTRO, PORTUGAL

COMPOSITION
The barn nestling in a tree-clad valley was a natural subject for the camera but I was, initially, unsure of the best approach to take. The sky was attractive, and a sweeping view of the valley with the barn acting as a focal point seemed to be the obvious picture. The first thought, though, is not always the best thought, and having tried several compositions it became apparent that the sky would have to be omitted. Including it added nothing to the photograph, because the appeal of the location lay in the repetition of the small, shapely trees.

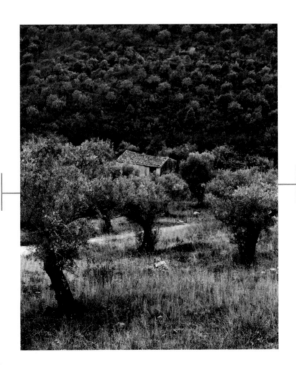

VIEWPOINT
In order to leave out the sky I had to point the camera down from an elevated position and use a telephoto lens. One of the effects of this lens is the compression of distance; fortunately the diminishing size of the trees compensates for this and the image still has depth. The barn also helps in this respect, because its readily perceivable size establishes its distance from the camera.

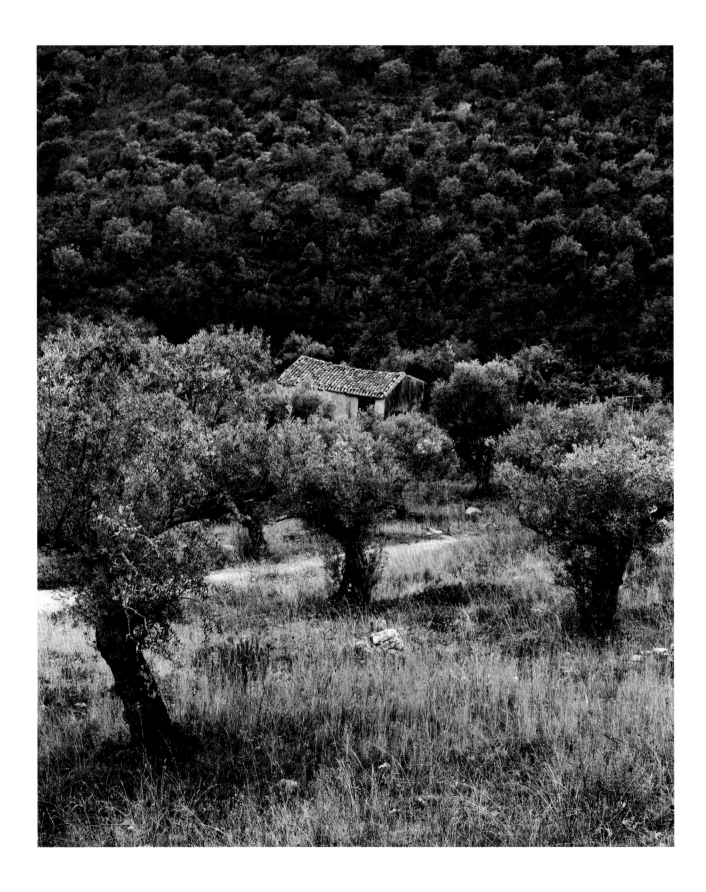

Camera: Mamiya 645 AFD II
with Mamiya digital back

Lens: Mamiya 150mm
telephoto

Filter: None

Exposure: 1/8sec at f/18,
ISO 100

Waiting for the light:
20 minutes

Post-processing:
No adjustments

35 USE LEAD-IN LINES

Lead-in lines are a very powerful compositional tool and their presence will greatly enhance depth in a photograph. Starting from immediately in front of the camera and stretching away into the middle or far distance, they engage the eye and lead the viewer right into the heart of the image. Lines are present everywhere and can be found in the most unlikely of places, besides obvious examples such as roads and paths. They may occur naturally, in many guises. Take, for example, tree roots. In woodland photography they might be the missing element you're searching for, but they can be easily missed – you might be standing on the perfect foreground without realizing it – so remember to look down as well as up.

For maximum effect, compose your picture in such a way that the lines travel away from the camera directly towards the main subject. This type of arrangement can look striking and is virtually guaranteed to give a photograph strong impact and a pronounced three-dimensional quality.

If you find photogenic lines, either natural or man-made, then explore every possibility of constructing an image around them. They are the perfect starting point, and a tremendous aid to successful composition and the capture of a memorable picture.

SILVEIRA, CASTELO BRANCO, PORTUGAL

TIME OF DAY
Had it not been for the colourful roof, I would have dismissed this view. The rows of tiles were irresistible, though, and I couldn't let them go unphotographed. They lead so perfectly to the group of trees that they alone made the picture worth capturing. The key element was the angle of the light. In order for the lines to be distinctive, the roof had to be lit from the side by a low sun. This reveals the rounded shape of the tiles and, importantly, creates the shadows that form the lines. The sidelight also gives shape and roundness to the trees and depth to the distant hills.

POLARIZER, FULLY POLARIZED
A polarizer was used to darken the blue sky and deepen the shadows in the rows of tiles. This has strengthened the appearance of the lead-in lines.

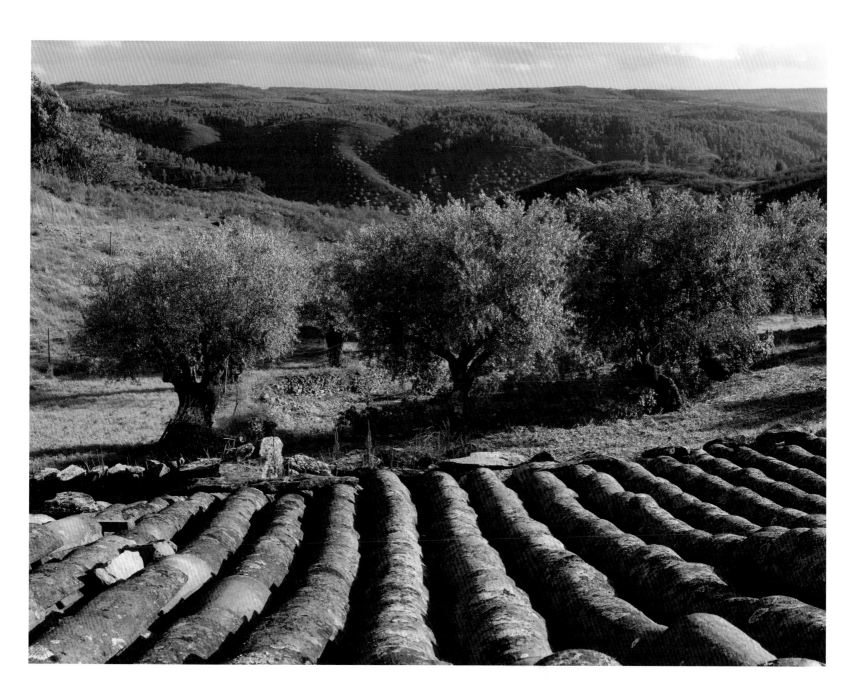

Camera: Mamiya 645 AFD II with Mamiya digital back

Lens: Mamiya 35mm wide-angle

Filter: Polarizer

Exposure: 1/4sec at f/22, ISO 100

Waiting for the light: 2 hours

Post-processing: Curves adjustment

36 EMPHASIZE THE FOREGROUND

A common cause of failure in landscape images is an absence of eye-catching foreground. The importance of foreground cannot be overstated: it is the foundation on which the rest of the composition is built, and any weakness in that area will affect the entire picture. Don't be afraid to use a lot of it – a photograph which consists of 40–50% foreground can look striking and visually arresting. Emphasize it by using a wide-angle lens and moving in close. The most effective distance is often closer than you would imagine, and a foreground starting just 2–3ft (0.6–0.9m) from the camera is often successful. A wide depth of field will be required as everything must be perfectly sharp, and it might be necessary to increase it by merging two images (*see page 70*).

Choose your foreground with meticulous care, because when seen in close-up any weaknesses or anything unsightly will be starkly apparent. The foreground is the first thing people look at and you don't want your picture to fall at the first hurdle, so a little tidying up (within reason) might be called for before making your exposure.

HELVELLYN GILL, CUMBRIA, ENGLAND

COMPOSITION
There is a tendency to associate foreground with large, open views, but images of a smaller scale can also have, and indeed often need, foreground. In this photograph of Helvellyn Gill the colourful rocks were the main attraction, as they provided an eye-catching platform on which the rest of the picture could be built. To make the most of them I chose a portrait-format composition with the camera positioned 18in (45cm) from the nearest rock. The wide-angle lens has given the foreground a degree of prominence, but the large angle of view of the lens has prevented it from being too dominant.

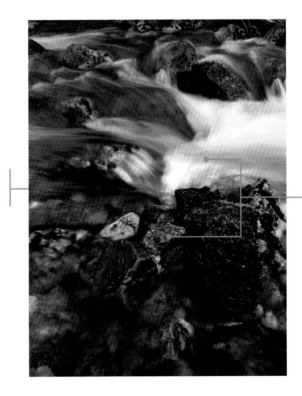

POLARIZER, FULLY POLARIZED
A polarizer was used to suppress reflections from the wet rocks. It also lengthened the required exposure, which helped to blur the flowing water.

Camera: Mamiya 645 AFD II with Mamiya
digital back

Lens: Mamiya 35mm wide-angle

Filter: Polarizer

Exposure: 1sec at f/22, ISO 100

Waiting for the light: Immediate

Post-processing: Highlight reduction

37 CONSIDER CAMERA HEIGHT

An integral part of composition which is often overlooked is the choice of camera height. Images are often captured at the 'default' height, which is eye level. This is fine if your picture contains no foreground, but when you have objects close to the camera then a lower shooting position is likely to be more successful. It's a simple step to take; it just needs to be borne in mind as you build your composition.

To give your photograph added impact, move in close to the foreground and reduce the camera height to waist level, or thereabouts. There is no hard-and-fast rule about this, but your objective is to construct an image with balanced elements, so an arrangement consisting of equal portions of foreground, middle ground and far distance is a good starting point. Take care to ensure there are no blind spots or obstacles that interrupt the view. Shooting too low will obscure the middle ground, while a position that is too high will lose impact. Generally speaking the best height is when your foreground gradually merges with the more distant features in one seamless transition.

It is not always obvious what the best camera height is, so if you are unsure then take more than one shot. What is important is that you think about it and avoid falling into the trap of routinely shooting at eye level. Your photography will benefit as a result.

WEST BURTON FALLS, YORKSHIRE DALES, ENGLAND

VIEWPOINT
In this autumn view of West Burton waterfall I chose to use a wide composition that included the colourful trees as a background. Once the viewpoint had been decided, it was then important to choose the correct camera height. There was little room for error; it had to be low enough to produce a strong foreground while also showing the river and the background trees and waterfall in their entirety, but without including any sky. There had to be a balance between foreground and background and, by careful selection of the camera height, I think this has been achieved.

POLARIZER, FULLY POLARIZED
The sky has been excluded because it is not relevant and would have been a distraction in this type of composition.

COMPOSITION
Although the foreground has a strong presence, all parts of the river can be seen without obstruction.

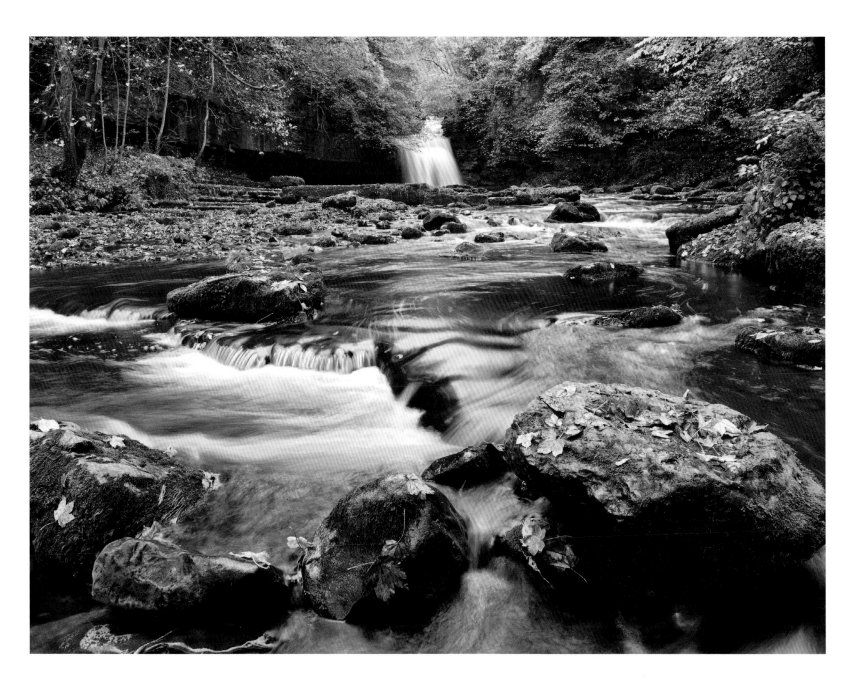

Camera: Mamiya 645 AFD II with Mamiya digital back

Lens: Mamiya 35mm wide-angle

Filter: Polarizer

Exposure: 2sec at f/22, ISO 100

Waiting for the light: Immediate

Post-processing: Curves and Color Balance adjustment

38 INCLUDE FOCAL POINTS

If an image is to succeed, it needs to connect with the viewer and make an immediate impression. For this feat of silent communication to occur, there should be a focal point that attracts attention and gives the eye something to latch on to. The absence of such an anchor point in a picture is likely to result in a loss of impact. Your composition should therefore start with the identification of an eye-catching feature around which your photograph can be structured.

In a landscape view, trees and isolated buildings are useful focal points; but almost anything can be used. If an object is appropriate to the theme of the picture, then it can act as a focal point. It doesn't have to be particularly large. Indeed, if it is too big you run the risk of it being too dominant; it might become the main subject, which will then change the theme of your photograph. To avoid this, a small, carefully positioned feature which nestles into its surroundings is normally a safer choice. Don't worry if it is distant and quite tiny, because lighting is a very effective means of enhancing even the most minuscule object. Wait for a burst of light to play across the landscape, and catch the moment when it highlights the part of the picture that you wish to emphasize.

GREAT LANGDALE, CUMBRIA, ENGLAND

COMPOSITION
The English Lake District is at any time of year a magnificent example of a photographer's perfect landscape – but even the most outstanding subject has to be captured in the right way. In this picture it was the colourful tree-clad mountain that caught my eye – but, attractive as it was, on its own it was not a complete arrangement. There needed to be a focal point to act as a visual anchor and provide depth and scale. The solution was to build the composition around the small farmhouse that stands in a wide valley in front of the mountain. Its diminutive size was compensated for by a beam of sunlight which brightly lit the building and boosted its presence.

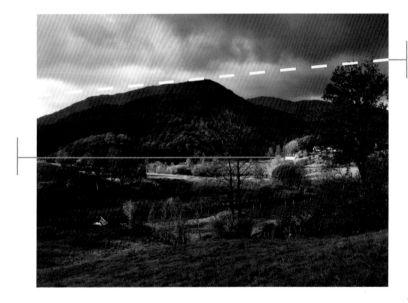

2-STOP (0.6) ND GRAD

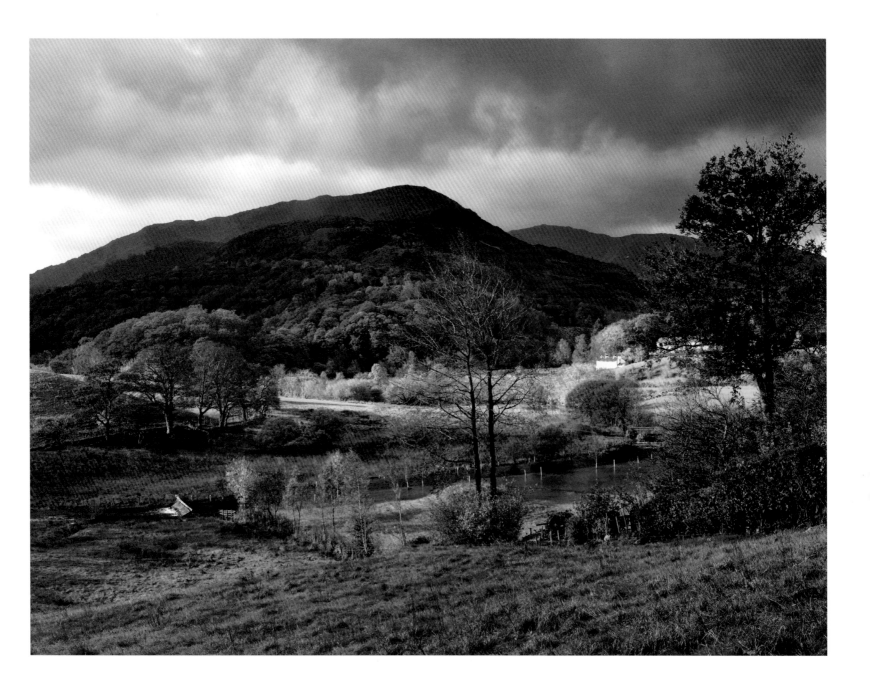

Camera: Mamiya 645 AFD II with Mamiya digital back

Lens: Mamiya 35mm wide-angle

Filter: 2-stop ND grad

Exposure: 1/15sec at f/16, ISO 100

Waiting for the light: 40 minutes

Post-processing: Curves and colour saturation adjustment

39 CREATE BALANCE

As we have seen, foreground is an important element, but at times there can be too much of it. In a distant view, for example, there might be other features that should be allowed to make a contribution. It is your role, as the photographer, to decide on the balance of the composition. Every landscape is different and rules cannot be rigidly applied, so keep an open mind as you assess a scenic view.

An elevated viewpoint might provide the balance you require, but this might be at the expense of a dominant foreground. This might be acceptable, and indeed there are times when it is preferable. If, for example, you are capturing a view which contains many features that recede progressively into the distance, then these should be given their due prominence. With the right composition, depth and distance can still be present even with no, or very little, foreground.

Consider also lateral balance. A photograph should, in addition to being evenly weighted from top to bottom, be balanced on both sides. In an ideal composition, equilibrium should exist across all parts of the picture. Therefore, when searching for a viewpoint, look for a position that enables features to be distributed across the width of the landscape.

GREAT LANGDALE, CUMBRIA, ENGLAND

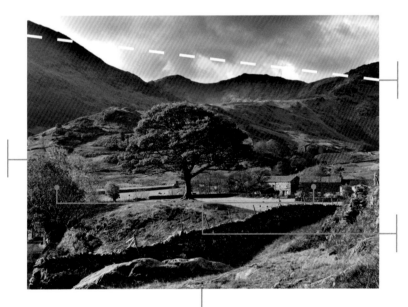

2-STOP (0.6) ND GRAD

COMPOSITION
Despite there being no close foreground, the image still has depth. This is due to the distinctive elements that lead the eye through the picture, starting with the rock nearest the camera, then the wall, tree, farmhouse, hills and distant mountains. These features also give the photograph balance from top to bottom.

BALANCE
Lateral balance has been created by the position of the tree on the left and the farmhouse on the right, which are visually connected by the stone wall.

FOCAL POINT
Trees are a wonderful adornment to the landscape and always a joy to photograph. The glorious specimen in this picture would make a fine subject on its own, but being located in the magnificent Langdale it has to compete with other attractions. While the tree has, as much as possible, been given centre stage, this image is really a view of the valley, and every part of the landscape makes a contribution.

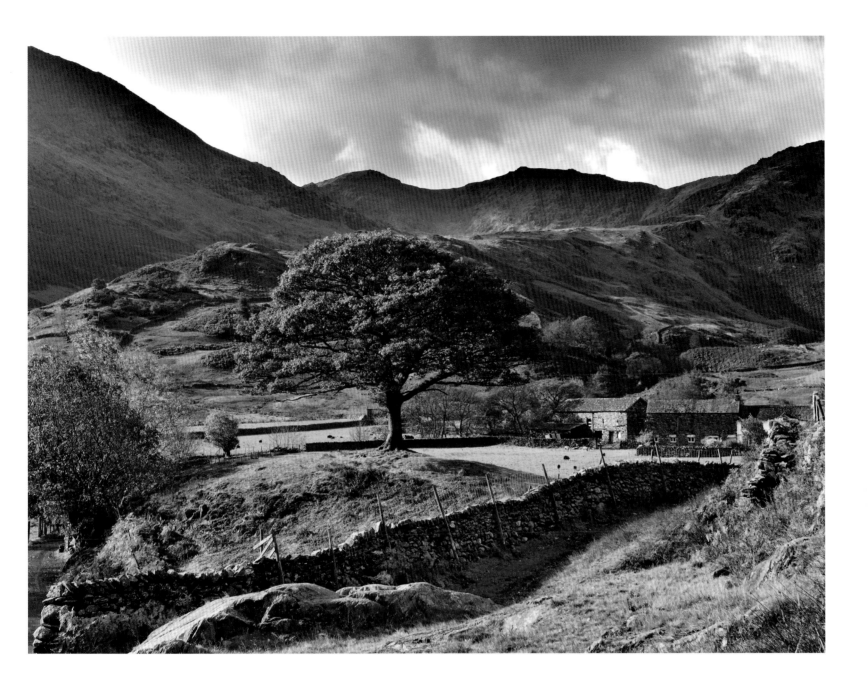

Camera: Mamiya 645 AFD II with Mamiya digital back

Lens: Mamiya 35mm wide-angle

Filter: 2-stop ND grad

Exposure: 1/20sec at f/16, ISO 100

Waiting for the light: 30 minutes

Post-processing: Curves and Color Balance adjustment

40 CHOOSE THE RIGHT VIEWPOINT

Sometimes, when you look across a scenic landscape, there is an obvious viewpoint. It might be because there are no other options and you find that you are restricted to a single vantage point; this does happen. But there are also times when, with a little investigation, you can find an alternative, superior position. It might not be immediately obvious but, once discovered, you will be able to capture images that are both original and of a higher quality than the many similar-looking pictures which have been taken from the 'standard' viewpoint.

The best approach is to research a location in advance. You will then be able to make a thorough investigation without worrying about losing light and missing the shot. As you make your search, think about the time of day and the angle of the light, because it is sometimes possible to produce quite different images of the same place. New viewpoints may emerge as the light changes, so an awareness of the position of the sun as it travels through its arc can help you to discover previously unseen opportunities.

SPRINGDALE, ZION NATIONAL PARK, UTAH, USA

OBSERVATION
Zion National Park is a magnet for photographers. Its spectacular landscape has been captured from the earliest days of photography, and it is therefore a challenge to find a new viewpoint. I hope I have succeeded with this picture; I think it is original, but I am cheating slightly because it is just outside the boundary of the national park. The image was taken in a remote area at the end of a long, little-used track. I was in the area for the best part of two days and at no time did I see another person.

VIEWPOINT
The viewpoint was chosen because of its aspect, which enabled an oblique angle of light to be used. This was important, as the sidelighting has given shape and depth to the landscape, which has enhanced its visual interest. A fully lit landscape would have looked flat and unappealing and would, I think, have failed as a photograph.

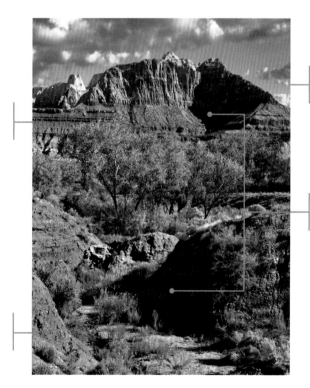

POLARIZER, FULLY POLARIZED

DEPTH
The presence of shadows has given the image depth, distance and visual appeal.

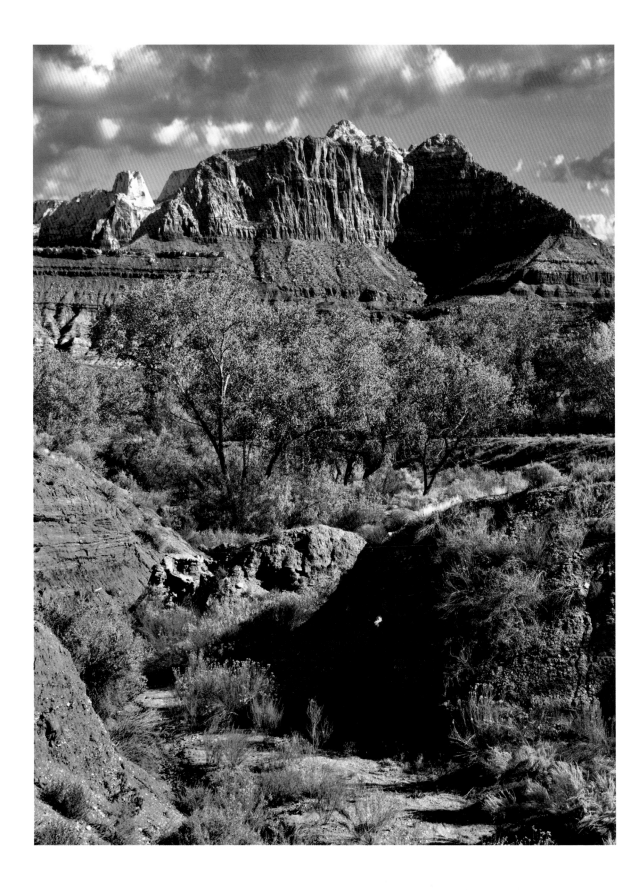

Camera: Mamiya 645 AFD II with Mamiya digital back

Lens: Mamiya 35mm wide-angle

Filter: Polarizer

Exposure: 1/5sec at f/16, ISO 100

Waiting for the light: 4 hours

Post-processing: Color Balance adjustment (warming)

41 CONSIDER THE RULE OF THIRDS

'Rule' is a word that I hesitate to use when discussing landscape photography. It implies inflexibility, which unequivocally does not apply to the making of images. There is, however, one rule that should be borne in mind when composing photographs, and that is the long-established 'rule of thirds'. Dating back to the 18th century, the rule applies to all types of picture, which, it proposes, should be divided by imaginary lines into thirds, both horizontally and vertically, to produce nine equal squares or rectangles as shown below. The meeting points of these nine sections are considered to be the strongest parts of an image. The theory is that a composition based on the rule of thirds produces a more balanced, aesthetically pleasing picture. Focal points placed along the lines, and particularly at their meeting points, will therefore engage the viewer and rest easily on the eye. The rule of thirds is also very effective if you have just one main feature: you can draw attention to it and give it maximum impact by the simple act of positioning it at one of the intersections. By doing this you will, at the same time, create a well-composed, professional-looking photograph.

Though the rule of thirds has been proved to strengthen a picture's composition, it should be considered as a guideline only. If you have a good reason to deviate from it, then don't hesitate to do so. You should not allow the rule to stifle your creativity, but it is, at the very least, a useful starting point as you consider your options.

SOUTH COYOTE BUTTES, UTAH, USA

COMPOSITION
In this picture of the South Coyote Buttes, the distinctive rock known as Half and Half is the main subject. Because of its tonal similarity with the background, I applied the rule of thirds in order to give it prominence. A composition was used which enabled the centre of the rock to be placed at approximately the meeting point of two background lines. It immediately draws the eye and, although one-sided, the image looks balanced. The equilibrium has, to a degree, been strengthened by the striped pattern on the background rock face.

BALANCE
The striped band helps to balance the off-centre position of the rock.

VIEWPOINT
Care was taken to place the rock in a position that enabled its lines to connect with similar lines in the background.

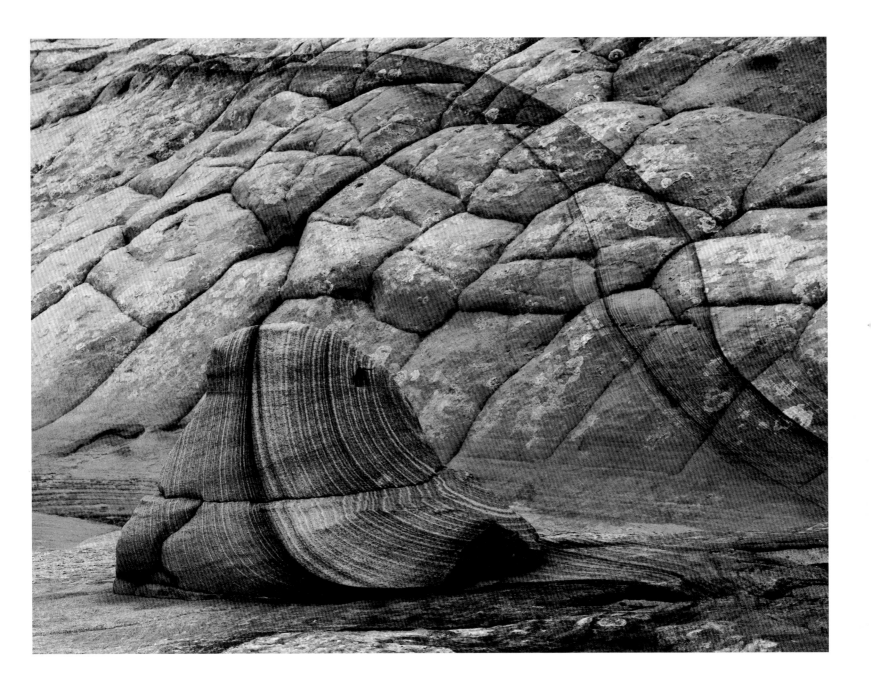

Camera: Canon EOS 7D

Lens: Canon 24–105mm L IS

Filter: None

Exposure: 1/30sec at f/11, ISO 100

Waiting for the light: Immediate

Post-processing: Color Balance adjustment (warming)

CONSIDER THE HORIZON POSITION

As we have just seen, the theory behind the rule of thirds proposes that images should not be split into equal halves, a ratio of 2:1 (or thereabouts) being preferable to 1:1. You might not be aware of it, but every time you capture a photograph of landscape and sky, the rule of thirds applies when you are deciding where to place the horizon. Often little thought is given to the matter, the position usually being determined by other elements in the picture. This approach is often successful, because it is not worth weakening a composition simply to enable the horizon to be placed at a predetermined height. If an arrangement looks right, then it probably is – but it is worth bearing in mind the rule of thirds, at least to the extent of not placing the horizon in the middle. A composition of half landscape, half sky is rarely successful, particularly if the horizon is a straight line.

Sometimes you can use the horizon creatively, building the composition around either a high or a low horizon. A powerful, stormy sky might, for example, be more effectively depicted if it is allowed to become the main subject and fill most of the picture. A ratio of as much as 9:1, with the landscape being restricted to a thin strip, might be very successful and have strong impact. Alternatively, the reverse also applies, and a magnificent landscape can often be given full rein and supported by a sliver of sky – or the sky can be omitted completely. All options are open to you, and the key to success is simple: think creatively and be consciously aware of the horizon's position.

VILA VELHA DE RÓDÃO, CENTRO, PORTUGAL

CROPPING
The image was cropped here to reduce the expanse of sky and raise the height of the horizon.

COMPOSITION
As I composed this image of Vila Velha, my options were limited. The nature of the landscape dictated the placement of the horizon, but it wasn't to my liking, as it virtually split the picture in half. Raising it by including more foreground was not the answer, and neither was lowering it. The only solution was to accept its position and then later reduce the sky by cropping it in post-processing. This is a useful way of adjusting the horizon and should be considered if you feel it will improve the photograph.

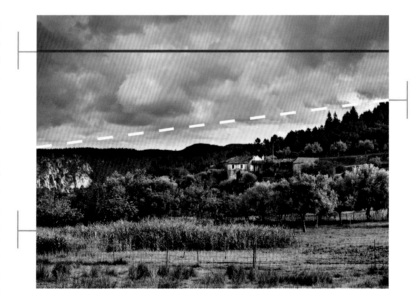

2-STOP (0.6) ND GRAD

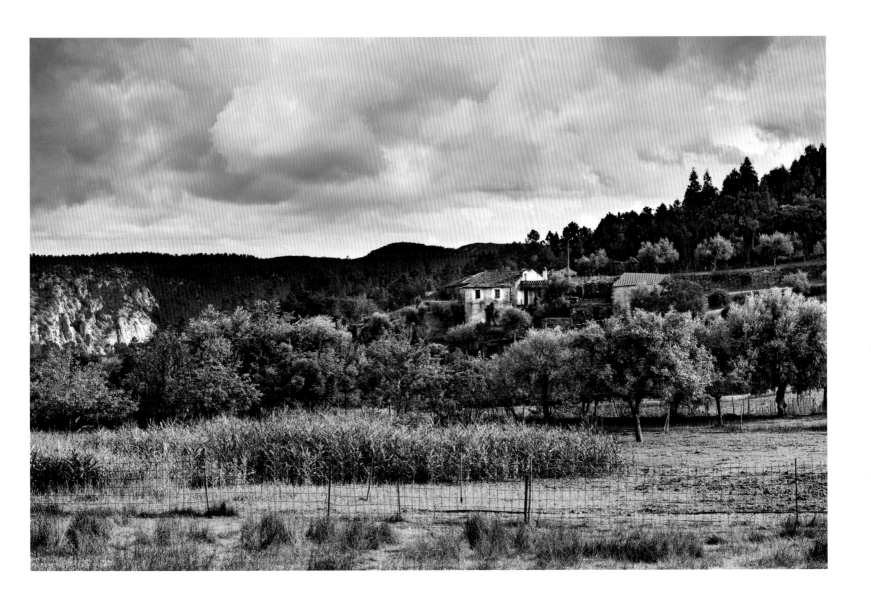

Camera: Mamiya 645 AFD II with Mamiya digital back

Lens: Mamiya 35mm wide-angle

Filter: 2-stop ND grad

Exposure: 1/5sec at f/22, ISO 100

Waiting for the light: 50 minutes

Post-processing: Curves adjustment and cropping

43 USE CLOUD

A common cause of failure in a photograph is, as we have seen, a poor sky. When it is included in an image, the sky is as important as the landscape itself, and it should not be underestimated or dismissed as being of little consequence. Photographs can stand or fall because of it, so ensure that the sky you capture does justice to the land beneath it.

The sky should be considered in the context of other elements in the picture. It is often beneficial if it shares common qualities with the landscape; for example, a stormy sky is likely to suit a dramatic location, whereas a serene scenic view will be enhanced by a calm sky. Pairing the landscape and sky in this way will strengthen the theme of an image and produce a balanced composition. Sometimes, though, the opposite approach can be successful, where a stormy sky is combined with gentle terrain or vice versa. Experiment with different combinations and compare the results.

The sky (or, more specifically, cloud) can also be used to balance a one-sided picture. If the horizon is uneven – there might, for example, be a mountain protruding – then cloud can be used to fill the gap on the other side. Watch as clouds drift by, and capture the moment as they reach the position you require. Often a single cloud of a moderate size will be sufficient, provided it is distinctive and in the right place – particularly if the rest of the sky is clear. This is a case of less is more: the smaller the cloud, the bigger the visual impact.

NEAR HESWALL, WIRRAL PENINSULA, ENGLAND

FOCAL POINT
There is a minimalist quality to this rural image. It is structured around horizontal bands of solid colour, and it was important that the sky should continue that theme. A cloudy sky would have ruined the minimalism and seriously weakened the composition. The single softly shaped cloud, though not absolutely essential, introduces a contrast to the repeating rectangles in the other elements and provides the missing focal point. In my, admittedly biased, opinion, that lonely little cloud elevates the photograph and greatly boosts its visual appeal.

POLARIZER, FULLY POLARIZED

COMPOSITION
The rule of thirds theory holds true here, and it was important that the cloud should occupy an off-centre position. Had it been in the middle, the picture would have looked very unsettled.

Camera: Mamiya 645 AFD II with Mamiya digital back

Lens: Mamiya 35mm wide-angle

Filter: Polarizer

Exposure: 1/4sec at f/16, ISO 100

Waiting for the light: 1 hour

Post-processing: Color Balance and Saturation adjustment

44 EXCLUDE THE SKY

Although the sky is often an essential feature, there are occasions when it can conflict with other elements and weaken the composition. It can sometimes be a distraction, or at the very least have no role to play, and if you feel this is the case then it might be preferable to exclude it from your photograph. The removal of the sky can often bring about a noticeable improvement in the composition and increase its impact, but it is not a decision that should be rushed. If you are unsure, then it is safer to leave the sky in because you can always remove it later during post-processing. If possible, though, it is preferable to exclude it at the time of capture, because you can then fill the entire frame with your subject. So, as you consider your compositional options, how do you decide what to do with the sky?

As with most aspects of creative photography, there are no hard-and-fast rules. It largely depends on the nature of the subject and the quality of the sky. Some images, for example expansive views of sweeping vistas, will need the sky if they are to portray the grandeur and majesty of the location. If, however, your landscape is of a smaller scale and the sky fails to inspire you, then it might be better to exclude it. One type of subject which generally needs no sky is forest and woodland. Trees have strong aesthetic appeal, and when grouped together they photograph well on their own. Images can usually be composed in a simple way with few additional features, so the presence of the sky is unnecessary.

LANGDALE FELLS, CUMBRIA, ENGLAND

COMPOSITION
Colourful trees are best captured under soft, shadowless light. An overcast sky is ideal, but does not look attractive in a photograph; it is therefore fortunate that it need play no part in this type of picture and can be completely excluded.

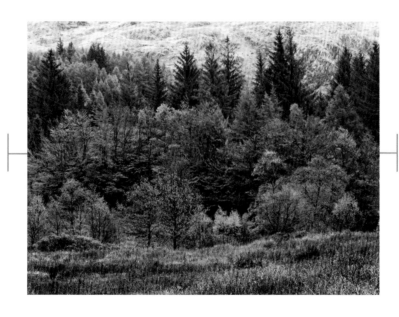

ATMOSPHERE
At the time I made this image of the Langdale Fells, there was fine drizzle falling from a milky-white sky. The soft light and damp atmosphere combined to saturate colour and enhance the appearance of the forest. It was a compelling view, so with an umbrella in one hand and my camera on a tripod I made three exposures using a telephoto lens to frame the trees tightly, with the distant mountain acting as the background.

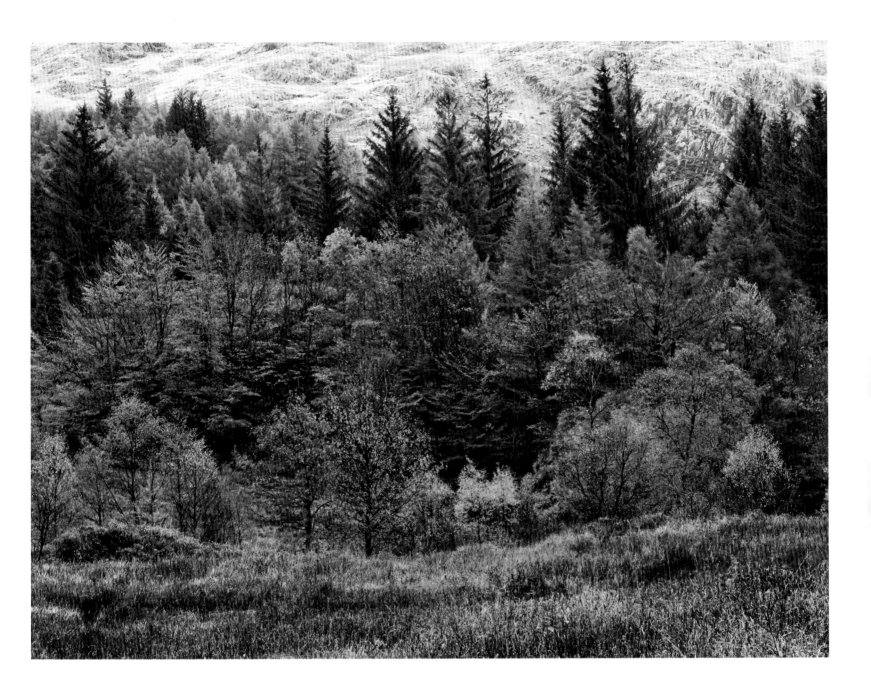

Camera: Mamiya 645 AFD II with Mamiya digital back

Lens: Mamiya 150mm telephoto

Filter: None

Exposure: 1/2sec at f/18, ISO 100

Waiting for the light: Immediate

Post-processing: Curves adjustment

45 COMPRESS DISTANCE

A telephoto lens is generally used to magnify objects. The magnification effectively reduces distance and, without your having to take a single step, brings your subject closer to you to enable you to capture it in a size that fills the frame. When first introduced they were heavy and cumbersome, but now the moderate size and weight of the ubiquitous zoom telephoto has allowed photographers to roam the landscape unburdened by the need to carry a back-breaking profusion of fixed lenses. Telephoto lenses are undoubtedly practical and convenient, but there is more to them than that – they also provide new creative opportunities.

One of the effects of magnification is the compression of distance. Depth begins to shrink as you increase lens focal length, and this can be used to introduce a graphic, semi-abstract quality to images. The natural world abounds with patterns and intricate, repetitive features that often go unnoticed, but, if isolated from their surroundings, they suddenly become more prominent and they can then be the source of quite striking photographs. Depth is not important in these types of picture. The objective is to produce a creative, graphic image, and two dimensions are often all you need.

Search for potential photographs by viewing the landscape through your telephoto lens. Previously unseen subjects should begin to emerge and they can be the source of many eye-catching images.

PARIA MOUNTAINS, ARIZONA, USA

COMPOSITION
I took several images of the striking Paria Canyon rock formations. There were many options, and I tried a number of different compositions using both wide-angle and telephoto lenses. When I compared the results, the most successful were, to my eye, the longer focal-length pictures. The flattened perspective allowed greater emphasis to be placed on the most important part of the photograph: the background mountain. The long lens also enabled the subject to be tightly framed with no dead space and no sky. Every part of the image therefore makes a contribution and adds to the visual appeal.

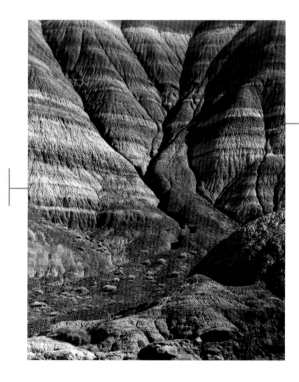

POLARIZER, FULLY POLARIZED
A polarizer was used to strengthen colour and increase contrast slightly.

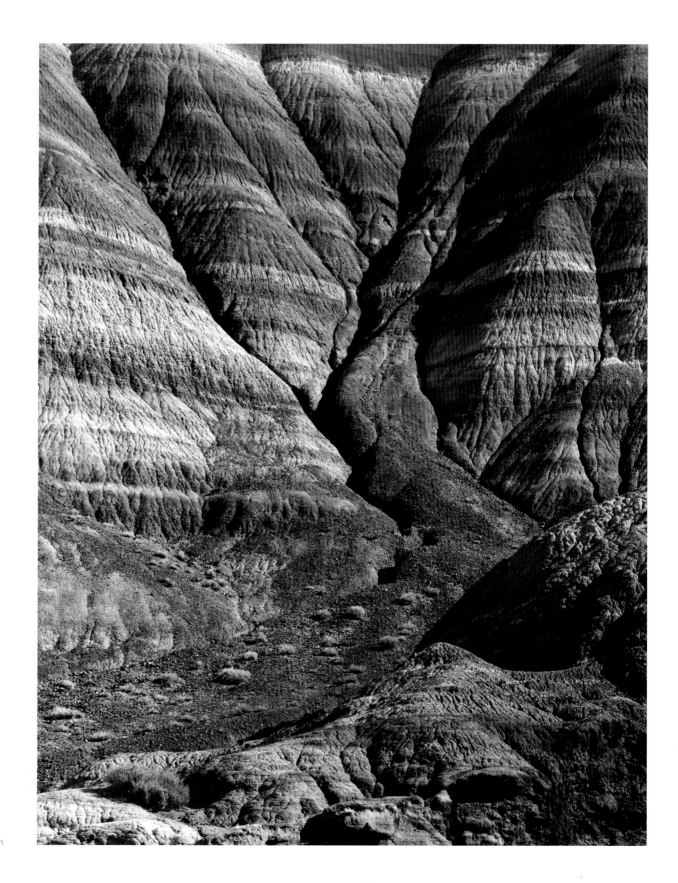

Camera: Mamiya 645 AFD II with
Mamiya digital back

Lens: Mamiya 150mm telephoto

Filter: Polarizer

Exposure: 1/15sec at f/16, ISO 100

Waiting for the light: 50 minutes

Post-processing: Highlight reduction

46 CHANGE THE FOREGROUND

A good location can yield more than one photograph. You might be delighted with the image you have captured but, if the place or subject inspires you, then why stop at one? There could be other options, and to capitalize on them all it might take is a small change in camera position.

Building a composition of an expansive view around a prominent foreground is usually a sound approach because it will give the picture depth, aesthetic appeal and impact. It is, or should be, a formula for success; but there is more than that, because the presence of a strong foreground also opens up new creative opportunities. You can make what is, effectively, an entirely new photograph by simply changing the foreground. You shouldn't have to travel far – sometimes just a few paces will be sufficient – because the location doesn't change, only the foreground. Also, if you wait a few minutes there is a good chance that the sky (and possibly the light) will have altered in some way. The combined effect of these changes will produce a new and discernibly different picture. The foreground is the key: change it and you can increase your output without replicating images.

GLEN ETIVE, RANNOCH MOOR, SCOTLAND

POSITIONING
The main picture of Rannoch Moor was captured from a position approximately 20 yards (18m) away from the small image shown right. The sky was continually changing, and 30 minutes after taking the first photograph I was able to produce a quite different picture, the only similarity being the range of mountains in the distance. Compare them and it will be apparent that two different photographs have been created with only a minimal change in position.

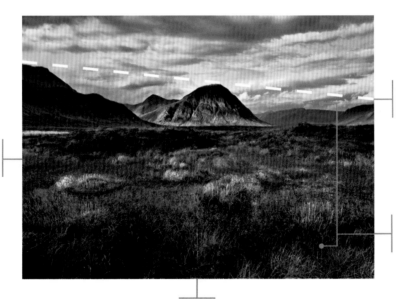

2-STOP (0.6) ND GRAD

VIEWPOINT
Capturing a different sky and foreground enables new photographs to be produced of the same location.

PERMUTATIONS
Rannoch Moor is a richly diversified landscape and there were many permutations of foreground/mountains/sky that I could have taken, but the weather interrupted my plans. Rain brought an end to proceedings, but one day I will return and resume my mining of images from this rich seam of landscape.

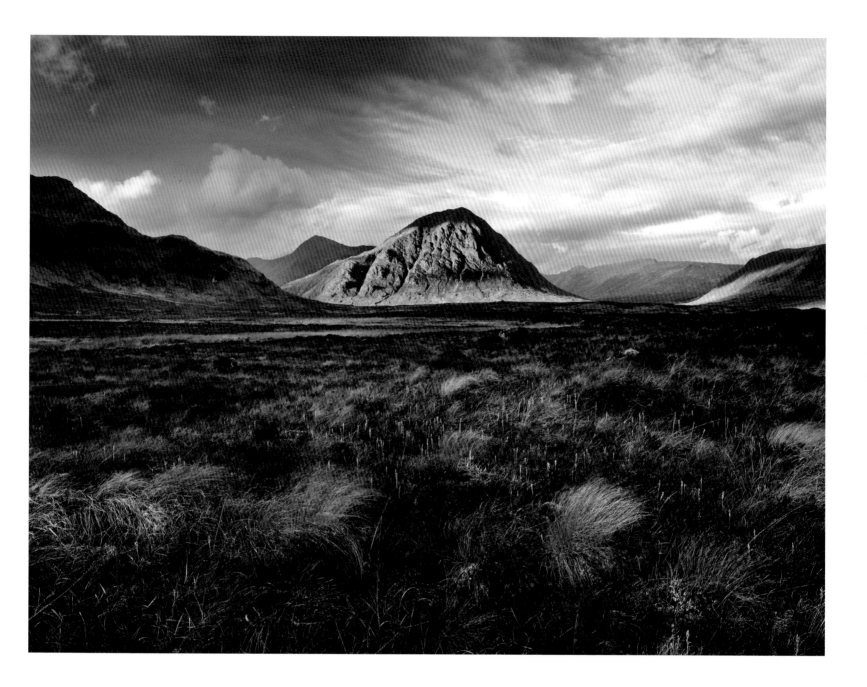

Camera: Mamiya 645 AFD II with Mamiya digital back

Lens: Mamiya 35mm wide-angle

Filter: 2-stop ND grad

Exposure: 1/4sec at f/22, ISO 100

Waiting for the light: 45 minutes

Post-processing: No adjustments

CHANGE THE FORMAT

Landscape or portrait? The choice of format is a decision that should be consciously made every time an image is captured. Often the nature of the subject dictates the orientation and there is no debate – you automatically compose the photograph in the only suitable format. But there are also times when the choice is not so clear: there might be good reasons for both options, and it then becomes a creative decision based on your compositional preferences.

Avoid using the more common landscape format by default, without thinking carefully about the image you wish to take. Your decision should be made after a thorough evaluation of all the subject's features.

Decide where the main interest lies, and use the format that looks right and has the greater impact. A portrait orientation will place emphasis on foreground elements, while landscape will give more weight to the sky. If in doubt, then take both, and if possible find two slightly different shooting positions. That way you will have two images that are not too similar and can be compared, which is both interesting and informative.

CHURCH COVE, CORNWALL, ENGLAND

BALANCE
Initially I took only this landscape version of the waterfall at Church Cove. As well as the waterfall itself, I was attracted by the colourful rocks and background. The lapping waves were also a feature I wanted to include, as they brought a balance to the right half of the image.

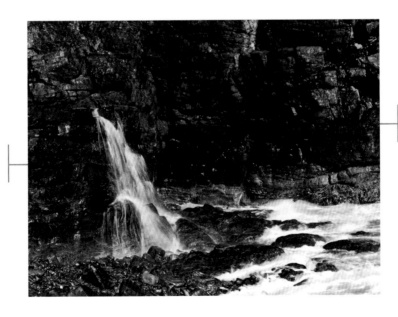

FORMAT
Once I had taken just one exposure, rain brought an unwelcome interruption to proceedings. Fortunately it was short-lived, and one hour later I returned. The earlier picture had been captured at high tide and now, with no water on the right, the landscape format looked a little unbalanced. I reluctantly settled for a portrait view, at the time thinking that it would be inferior to the earlier photograph. However, viewing it later, I much preferred it. The waterfall, being the only water in the picture, has more impact. It contrasts well with its rocky surroundings, which are, to my eye, quite attractive on their own. There are fewer elements and it is a simpler composition. The image, I believe, benefits from this.

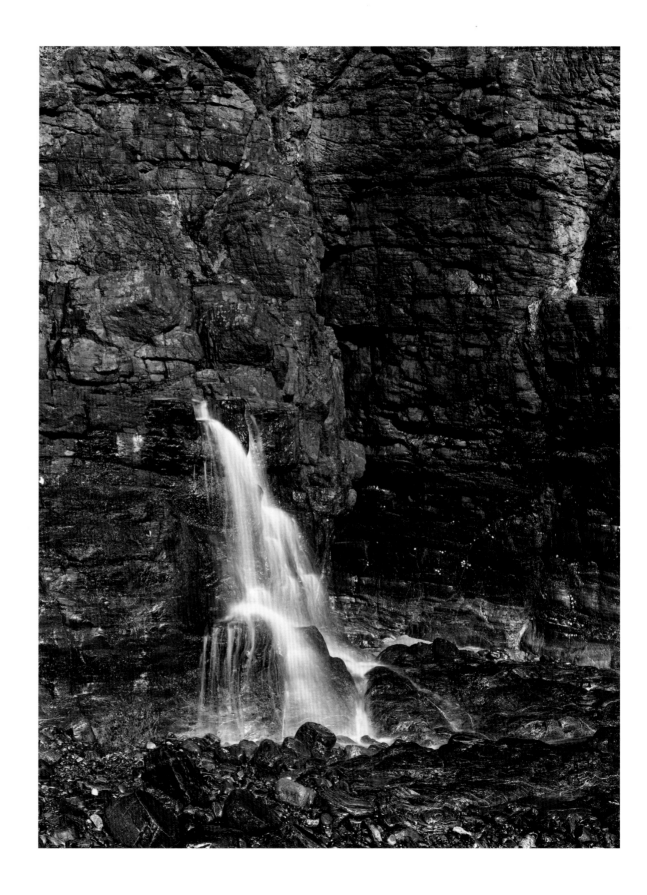

Camera: Mamiya 645 AFD II with Phase
One digital back

Lens: Mamiya 80mm standard

Filter: None

Exposure: 1sec at f/22, ISO 100

Waiting for the light: 1 hour

Post-processing: Highlight reduction

USE COLOUR CREATIVELY

Colour in an image is a potent force and its pulling power should not be underestimated. Bright hues, in particular, have a magnetic quality that attracts the eye and draws attention away from other elements. The subtleties of a photograph can become obscured in the presence of bright contrasting colours, so avoid including vivid objects in a composition if they have no contribution to make. They will act as strong focal points and detract from the theme of your picture.

Colour can, however, also be used creatively, and colour-based arrangements can produce distinctive, eye-catching photographs. Simplicity is the key to success. For maximum impact, compositions should not be too complex and colours should be of a restricted range. Images should consist of large, distinct blocks of a small number of colours, rather than a multitude of shapes and hues. Too much visual information will confuse the viewer, and the theme you are trying to create will be lost.

A very effective approach is to portray one clearly defined object of a single colour against a uniform, contrasting background. It will become an irresistible focal point and will not fail to draw the eye. The best results are usually obtained by excluding the sky and using flat light. This will remove distractions and keep the viewer focused on the main subject.

TILBERTHWAITE FELLS, CUMBRIA, ENGLAND

CONTRAST
Rounding a bend near the Langdale Valley my attention was drawn immediately to an isolated bush. Nestling in a richly textured, hilly terrain its bright colour was in stark contrast with the muted background. It was an overcast afternoon and the daylight was beginning to fade; it was all rather gloomy but the low level of shadowless light was perfect for this type of subject. I was able to find an elevated viewpoint and, to keep the composition as simple as possible, used a telephoto lens to enable the sky and much of the surrounding landscape to be excluded.

COMPOSITION
The slightly off-centre position of the tree is a variation of the rule of thirds. It suits simple compositions where there is one main point of interest.

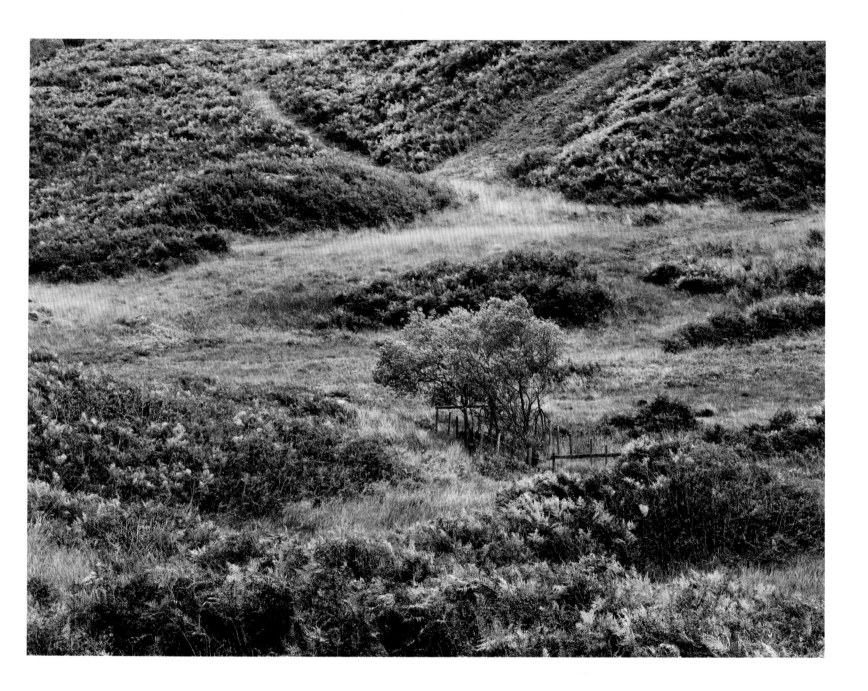

Camera: Mamiya 645 AFD II with Mamiya digital back

Lens: Mamiya 150mm telephoto

Filter: None

Exposure: 1/4sec at f/22, ISO 100

Waiting for the light: 50 minutes

Post-processing: No adjustments

49 EXCLUDE UNNECESSARY ELEMENTS

Good composition is not only about what you put into a photograph – what you leave out is just as important. To succeed, an image has to make an immediate connection, and the simpler the arrangement the greater the chance that it will instantly engage with the viewer. Too much visual information can be daunting and if, at first glance, a photograph fails to register, then you are likely to lose your audience – so keep the variety of components you use in your picture to the bare minimum.

When deciding on a composition, have a clear idea what the main feature is and try to exclude anything that draws attention away from it. For example, if your subject has a distinct colour or shape, there should be no other objects of a similar colour or shape. They will be a distraction and will draw the eye away from the main focal point. Keep this in mind when you search for a vantage point, and choose a position that gives you an uncluttered view, free of non-essential elements.

ABOBOREIRA, SANTARÉM, PORTUGAL

COMPOSITION
There is a hint of impressionism to this picture of a forest near Aboboreira in northern Portugal. The subject is the pair of dilapidated roofs buried in the depths of a wooded valley. Their angled shape, hard edges and warm colour are in stark contrast to the surrounding softly contoured trees and foliage. The rooftops form a single entity and it was important that they stand completely alone, with no other elements present that would weaken their isolation. The composition had to consist only of trees, foliage and the two roofs.

CROP
Care had to be taken to ensure that no part of another building appeared in the foreground.

VIEWPOINT
The viewpoint had to be chosen with care because there were remains of another building occupying much of the foreground. It was essential that they were not included, and there was just one, rather inaccessible shooting position that suited my requirements (why is it that the best places always seem to be the most difficult to reach?). After a little scrambling and fighting my way through spiked thorn bushes, I reached the only suitable viewpoint. By that time the hard work had been done and the picture was captured without difficulty. The sky was cloudy but the shadowless light it produced was perfect for this type of image.

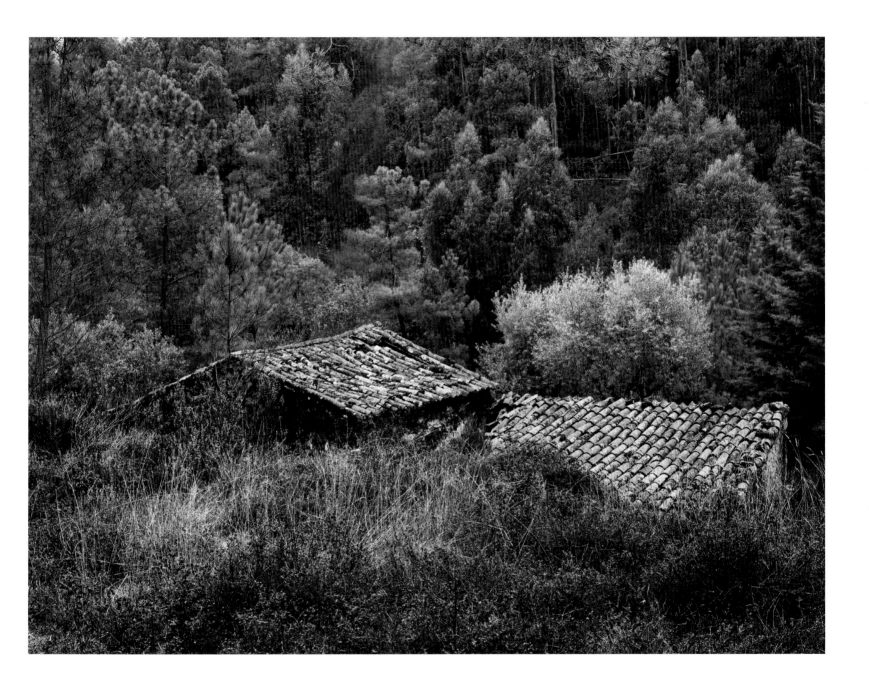

Camera: Mamiya 645 AFD II with Phase One digital back

Lens: Mamiya 80mm standard

Filter: None

Exposure: 1/2sec at f/22, ISO 100

Waiting for the light: Immediate

Post-processing: Curves adjustment

APPLY YOUR OWN INTERPRETATION

Images do not have to be realistic to be successful, and many examples of this can be seen hanging in prestigious galleries. However, at the mention of abstract art it is paintings, not photographs, that normally come to mind. This is to be expected, because there is a long history of abstract art, painted by famous masters such as Picasso and Matisse, which has overshadowed abstract photography. This is unfortunate, because the medium of photography is a perfect tool for portraying abstract interpretations, particularly of landscape subjects. However, there are signs that abstract photography is now beginning to gain the recognition it deserves.

Creativity and imagination lie at the heart of all visual art and, in photography, observation also plays an important role. To capture any picture you first have to see it, and this is particularly the case with abstract arrangements. They are by their nature not obvious; as the photographer, you have to apply your own interpretation to a subject and remove it from reality. This is the key to success. Potential images are everywhere and you can find them by training your eye to isolate small parts of the landscape from their surroundings. Look for repetition, patterns and shapes, and imagine how they would look as a print hanging on a wall. Use your imagination, and if you find an abstract arrangement attractive then photograph it.

TREE BARK, BRITTANY, FRANCE

INTERPRETATION
This image is completely abstract – at least, I hope you think it is. This, however, is an illusion. If you turn the page anticlockwise by 90°, the reality of the subject may become apparent. It is not, as you might have initially thought, a strange geological landscape, but the rather more prosaic bark of a tree. This, I believe, demonstrates the power of photography, and also the results that can arise when you apply your own interpretation to an object. Try it yourself – there is no limit to the photographs you can create.

Camera: Mamiya 645 AFD II with Phase One digital back

Lens: Mamiya 80mm standard

Filter: None

Exposure: 1sec at f/22, ISO 100

Waiting for the light: Immediate

Post-processing: Highlight reduction

CHAPTER FOUR

USING LIGHT

LESSONS

 >> 61

If you make repeat visits to a location and capture the same scene at different times of day, you can be sure that no two of these images will be identical. The change in appearance will vary from subtle to dramatic, and this will be solely the effect of light. Light is by far the most critical ingredient in a landscape photograph, and how you use it will be a decisive factor in the quality of your work. Understand light, and your photography will reach another level.

PORTHCURNO, CORNWALL, ENGLAND

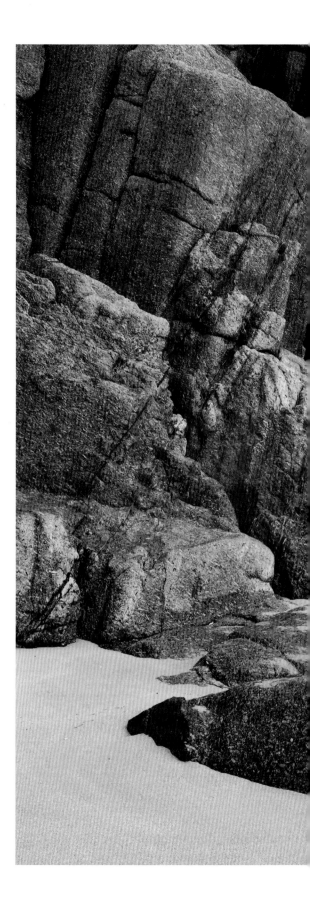

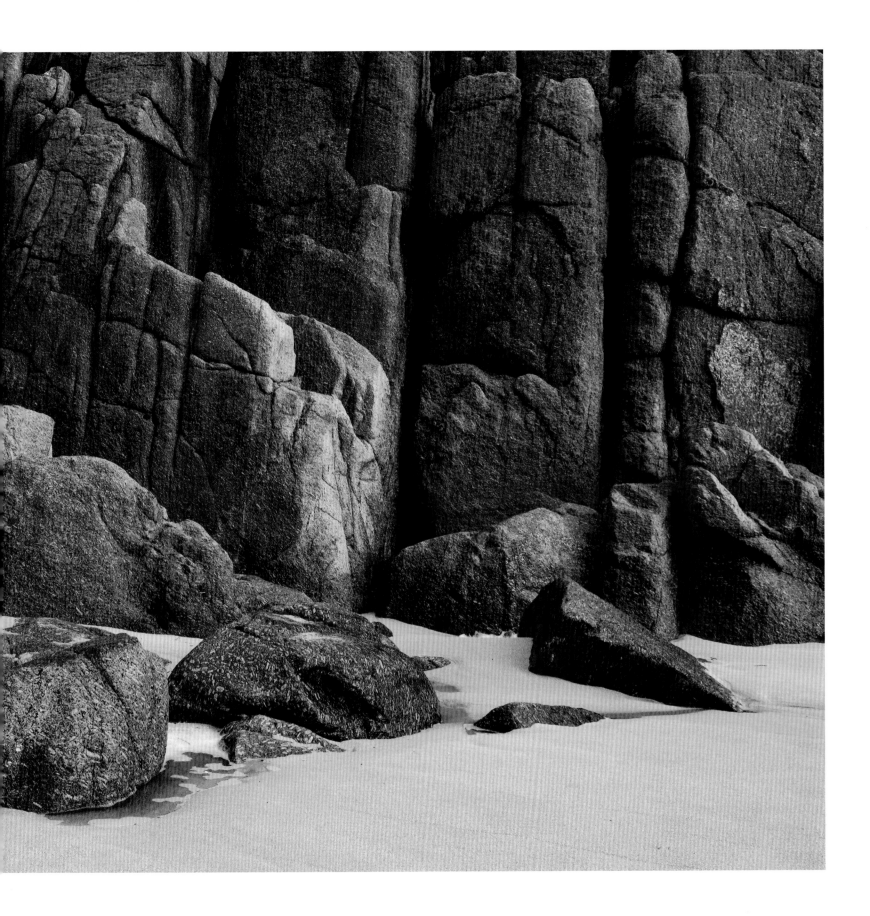

51 CONSIDER THE ANGLE OF LIGHT

Imagine, if you will, a photographer's studio equipped with just one light. The light is old and unreliable, varies in intensity, illuminates the subject in a fickle and haphazard manner and sometimes switches itself off altogether. The exasperated photographer would soon admit defeat and the studio would close. It would be virtually impossible to work in such an environment, yet many photographers do – every time they venture out into the landscape.

Our single light source, although capricious, has one important point in its favour: it keeps moving, and it moves in a predictable way. Every day, as it travels through its arc, the angle of light is constantly changing, and this provides tremendous scope for creativity. Consider, therefore, the position of the sun and the angle of the light every time you capture an image. Before you make an exposure, ask yourself: 'Is the light suitable? Should I wait, or should I return?' The sun should not, as a rule (this is one rule you can follow!), be behind you. It should be to one side so that it shines across the landscape. This will give shape and depth to the terrain and heighten visual interest.

The angle of light is the most important factor in a landscape image, and it is also the most variable. Use the angle that most effectively lights your subject, and you will raise the quality of your photography no end.

SWALEDALE, NORTH YORKSHIRE, ENGLAND

LIGHT
The angle of light is the most important element in this autumn photograph of Swaledale. The acute sidelighting (verging on backlighting) gives shape to the landscape. In addition to this there is a sense of scale and distance, which is also due to the angled sunlight. This is partly the result of the barns and trees on the floor of the valley, which have been given a degree of prominence by being lit from the side.

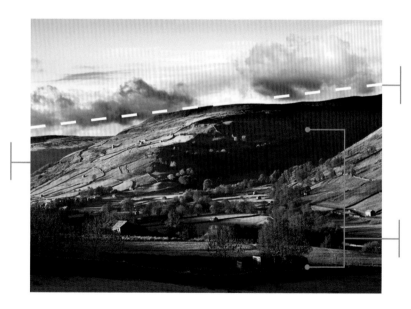

2-STOP (0.6) ND GRAD

SHADOW
Low sidelighting has created long shadows which give the valley shape, depth and distance.

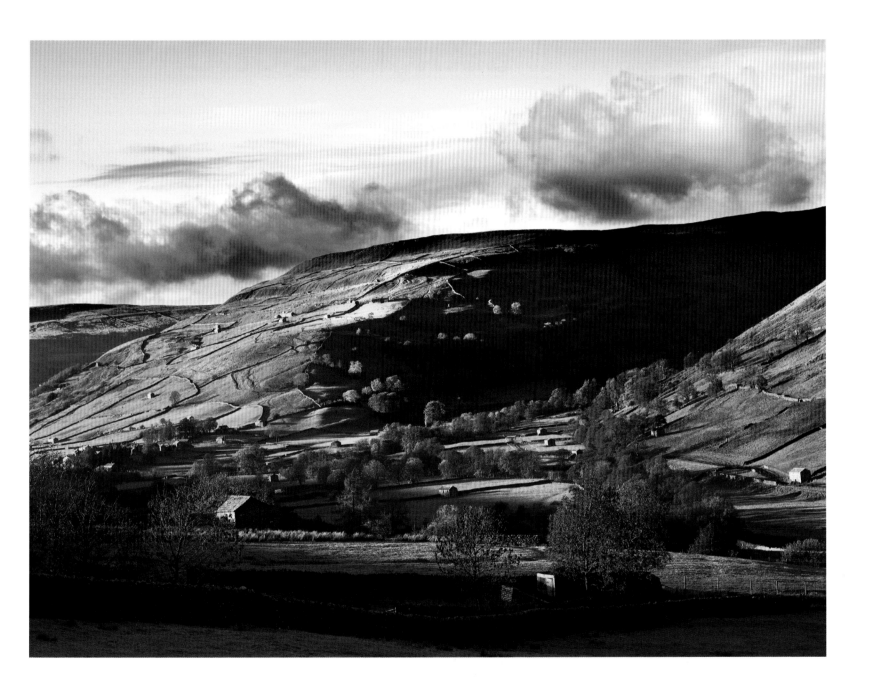

Camera: Mamiya 645 AFD II with Mamiya digital back

Lens: Mamiya 35mm wide-angle

Filter: 2-stop ND grad

Exposure: 1/5sec at f/22, ISO 100

Waiting for the light: 1 hour 30 minutes

Post-processing: Curves adjustment

52 CHOOSE THE BEST TIME OF DAY

If you spend a day at one location you will see that the appearance of the landscape changes as the sun travels through its arc. Minute by minute it is undetectable, but at hourly intervals a gradual transformation becomes apparent, and as the hours tick by it grows more and more noticeable. By the end of the day the landscape will bear little resemblance to the view you first encountered early in the morning; the difference can be profound, and it is mainly due to the position of the sun and the progressive change in the angle of light.

Different locations look their best at different times of day. Early morning and late evening, when the sun is low in the sky and shadows are long, are the prime periods, but not all places suit those hours. It depends on

the aspect of your viewpoint; each direction has its own optimum time, and with a little planning you can ensure that you are at your location at the best moment, when the angle of light is most favourable. A large-scale map can be a useful aid in this respect: it will enable you to determine the aspect of your view, and you should then be able to calculate the approximate time of day when the sun will be in perfect position. The best approach, however, is to research your viewpoint in advance. There is nothing better than becoming familiar with a place, seeing it in different lights and pinpointing the peak moment.

BALLYNAKILL HARBOUR, CONNEMARA, IRELAND

TIME OF DAY
My map indicated that the picture I had in mind of Ballynakill Harbour should be taken during mid to late afternoon. On arrival, though, the sun was not quite where I wanted it: it was partly backlighting the harbour, which wasn't to my liking. I therefore returned two hours later. By then it was approaching sunset and the light had warmed and softened. It was quite exquisite, and within minutes the image had been captured. I watched as the sun crept towards the horizon, deeply satisfied in the knowledge that the photograph had been taken at the ideal moment.

2-STOP (0.6) ND GRAD

SHADOW
As the day draws to a close, low sun and cloud combine to scatter light and shadow across the hilly landscape to create a perfect moment.

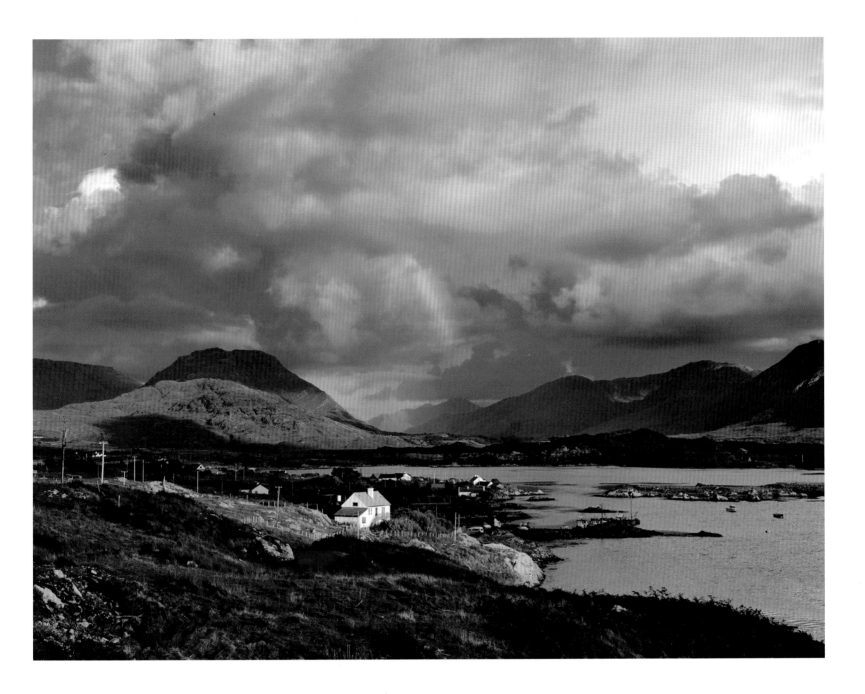

Camera: Mamiya 645 AFD II with Mamiya digital back

Lens: Mamiya 35mm wide-angle

Filter: 2-stop ND grad

Exposure: 1/8sec at f/22, ISO 100

Waiting for the light: 2 hours

Post-processing: Curves adjustment

53 CHOOSE THE BEST TIME OF YEAR

Although the time of day is, as we have seen, a critical factor, it is not the only consideration. Seasonal changes affect both the quality of light and the appearance of the landscape, so, when deciding on the timing of your shot, your calendar is as essential as your watch. Just as you can choose between, say, twelve hours per day to make your exposure, you also have the twelve months of the year available, and it is important that you choose the right one.

The type of landscape will, to some extent, determine the best month or season. An area rich in deciduous trees is likely to be at its peak in October (in the northern hemisphere), while arable farmland is likely to

be at its most photogenic during the spring and summer months. Rugged and mountainous areas often suit wintry conditions and dramatic light, so November to February is potentially a rewarding time to visit.

Landscape photography is a year-round pursuit. Plan your schedule according to the type of location, and you will reap the benefits.

GREAT LANGDALE, CUMBRIA, ENGLAND

TIME OF YEAR
There is more to the English Lake District than just lakes. The area has a wealth of deciduous trees and its magnificent appearance is further boosted during the autumn weeks by a superb display of leafy colour. Attractive all year round, it is undoubtedly in autumn that the beauty of the Lakeland fells reaches new, dizzying heights. This picture was captured in late October when the colour was at its peak.

2-STOP (0.6) ND GRAD

TIME OF DAY
The time of day was also important in the making of this image. It was captured at midday when the trees were slightly backlit. This angle of light has given the leaves a luminosity which has strengthened their colour, and has also given the trees shape and depth.

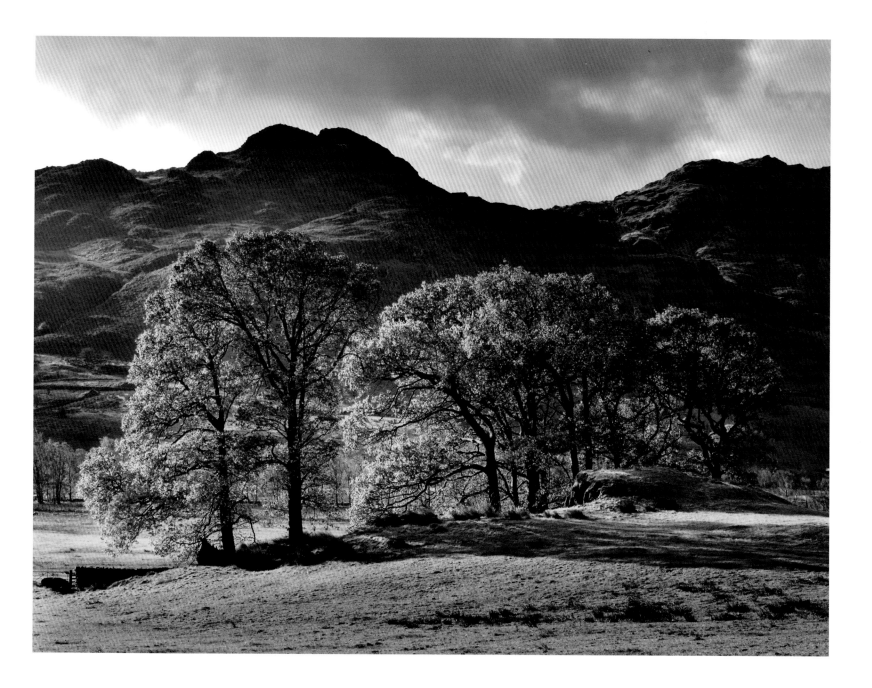

Camera: Mamiya 645 AFD II with Mamiya digital back

Lens: Mamiya 35mm wide-angle

Filter: 2-stop ND grad

Exposure: 1/15sec at f/22, ISO 100

Waiting for the light: 45 minutes

Post-processing: Curves adjustment

WATCH THE PLAY OF LIGHT

The short periods after sunrise and before sunset are, with good reason, considered to be the peak times for capturing landscape images. The light at those precious moments can be exquisite, but once it is over there is no need to pack away your equipment and ignore the rest of the day. With the right type of sky, high-quality light can occur at any hour.

When you find broken cloud drifting across the sky, watch as the sunlight plays across the landscape. On a breezy day there will be a constant change in the distribution of light, and this will provide you with a wealth of creative opportunities. The shape and contour of the land will appear to change as hidden undulations reveal themselves under the scrutiny of piercing beams. It can be fascinating to witness the transformation as different features and focal points are briefly illuminated. Consider what the key elements are in your photograph, and make your exposure the moment they are brightly lit.

In varying light a single location can yield many different images. Spend a few hours watching the play of light and you should be well rewarded.

LLANTYSILIO, DENBIGHSHIRE, WALES

PERMUTATIONS
This image is one of many I have taken over several years of the fascinating Llantysilio Valley. It is one of my favourite places because, thanks to the nature of its landscape and the changeable weather in the area, it is always possible to find a new, original photograph. As sunlight plays across the steep sides of the valley, hidden contours and undulations are suddenly thrown into relief to subtly alter its appearance. Combine this with a small change in camera position and the result is the capture of a completely new image.

2-STOP (0.6) ND GRAD

LIGHT
Because of the size and bright colour of the foreground, it was essential that it should be captured under a soft light, free from highlights and shadows. It was also important that the distant hills were brightly lit. This draws the eye to the distance and gives the picture depth and scale. The play of light is, therefore, the critical element in this image.

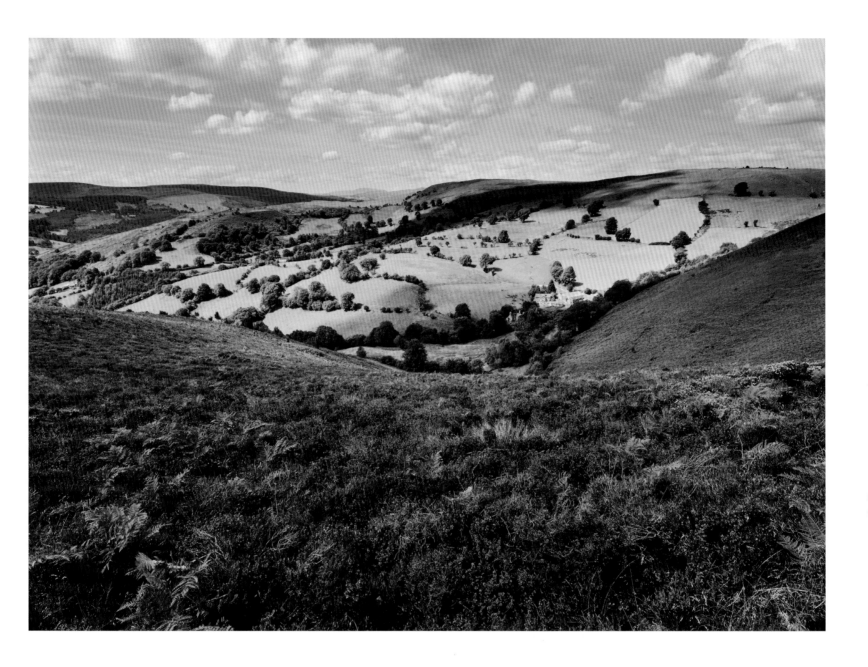

Camera: Mamiya 645 AFD II with Mamiya digital back

Lens: Mamiya 35mm wide-angle

Filter: 2-stop ND grad

Exposure: 1/5sec at f/22, ISO 100

Waiting for the light: 1 hour 20 minutes

Post-processing: Highlight reduction, Color Balance adjustment

USE HIGHLIGHTS AND SHADOWS

It is an inescapable fact that the appearance of the landscape is a direct result of how it is lit. A poorly lit landscape will, if photographed, produce a poor image. Even the most spectacular subject will disappoint if the lighting is weak; it is therefore imperative that, every time you consider capturing a scenic view, you ask yourself whether the lighting conditions match the quality of the landscape. There is a good chance that they will do not.

Highlights and shadows are key elements in a large, open view, and how they are scattered across the landscape has a bearing on the success of a picture, so it is important to capture the right moment. But when, you may ask, is the right moment? This is something that you, as the photographer, must decide.

Highlights draw the eye, so an effective way of creating depth is to release the shutter when distant features are brightly lit while the foreground remains in shadow. A scenic view illuminated in this way will encourage the viewer to travel across the landscape and continue towards the horizon. It is also worth considering the focal points and features that you wish to draw attention to, because highlighting them will bring them out. Timing is important: light can change in a split second, so remain poised and ready to respond when the magic moment materializes.

WIDDALE FELL, NORTH YORKSHIRE, ENGLAND

WEATHER

A gloomy day in the Yorkshire Dales was briefly interrupted by a beam of sunlight which illuminated the moorland in precisely the way I had been praying for. There were glimpses of blue in the heavy sky, and where there's a gap in the cloud there is always the possibility of light bursting through. I therefore set up my camera and waited in hope. Forty minutes later my prayers were answered and three exposures were made before the gloom returned.

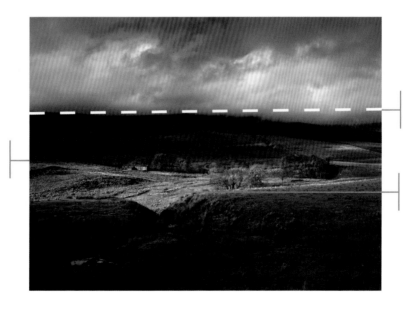

2-STOP (0.6) ND GRAD

FOCAL POINTS

The sunlight illuminates the focal points and reveals the contours of the landscape. This highlighted area is the key element, because without it there would have been nothing to photograph.

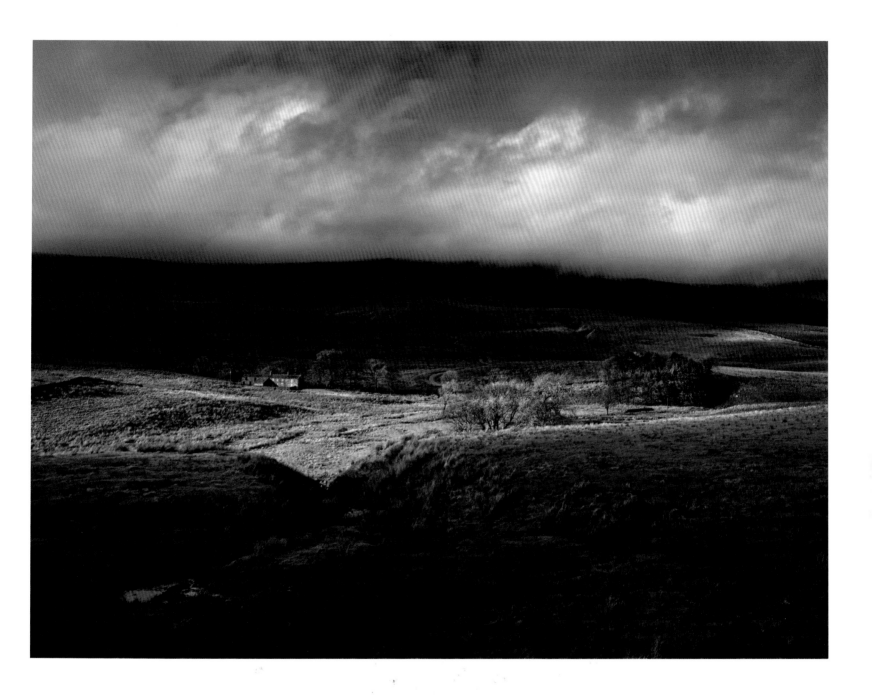

Camera: Mamiya 645 AFD II with Mamiya digital back

Lens: Mamiya 35mm wide-angle

Filter: 2-stop ND grad

Exposure: 1/4sec at f/22, ISO 100

Waiting for the light: 40 minutes

Post-processing: No adjustments

56 USE LESS LIGHT

If light wasn't free and so readily available, it would be used more sparingly. It would be recognized as the valuable commodity it is, and its liberal application would be curtailed. The result of adopting a more frugal approach to its use would be a noticeable increase in image quality. Light is a powerful element, and it doesn't take much of it to make a statement. A splash of light falling across a small feature can be very effective and, when compared to a bright, generally lit landscape, will make a bigger impact.

Both the extent and the position of highlights are important factors in the success of a photograph. In the right place, they can elevate an image and give it a distinctive quality that enables it to stand out from the crowd. However, bright light which is misplaced, or ill-considered, will be a distraction. It will draw attention away from the features around which you have built your composition; your photograph will suffer, and the opportunity to make a distinctive picture will have been missed.

Light is a photographer's paint; apply it to your image in the way a grand master would apply it to a canvas. Use it creatively, in moderation, and the result will be pictures that you can view with pride.

GREAT LANGDALE, CUMBRIA, ENGLAND

TIME OF DAY
The Lake District is an area I have visited many times, and over the years I have gained a rough idea of the best time of day to photograph most of its viewpoints. The aspect of this shot across the valley makes it a mid- or late-afternoon location during either autumn or winter. At that time the sun is low and to the left. In the right conditions, light plays across the mountain to reveal its craggy character. The angle of illumination is perfect, but even so only a little is required. In this image, too much light would have weakened the drama and produced a rather bland picture.

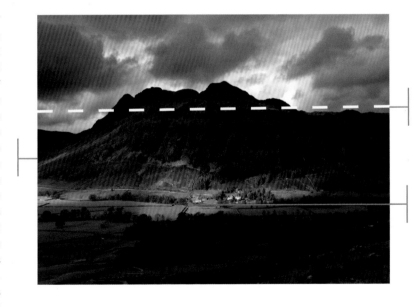

2-STOP (0.6) ND GRAD

LIGHT
A single splash of light is all that is needed to give interest to this type of view. This is an example where less light equals more impact.

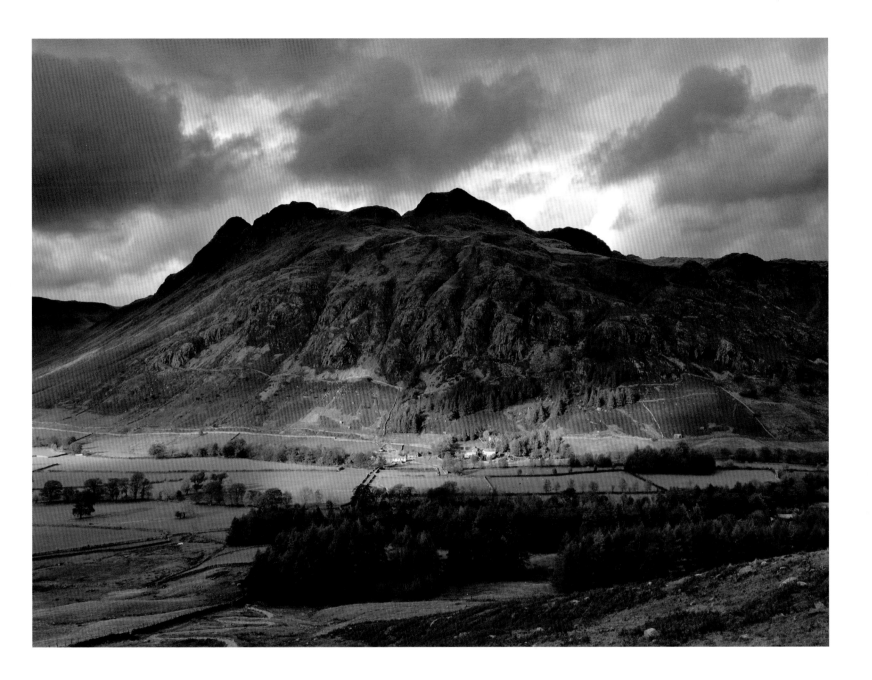

Camera: Mamiya 645 AFD II with Mamiya digital back

Lens: Mamiya 35mm wide-angle

Filter: 2-stop ND grad

Exposure: 1/4sec at f/22, ISO 100

Waiting for the light: 2 hours

Post-processing: Curves and Color Balance adjustment

57 USE BACKLIGHTING

Scenic views are usually best captured when they are lit from one side. This angle of light rarely disappoints, because it gives shape and modelling to a landscape, but there are times when a more adventurous approach might be worth considering. Backlighting (when the sun is in front of the camera and behind the subject) can sometimes give images a vibrant, dynamic quality and bring an added dimension to what might otherwise be an unremarkable location. At its best it can be exquisite, but if it is not used with the greatest of care it can ruin a picture.

When the sun is shining towards the camera there is always a risk of lens flare, and the only way to eliminate it is by preventing the sunlight from falling directly onto the lens. With a partially cloudy sky you can let nature do the work and simply wait for passing cloud to obscure the sun. This, in fact, is often worth doing anyway, because it will improve the appearance of the sky and will help to reduce contrast, which can be high in a backlit scene.

There is a common misconception that backlighting requires the sun to be directly in front of the camera, but this is not the case. One of the most beautiful types of illumination is a combination of side and back light, when the sun is only partly in your angle of view. For many landscapes this is my preferred light, as it casts shadows both across and very slightly in front of the subject. This emphasizes shape, texture and depth, and also creates less contrast. It can, for many landscapes, be very effective.

UPPER SWALEDALE, NORTH YORKSHIRE, ENGLAND

2-STOP (0.6) ND GRAD

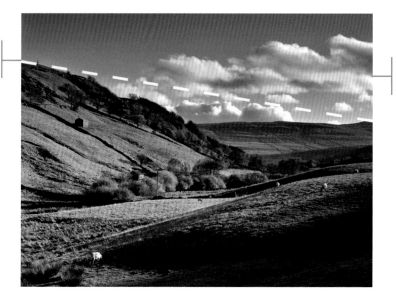

LIGHT

The sun is just out of view. It is also low in the sky, and this position produces a combination of back and side light with long shadows. This gives depth to the landscape, which is further strengthened by the shaded foreground. The partial backlighting reveals the rich fabric of the hillside, which adds foreground interest.

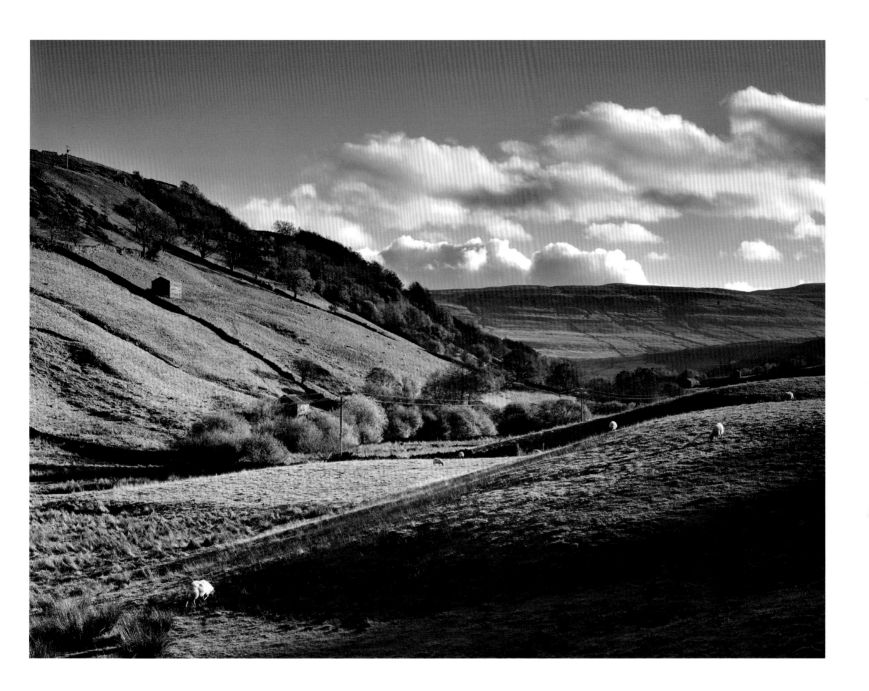

Camera: Mamiya 645 AFD II with Mamiya digital back

Lens: Mamiya 35mm wide-angle

Filter: 2-stop ND grad

Exposure: 1/8sec at f/22, ISO 100

Waiting for the light: 30 minutes

Post-processing: No adjustments

58 AVOID LENS FLARE

You will quite possibly have seen pictures that have been affected by lens flare. It can appear as circular or polygonal bright spots, or can sometimes be randomly scattered across an image, reducing contrast and colour saturation. It doesn't look attractive and should always be avoided. It occurs when a beam of bright light strikes the camera lens, and the only way to avoid it is to prevent this from happening.

One solution is to use an umbrella or some other form of shade to cast a shadow onto the lens, but take care to avoid it creeping into your picture, particularly when using a wide-angle lens — an umbrella in a corner of the frame will not enhance your composition! A cable release will be useful because it will enable you to stand away from the camera, and you can then check that no direct sunlight is falling on the lens.

Beware also of flare caused by reflected light, particularly if there is water present. Wet rocks and still water are very efficient reflecting surfaces, so lakes and rivers can often be the source of very strong reflections. A slight change in camera position is sometimes all that is necessary; alternatively, if there is cloud present you could wait for the sun to be partly hidden by it.

BUACHAILLE ETIVE MÒR, RANNOCH MOOR, SCOTLAND

VIEWPOINT
After a challenging scramble across treacherous rocks to the middle of the river, I found what I thought was a perfect viewpoint. At other times of day it might have been — but at that particular moment there was a bright reflection on the water in the middle distance. Not only was it unsightly, it was also causing lens flare so, reluctantly, I had to change position. However, on this occasion I had to be thankful for that reflection because the new viewpoint was, if anything, slightly superior. Without delay I composed the image using portrait format, which made the most of the attractive foreground, fitted a polarizer to strengthen the colour of the sky and water, and made three exposures. Minutes later a heavy shower interrupted my search for more pictures but, with one photograph safely captured, the day had by that point been successful.

POLARIZER, FULLY POLARIZED

POSITION
From my original viewpoint there was a bright reflection on the water's surface. Lens flare was avoided by making a small change in camera position.

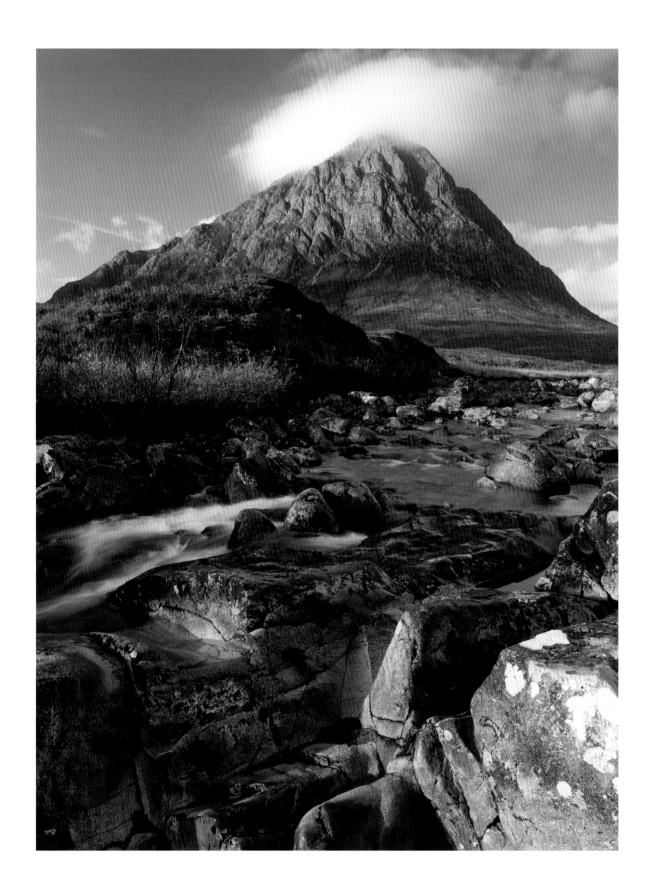

Camera: Mamiya 645 AFD II with Mamiya digital back

Lens: Mamiya 35mm wide-angle

Filter: Polarizer

Exposure: 1/5sec at f/22, ISO 100

Waiting for the light: Immediate

Post-processing: Selective Color Saturation adjustment

59 PHOTOGRAPH DURING THE GOLDEN HOURS

Ask any landscape photographer their favourite time of day, and they are likely to tell you it is the hours around dawn or dusk. This is the time when the quality of light reaches its peak as the low sun illuminates the land with long fingers of gentle highlights. These are known as the 'golden hours', although this is slightly misleading because the truly golden periods can often be counted in minutes or sometimes even seconds. The absolute peak moment can be short-lived and the timing of its arrival is unpredictable (although it always occurs near the beginning and end of the day). To avoid missing it, arrive early and watch and wait as the sun rises (or falls).

During these times the sun has relatively little strength and produces warm, slightly diffused light and long shadows. Contrast levels are also low, which enables detail to be retained across a wide tonal range. It is a very flattering light and, when combined with mist and a magnificent sky, can elevate the most basic landscape to something truly spectacular.

Refer to sunrise and sunset timetables and photograph around these times. Your efforts will be well rewarded!

PARIA CANYON WILDERNESS, UTAH, USA

TIME OF DAY
This view of the Paria Mountains was captured during the last 20 minutes of daylight. This was the time of day when the sun's position best suited the aspect of the viewpoint. The sun in this image is low and at an angle of 90°. Although still bright, it has lost a lot of its intensity and taken on a warmer colour. This has given the landscape a softly glowing radiance and enabled detail to be recorded in both highlights and shadows. Earlier in the day the contrast level would have been too high, resulting in blown-out highlights and overly dark shadows. The higher position of the sun would also have had a flattening effect on the terrain.

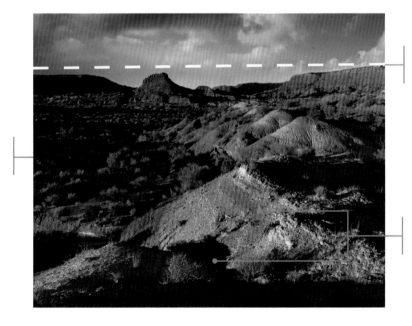

2-STOP (0.6) ND GRAD

LIGHT
Capturing this view during the 'golden hour' has enabled detail to be recorded in both the brightest and darkest parts of the image.

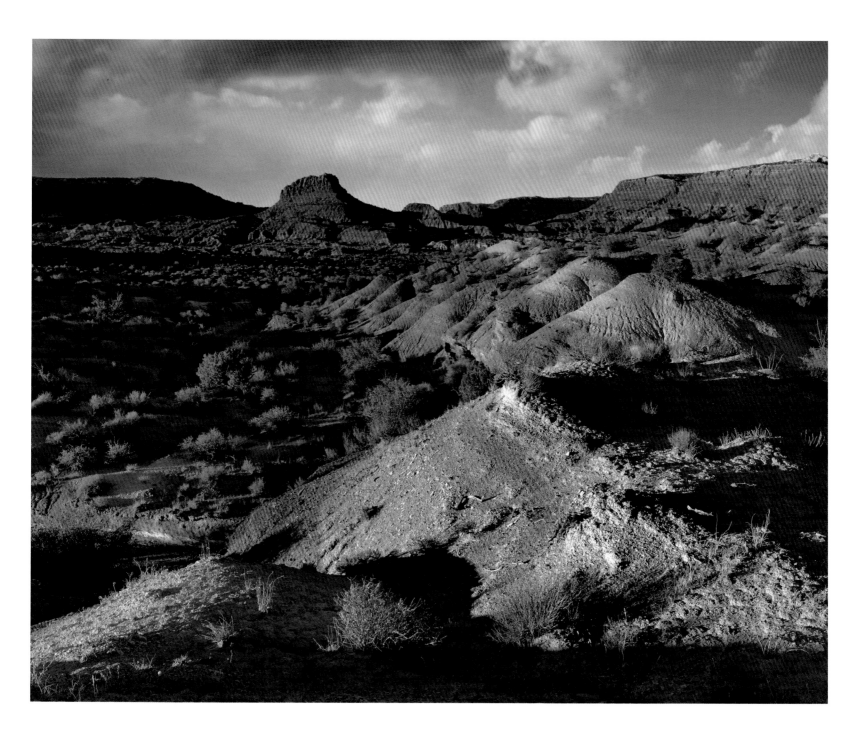

Camera: Mamiya 645 AFD II with Mamiya digital back

Lens: Mamiya 35mm wide-angle

Filter: 2-stop ND grad

Exposure: 1/2sec at f/22, ISO 100

Waiting for the light: 50 minutes

Post-processing: Color Balance adjustment (warming)

MAKE THE MOST OF SUNSET

Sunsets have been, and always will be, an irresistible subject for visual artists. Photographers from every corner of the world are drawn by their colourful displays. What makes them so compelling is the fact that no two are ever the same. Day after day (weather permitting!) you could keep returning to the same place and always see something different. So, how do we best capture their magnificence?

The critical factor is the cloud formation. Ideally there should be a scattering of small, white clouds floating above a clear horizon. As the sun sinks, the clouds will begin to glow with increasing intensity, in hues of golden-red and pink which can contrast quite superbly with the darkening blue sky. The quality of the sunset depends on the amount and structure of the cloud: a sky that is too heavy will obscure the sunlight, while a light, airy cloud structure will lack impact.

A sky on its own may not make a complete picture, so for maximum effect a sunset should usually be supported by other features. A large expanse of silhouetted landscape will not look appealing, so avoid this by using a graduated neutral-density filter. A 2-stop grad will probably be strong enough to enable some detail to be retained in the land. It is important that the twilight atmosphere is preserved, so underexposure is preferable to overexposure.

Finally, don't rush off too soon. The display can reach its peak several minutes after the sun has disappeared, so wait until you are absolutely certain that you have captured the optimum moment.

LOCH TUMMEL, PERTHSHIRE, SCOTLAND

CLOUDS
The cloud structure in this picture is by no means perfect but it is relatively clear along the horizon, which is the most important part. A clear horizon will enable the sun's rays to reach higher clouds, whereas a cloudy horizon will probably prevent any display at all.

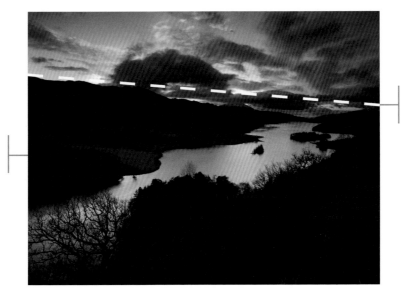

2-STOP (0.6) ND GRAD
A graduated ND filter has reduced the brightness of the sky and enabled a small amount of detail to be recorded in the landscape. This has prevented it appearing as a silhouette, which would have been unsightly.

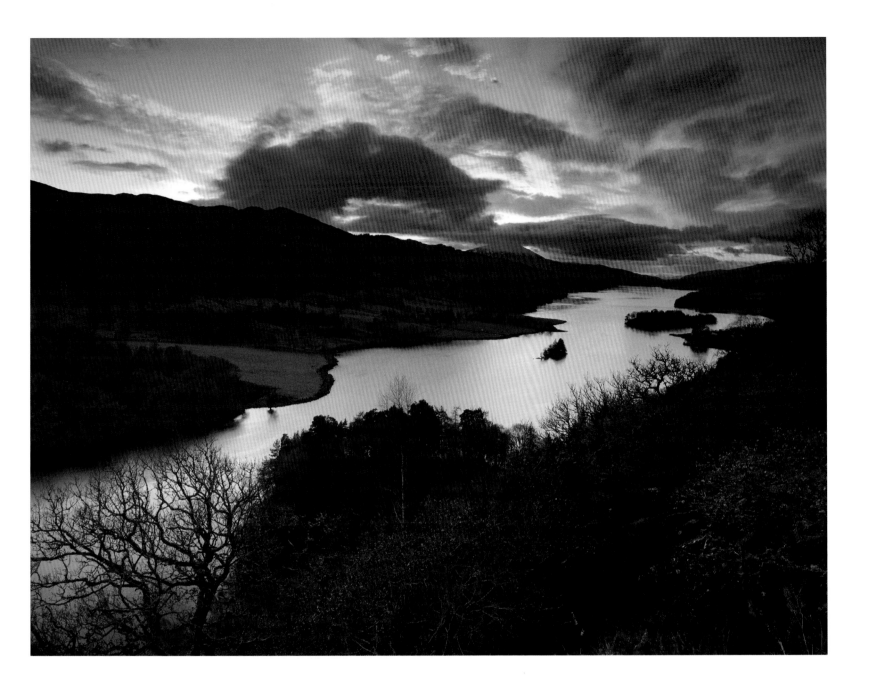

Camera: Mamiya 645 AFD II with Mamiya digital back

Lens: Mamiya 35mm wide-angle

Filter: 2-stop ND grad

Exposure: 1/5sec at f/22, ISO 100

Waiting for the light: 45 minutes

Post-processing: Color Balance adjustment (warming)

THRIVE IN DULL WEATHER

Landscape photography is a challenging and unpredictable pursuit. The unexpected happens all the time, and from one day to the next you never know what you might encounter. The reason for this is, of course, the weather. Its capricious nature can be frustrating, but it is a fact that inclement conditions provide the greatest opportunity for making distinctive images. Photographers often give up in bad weather because of discomfort or lack of persistence. If you are adequately equipped and physically and mentally prepared for the day, then you will immediately improve your chances of success.

There is always something to photograph, so choose your subjects according to the prevailing conditions. Dull, overcast days are perfect for close-ups and for rivers and waterfalls. If storms are brewing, look for seascapes and expansive views that will allow you to fill the frame with a powerful sky, capturing the drama and impact that this type of weather produces. During winter, snow and frost bring a new dimension to the landscape. Distant views can be atmospheric, and on a smaller scale, frost-covered leaves and patterns on frozen water can make intriguing subjects.

Don't be deterred by bad weather. Tailor your photography to the conditions, and you will find images. Remember that it takes just a few seconds of sunlight bursting through a cloud-filled sky to lift the gloom and provide you with the opportunity to capture an image that will make the entire rain-filled day worthwhile.

PORTH NANVEN, CORNWALL, ENGLAND

LIGHT
On the day this picture was captured, the landscape was obscured by mist and intermittent drizzle. It wasn't the weather for distant views, but it suited smaller-scale, colourful subjects which can – and, indeed, usually should – be captured in soft, shadowless light. I therefore spent the day rummaging around the boulder-covered beach at Porth Nanven, searching for images among the sprawling mass of fascinating rocks.

SHADOWS
In spite of the overcast sky there are still subtle highlights and shadows in this image. They are sufficient to give depth and shape to the boulders without interfering with the subtle tonal range.

TONE
The delicate hues of stones can be lost in bright sunlight, so shadows and highlights should be avoided. In order to capture the full tonal range, contrast levels must be low, and gloomy weather is therefore perfect.

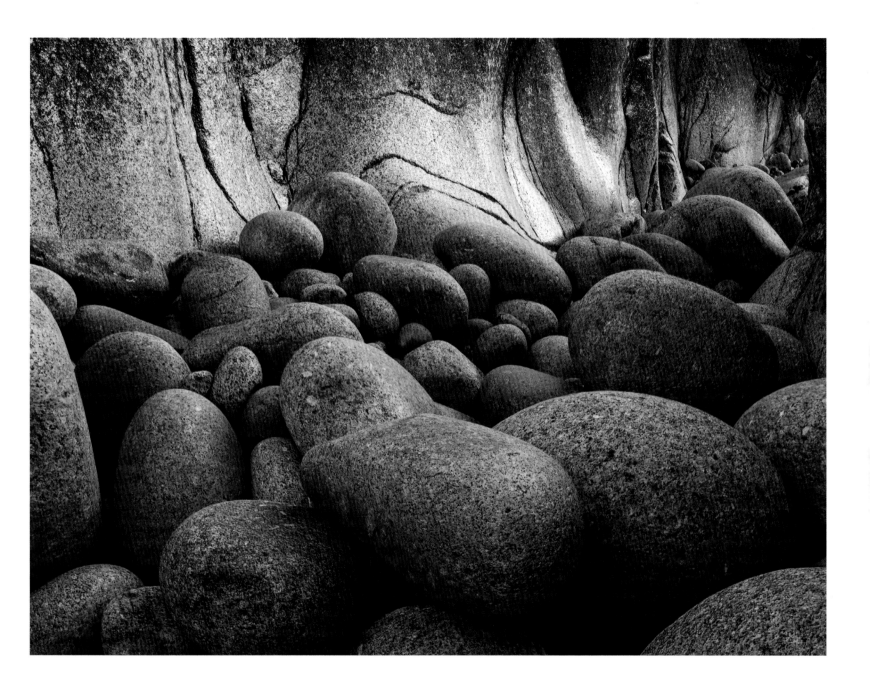

Camera: Mamiya 645 AFD II with Mamiya digital back

Lens: Mamiya 35mm wide-angle

Filter: None

Exposure: 1/2sec at f/22, ISO 100

Waiting for the light: Immediate

Post-processing: No adjustments

CREATIVITY

Successful landscape photographers view the world in a particular way. Instead of seeing what everybody else sees, they discern shapes, patterns and repetitions. They recognize the potential for making original images because they don't just see what's in front of them – they observe, and an observant photographer is a creative photographer. The following pages will guide you through the process of developing your photographer's eye and explain the technique of creative observation and interpretation of landscape subjects.

PORTHCURNO, CORNWALL, ENGLAND

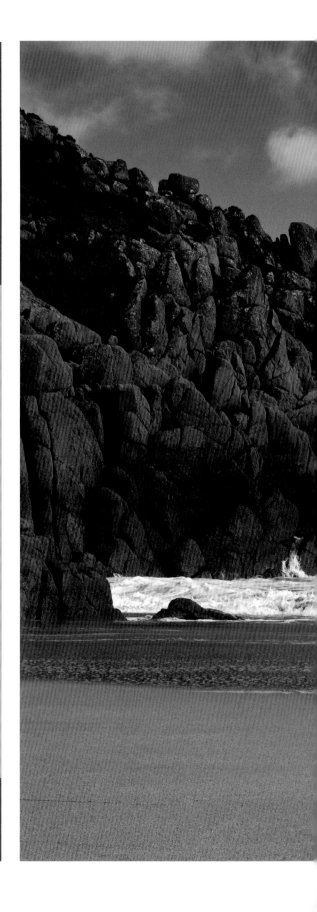

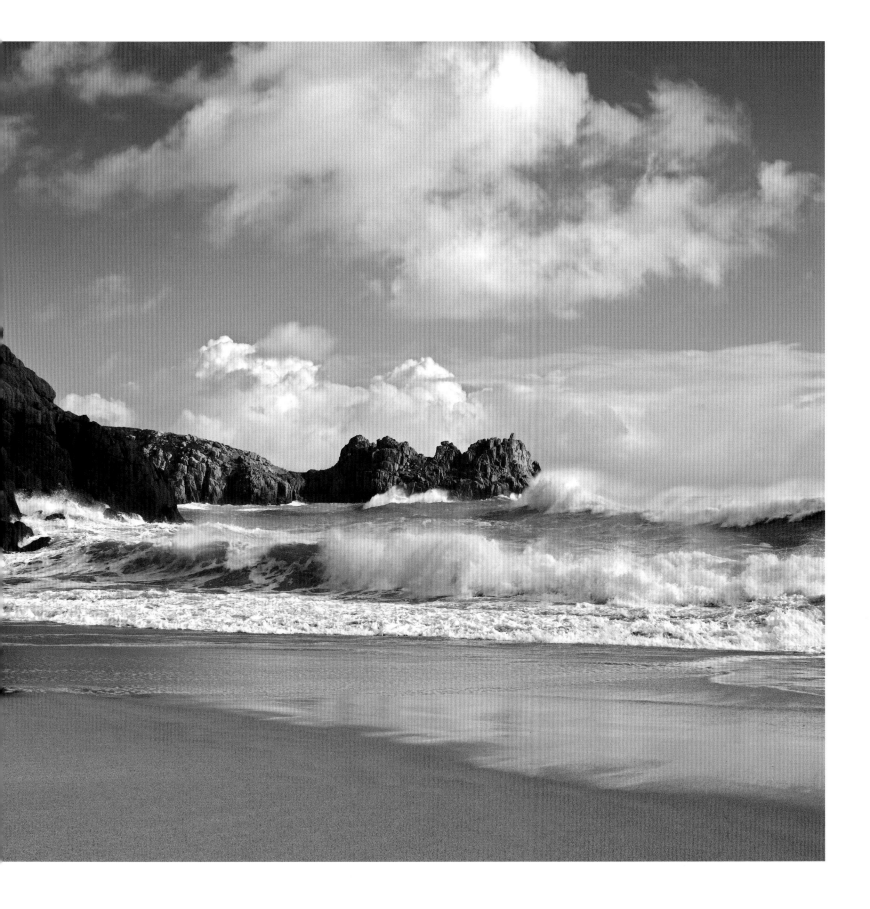

62 DEVELOP YOUR EYE

When you look at the landscape, what do you see? Fields? Mountains? Trees? Lakes? These are the obvious features, but look more closely and ignore the reality of objects; observe instead their shape and outline, search for flowing lines and repeating patterns. These are what matters in a photograph; they are the building blocks of composition, and it is important to gain an awareness of them.

When seen as a two-dimensional image, the landscape consists of lines, contours, textures and colours. The success of a photograph is determined by how these basic elements are observed and used. When searching for pictures, therefore, train yourself to view the landscape in its simplest form and break it down into these elements. Once you perceive them you will be one step closer to making original, creative photographs.

Pictures can be found anywhere but they are not always obvious, and keen observation will be necessary if they are to be discovered. It is a skill, but it is not an inborn talent, and with practice and experience you can develop your eye to spot the opportunities.

PORTH NANVEN, CORNWALL, ENGLAND

IMAGINATION
The beach at Porth Nanven is covered with large, colourful boulders which date back over 100,000 years. This fascinating site offers endless photographic opportunities. It is a location where both distant views and close-up images can be captured with equal success. There are many options, which are limited only by your imagination.

ABSTRACTION
In this picture I have made a semi-abstract composition based on shape, colour and texture. My objective is always to produce something original, and I hope I have achieved that with this image.

POSITION
I used an elevated shooting position with the camera pointing very slightly down, to ensure that the top edges of the background rock were excluded from the composition. For the image to succeed, the background had to be an unbroken, solid expanse of colour with no distracting intrusions.

COMPOSITION
Moving in close and capturing just a small part of a subject can often produce an image that is more revealing than a large, open view. Here, just a tiny snippet of a boulder-covered beach portrays, in my opinion, the location's striking character.

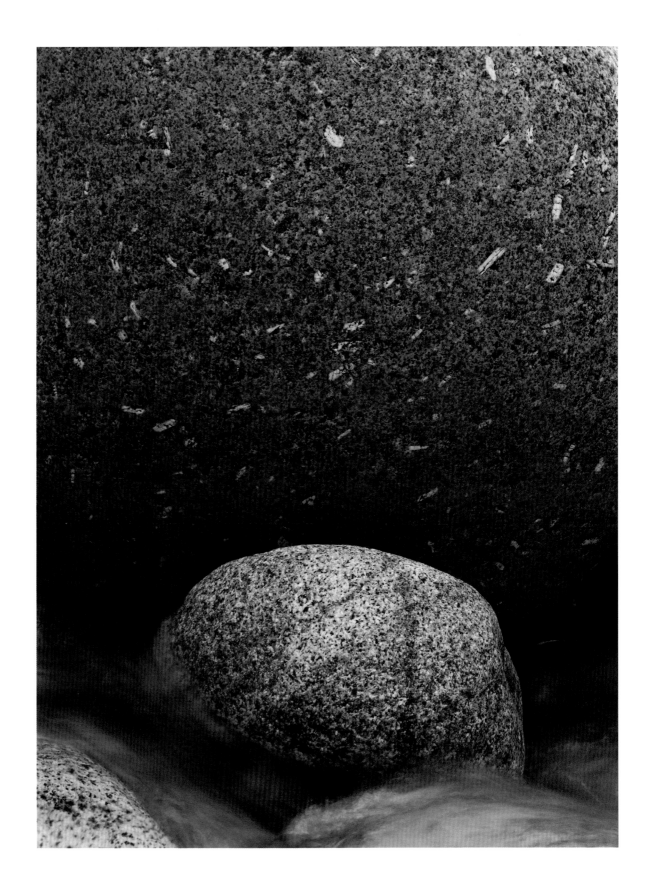

Camera: Mamiya 645 AFD II with Mamiya
digital back

Lens: Mamiya 35mm wide-angle

Filter: None

Exposure: 1sec at f/22, ISO 100

Waiting for the light: Immediate

Post-processing: Curves and Color
Balance adjustment (warming)

63 LOOK FOR NATURE'S PATTERNS

There is more to the landscape than might at first glance be obvious. There are, as we have seen, patterns and details which will become apparent under the scrutiny of an observant eye. These small-scale 'landscapes within landscapes' can make intriguing images both as abstract and realistic portrayals of a subject.

When an object is viewed close up, its colours and textures will become prominent and interesting compositions can be built around subtle tonal variations and intricate shapes. These types of picture can be found anywhere, but coastal locations are among the best sources. The flora found in these areas is very photogenic and offers great scope for

creativity, as do weathered stones and boulders. Cliffs and rock faces are also worth exploring, but close scrutiny is required because tiny details can be hidden away in cracks and crevices.

These types of subject tend to look their best in soft light and are therefore perfect for capturing on dull, overcast days. Highlights and shadows should not, generally speaking, be present. If surfaces are wet they can be highly reflective, even in flat lighting, so it might be worth using a polarizer. This filter will improve the appearance of your subject by suppressing highlights and strengthening colour. It is a very effective accessory and I strongly recommend it.

KINGSTOWN BAY, GALWAY, IRELAND

CHALLENGE

I have always found seaweed to be a difficult subject. Rich in colour and texture, it should in theory be easy to photograph, but I had never managed to capture an image that I liked. It was proving to be a challenge, but finally my luck changed with a visit to Kingstown Bay on the west coast of Ireland.

COMPOSITION

The difficulty with seaweed is its tendency to grow in shapeless clumps. For a close-up image to have aesthetic appeal, the composition must have a pattern or shape which is easy on the eye. Without a perceivable structure it can appear as no more than a meaningless patch of colour; but after much searching and experimenting I finally found an arrangement that had the basic design I was seeking. The combination of the two quite different colours and textures in two distinctive shapes gives the photograph a balanced appearance which has, I believe, a degree of visual appeal.

Camera: Mamiya 645 AFD II with Mamiya
digital back

Lens: Mamiya 35mm wide-angle

Filter: None

Exposure: 1/4sec at f/22, ISO 100

Waiting for the light: Immediate

Post-processing: Highlight reduction

BROADEN YOUR BOUNDARIES

There is no such thing as a typical landscape. As a source of photographs the landscape has no boundaries; it can be any type of object or feature because it is whatever you, as the photographer, decide to capture. If you deem something to be a worthy subject for your camera, then don't hesitate – photograph it. What it actually is should have no bearing on your assessment of its photogenic qualities. If you like its appearance, then there is a good chance that other people will like it too; so at that point you have the makings of a successful image.

You can also increase your options by making abstract pictures. There is no limit to the number and type of photographs you can make. The objective is to find compositions that engage the eye without bombarding the viewer. Too much information can be confusing, so as a general rule choose a subject that either has a narrow colour spectrum or a readily discernible pattern (or both). The picture has to have instant appeal, so keep the arrangement simple and you will increase your chances of making a successful image.

PARIA CANYON WILDERNESS, UTAH, USA

OPTIONS
The baked earth of the Arizona desert provided me with an opportunity to make an image in complete contrast to the more obvious attractions. Surrounded by the majestic peaks of the Paria Mountains, I had been concentrating on capturing distant views; but there are always other options so, for the sake of variety, I started to search for pictures on a smaller scale.

DIFFUSION
The diffused light and restricted colour palette are the important factors in this image. They enable the detail of the flaking mud to be viewed without other distractions.

COMPOSITION
I was attracted by the pronounced three-dimensional appearance of a small stretch of parched mudflats. Their curls and subtle variations of colour and texture made, to my eye, a striking image; so, with the aid of an umbrella to soften the harsh sunlight, I captured just one tiny section. This close-up composition has, I believe, portrayed the character of the landscape more effectively than could have been achieved by capturing any number of distant views.

Camera: Mamiya 645 AFD II with Mamiya digital back

Lens: Mamiya 35mm wide-angle

Filter: None

Exposure: 1/5sec at f/22, ISO 100

Waiting for the light: Immediate

Post-processing: Curves and Color Balance adjustment (warming)

65 USE REPETITION

Images based on a theme of repeating shapes and patterns can be striking and their presence can give a photograph great impact. Repetition is everywhere in the rural landscape – think, for example, of regimented rows of trees, or the graphic lines of emerging crops. These are relatively easy to spot, but it often takes a little scrutiny and creative observation in order for the more abstract opportunities to be found.

When searching for this type of picture, the first point to bear in mind is that repetition does not require objects to be identical. This is a common misconception and it can lead to potential photographs being overlooked.

For an image to be successful, all that is required is an easily discernible repetitive quality; this might consist of a grouping of elements which, provided they are of similar nature, can be of diverse appearance. To prevent this more subtle repetition from being lost on the viewer, the composition and the range of colours should be kept very simple. This will avoid the inclusion of distracting features or interference in the pattern.

Remain aware of the possibility of using repetition as a theme in your photography, and new, previously unseen opportunities will become apparent.

NEAR LARAGH, WICKLOW MOUNTAINS, IRELAND

OPTIONS
I am always attracted to the colourful, richly textured fabric of moorland. Often these sprawling landscapes are depicted as majestic, sweeping views, but there always other possibilities. I was reminded of this as, gazing across the terrain surrounding the imposing Wicklow Mountains, I contemplated a wide range of options.

JOURNEY
Viewer interest is maintained across the image by the positions of the receding stones, which take the eye on a journey from the foreground through to the most distant point. The arrangement of the rocks ensures there is no dead space in the picture.

COMPOSITION
My objective was to portray the character of the distinctive landscape, and after much consideration I chose to capture a simple arrangement of receding boulders scattered across a thickly textured terrain. This, I felt, was preferable to a wider, more general view, which would have resembled a generic landscape.

Camera: Mamiya 645 AFD II with Mamiya digital back

Lens: Mamiya 35mm wide-angle

Filter: None

Exposure: 1/8sec at f/22, ISO 100

Waiting for the light: 40 minutes

Post-processing: No adjustments

66 USE REFLECTIONS

Reflections on the surface of still water are a beautiful source of repetition. They are a powerful compositional aid and can transform an otherwise unspectacular view, particularly when mist, or a hint of it, is present.

The best time to find reflections, and also mist, is at dawn. Wind tends to drop at night, as of course does the temperature, and this combination forms the perfect conditions for a layer of mist to develop over a calm expanse of water. This is when lakes look their magical best; they can be quite stunning, particularly if there is a glimpse of sunlight present.

Water does not have to be perfectly still to create an arresting photograph. You don't always need a mirror image, because a hint of movement can often bring a further improvement; the slight variation it gives to the reflection introduces another dimension, which can add to a picture's appeal. When there is a hint of a breeze, spend a few moments watching the subtle changes in the appearance of the reflections and be ready to make your exposure the moment you think they look most attractive.

LOCH TUMMEL, PERTHSHIRE, SCOTLAND

EQUIPMENT
Nowadays I rarely use more than one filter at a time, but on this occasion both a 2-stop ND graduated filter and a polarizer were employed. The sky, although cloudy, was still brighter than the landscape and water, and to prevent it from being overexposed it was necessary to use the ND grad. This has enabled detail to be retained in all parts of the sky, water and landscape.

COLOUR
The polarizer was used to improve the transparency of the water. This has enhanced the colour and clarity of the stones in the foreground, and has also strengthened the appearance of the distant reflections.

2-STOP (0.6) ND GRAD

POSITION
The sunlight falling on the distant bank is an essential detail. Without that highlight, the foreground would have been too dominant and visual interest would have been lost in the upper half of the picture.

POLARIZER, FULLY POLARIZED

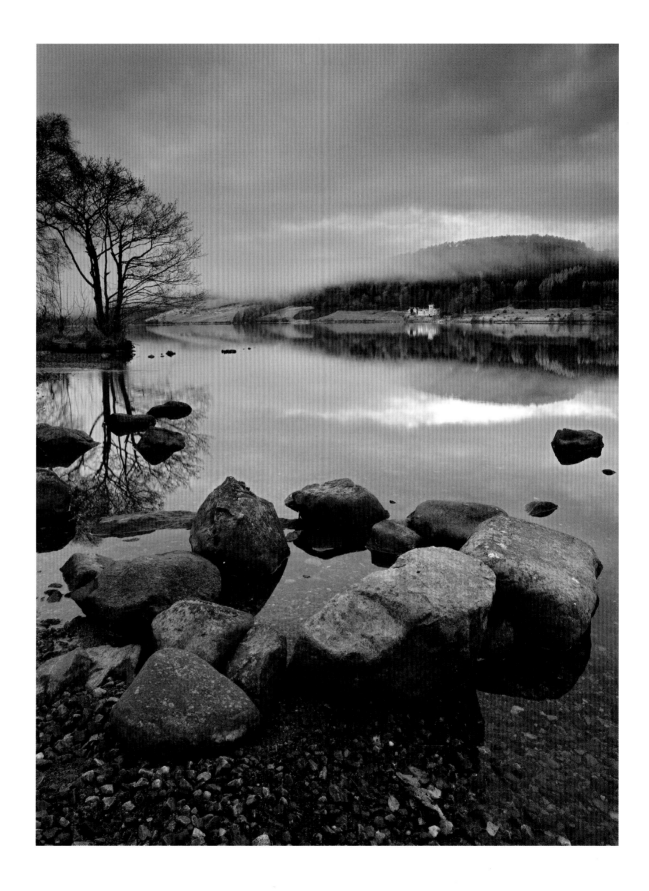

Camera: Mamiya 645 AFD II with Mamiya digital back

Lens: Mamiya 35mm wide-angle

Filters: 2-stop ND grad, polarizer

Exposure: 1/2sec at f/22, ISO 100

Waiting for the light: 1 hour

Post-processing: Color Balance adjustment, highlight reduction

MAKE THE MOST OF FROST AND ICE

Sub-zero temperatures can have a magical effect on the landscape. When frost and ice are present, a transformation takes place and images can emerge almost anywhere. Look for patterns on frozen water, particularly at the edges of lakes. They can provide you with finely detailed foreground, which can look stunning when used as a lead-in to a wider view. Frozen leaves and grass or reeds just below the surface can add to the appeal, so consider using a polarizing filter; it will improve the transparency of the water and can also boost the appearance of the ice patterns.

Frost forming on the surfaces of flora can also be an enticing subject. Look for frozen leaves and photograph them close up to capture the detail of their frost-covered edges. In very cold weather frost can form on virtually any surface. For example, wooden fences and gates in exposed, rural areas can, when frozen, display a richly textured, visually arresting surface which can be the source of interesting and attractive images.

Rivers and waterfalls can also be worth investigating. In the right conditions icicles often form and these can, on their own, make intriguing subjects. The opportunities are endless but they can be short-lived. So, when the temperature drops, brave the elements and make the most of the frosty conditions; you should, with any luck, be well compensated for your efforts.

WEST BURTON, NORTH YORKSHIRE, ENGLAND

SCALE

Groups of icicles are an interesting subject, and in Britain a relatively rare one. Although not particularly difficult to photograph, they can suffer from a lack of scale. Icicles come in all sizes and in the absence of other features their scale can be difficult to gauge. If your intention is to make an abstract composition, then perception of size is not essential; but for realistic pictures the inclusion of another feature is desirable.

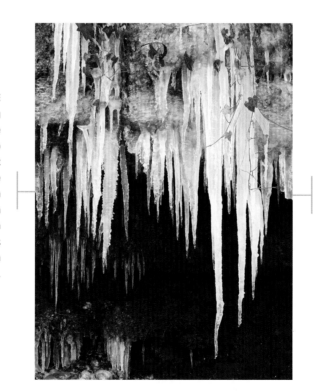

BALANCE

The hanging ivy leaves are an important element of the image. Not only do they provide scale, they also introduce a welcome splash of colour and act as a balance to the rather heavy lower part of the photograph.

Camera: Mamiya 645 AFD II with Phase
One digital back

Lens: Mamiya 80mm standard

Filter: None

Exposure: 1sec at f/22, ISO 100

Waiting for the light: Immediate

Post-processing: Highlight reduction

68 TAKE ADVANTAGE OF FOG AND MIST

Fog and mist introduce a new dimension to a scenic view. A layer of mist creates mood and atmosphere, and in the right conditions it can elevate even the most basic landscape into something quite spectacular. Capture the view at the right time and you are virtually guaranteed to make a successful image. But when precisely is the right time?

The most important factor is the ratio of land to mist. There is a fine balance between the two elements; too much mist will obscure key features, and you will be wondering what it is you're looking at as you contemplate an almost blank canvas, while too little will weaken impact and produce a flat-looking photograph. Conditions can change quickly,

so timing is critical. Choose the moment when you feel that both elements are making a significant contribution to the composition. If there is a hint of sunlight you are in luck, because a burst of light can have a magical effect on a misty scene, particularly if it is backlit.

As discussed on page 150, mist tends to develop overnight as wind speed and temperature drop, and is most likely to form over water. So, visit a picturesque lake at dawn and you might just strike gold: mist, mountains, sunlight, reflections — what better recipe is there for the making of an outstanding photograph?

PITLOCHRY, PERTHSHIRE, SCOTLAND

TIME OF DAY
This image is one of several that I took early one misty autumn morning in the hills surrounding Pitlochry in the Scottish Highlands. The timing of the shot was influenced by the sky, which has an agreeable balance of cloud, light and mist. This, to my eye, is the most successful part of the picture, because the lower portion of the landscape suffers from too high a density of mist. It is completely obscured, and this detracts from the photograph. I waited for the mist to clear, but when it did eventually dissipate it took the atmosphere with it and the moment was lost.

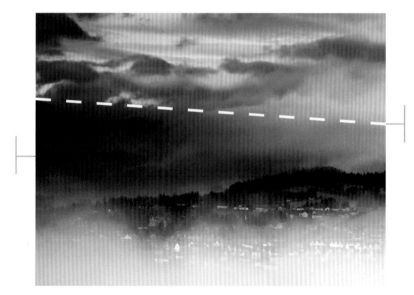

2-STOP (0.6) ND GRAD

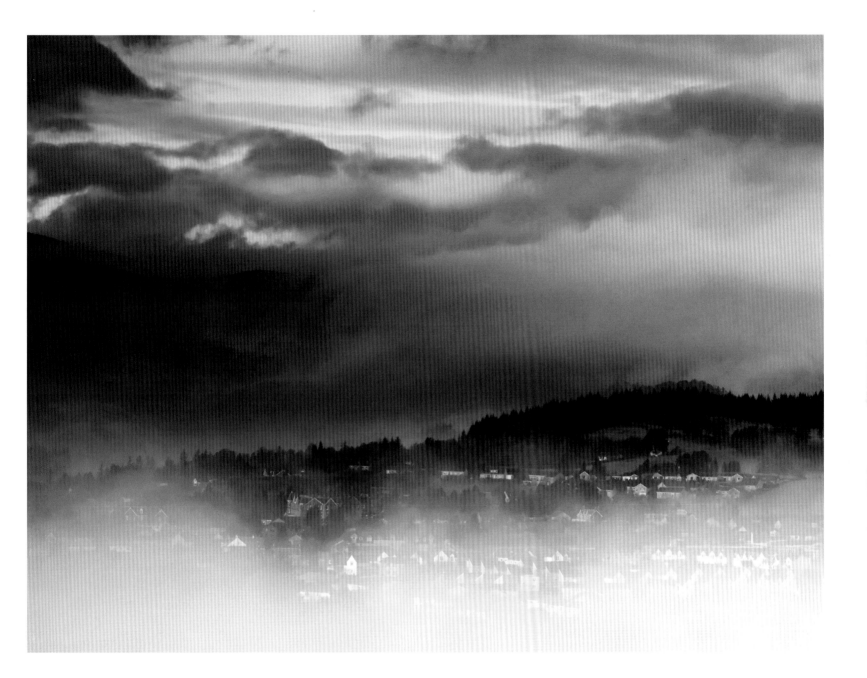

Camera: Mamiya 645 AFD II with Mamiya digital back

Lens: Mamiya 150mm telephoto

Filter: 2-stop ND grad

Exposure: 1/5sec at f/22, ISO 100

Waiting for the light: Immediate

Post-processing: Curves adjustment

69 PHOTOGRAPH MOVING WATER

Waterfalls are a popular subject for the camera – with good reason, because there is something about cascading water that is utterly compelling. Visit a viewing spot for a well-known waterfall during tourist season and you will be fighting for space for your tripod – but it's best to ignore those places anyway, as you can never find a position to make an original image and there are usually better options elsewhere. Often there are many alternatives to be found on a smaller scale, close by but off the beaten track. Search the rivers that lead to the main fall, and you should discover new picture-making opportunities. Look for colourful rock formations and include both rocks and water in your composition. For maximum impact, exclude the sky and ensure there is no dead space in your image: avoid monotonous expanses of plain rock and flat water. Your picture should be filled with interesting features from top to bottom.

To blur water, a shutter speed of between 1/2sec and 2sec will normally give the best results, but don't be afraid to experiment. Try different lengths of exposure and compare the changing appearance of the flowing water; it can be both interesting and educational. To enable long shutter speeds to be selected, it might be necessary to use a polarizer or a neutral-density filter (or a combination of both) to increase the exposure time. You will, of course, also need a sturdy tripod, because any hint of camera movement has to be avoided and riverbeds are not the most stable photographic environments.

AFON COLWYN, SNOWDONIA, WALES

COMPOSITION
The River Colwyn is a location I have visited many times, and I have never failed to find a new image. Like many rivers, its appearance changes with the level of water, and this creates new opportunities. On the day this picture was captured, the river was very low, and many rocks which are normally submerged were visible. This enabled the photograph to be built around an extensive rocky foreground. The waterfall, although of modest proportions, still draws the eye and brings balance to the composition. It is therefore an essential feature in the picture.

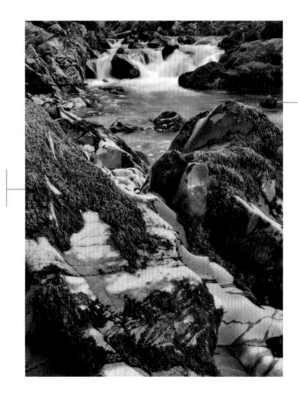

POLARIZER, FULLY POLARIZED
A polarizer was used to absorb excess light and enable a shutter speed of 1/2sec to be selected.

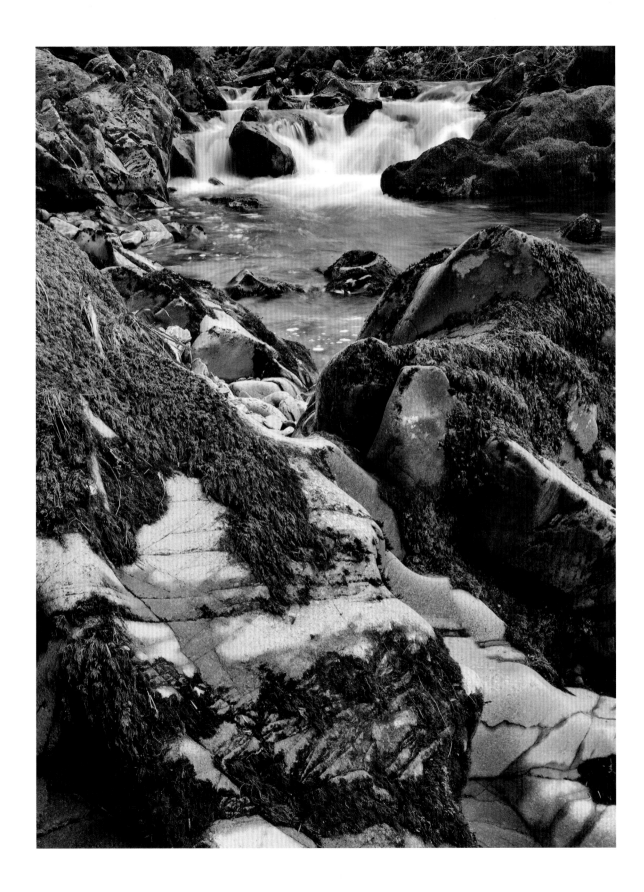

Camera: Mamiya 645 AFD II with Mamiya digital back

Lens: Mamiya 35mm wide-angle

Filter: Polarizer

Exposure: 1/2sec at f/22, ISO 100

Waiting for the light: Immediate

Post-processing: No adjustments

70 MAKE LONG EXPOSURES

Flowing water is not the only element that can benefit from being photographed with a long exposure. The sky, too, can be transformed by capturing it over a period of seconds or, quite possibly, minutes. There is always movement in the sky, even on a calm day, but very long shutter speeds may be necessary in order to depict it. Even at the smallest aperture this will cause images to be grossly overexposed, and to prevent this a very strong neutral-density filter will have to be used. These are not the graduated type; they are equally dense across their entire surface, and their sole purpose is to absorb excess light. They are now available in densities of up to 10 stops, and at that strength they have a dramatic effect on exposure times. For example, if you have an initial reading of, say, f/11 at 1/30sec, the filter will increase shutter speeds as shown in the table.

FILTER STRENGTH (STOPS)	SHUTTER SPEED (SECONDS)
1	1/15
2	1/8
3	1/4
4	1/2
5	1
6	2
7	4
8	8
9	15
10	30

You can see that exposure times double for every 1 stop of light absorption, so with a 10-stop ND filter we have increased an initial exposure of 1/30sec to 30 seconds. At the beginning and end of the day, when light levels are low, shutter speeds of several minutes are possible, so experiment with strong ND filters and watch how they can bring an ethereal, dreamlike quality to your images.

ABERDESACH, GWYNEDD, WALES

6-STOP ND FILTER

2-STOP (0.6) ND GRAD

FILTERS
There was quite a strong wind blowing at the time I made this photograph of the coast at Aberdesach, so a shutter speed of 30sec was sufficient to produce the desired effect. A 6-stop ND filter was used to prevent overexposure, and a 2-stop ND graduated filter was also added to balance the light values across the sky and foreground stones. I calculated exposure by taking an initial meter reading without the ND filter, then manually increasing it by 6 stops.

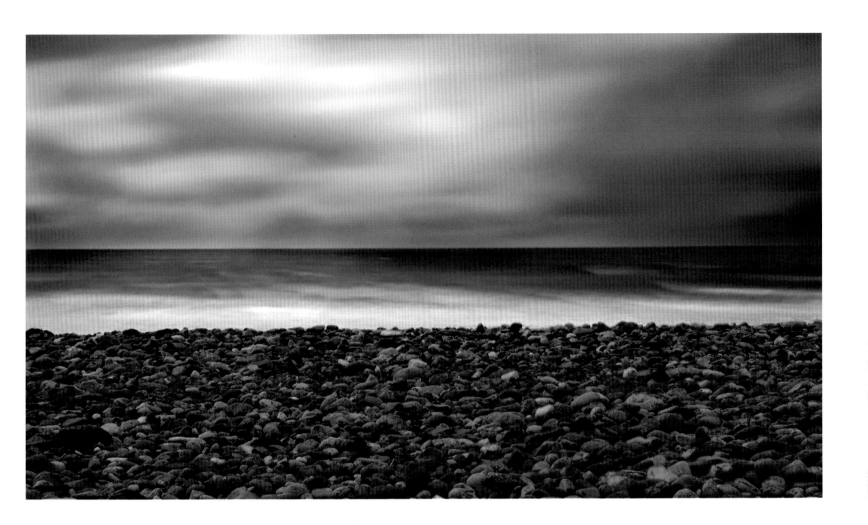

Camera: Mamiya 645 AFD II with Mamiya digital back

Lens: Mamiya 150mm telephoto

Filter: 2-stop ND grad, 6-stop ND

Exposure: 30sec at f/22, ISO 100

Waiting for the light: 50 minutes

Post-processing: Curves adjustment, highlight reduction

71 CAPTURE URBAN ELEMENTS

When we think of landscape, what normally comes to mind are images of mountains, fields and rolling hills. Rarely does the urban landscape register as a source of pictures; but it should not be dismissed, because it can be just as bountiful as its rural counterpart. Buildings – particularly those showing signs of age – can make attractive subjects, as can close-ups of small architectural details and features.

Look for graphic, shape-based compositions and interesting combinations of colour and texture. Repetitive and regimented shapes – a sweeping flight of steps, a row of identical buildings or perhaps a street of cobblestones –

are potentially very rewarding subjects. As always, observation is the key to finding images. As you stroll through towns and cities, look carefully at your surroundings and be aware of the possibilities. The older parts of towns tend to be the most promising, so delve into narrow streets and alleys and think creatively. With a keen eye, you will find pictures.

Cityscapes and sweeping views are also worth considering. Often the best time to capture them is at dusk, when there is still some light and colour in the sky. For a short period the brightness of the city lights and sky will be evenly balanced and, with the right timing, the results can be quite exquisite.

NEWLYN HARBOUR, CORNWALL, ENGLAND

CHARACTER

Newlyn Harbour may not be considered one of the major attractions of the superb Cornish coast, but within minutes of my arrival I realized that hidden away among the weathered sheds and workshops was a gold mine of potential images. Old buildings have always appealed to me, and I will happily spend several hours investigating their nooks and crannies in the hope of finding a picture. It wasn't long before I discovered a gloriously dilapidated shed which displayed a perfect combination of colours, textures and shapes. The derelict structure shown here was a ready-made photograph and there was little to do other than set up my camera and tripod, focus and release the shutter.

BALANCE

This composition was based around the three light bulbs. For balance, I felt they had to be uniformly positioned across the picture. Fortunately this placed the window off-centre, but it is perhaps slightly more to the left than it should be.

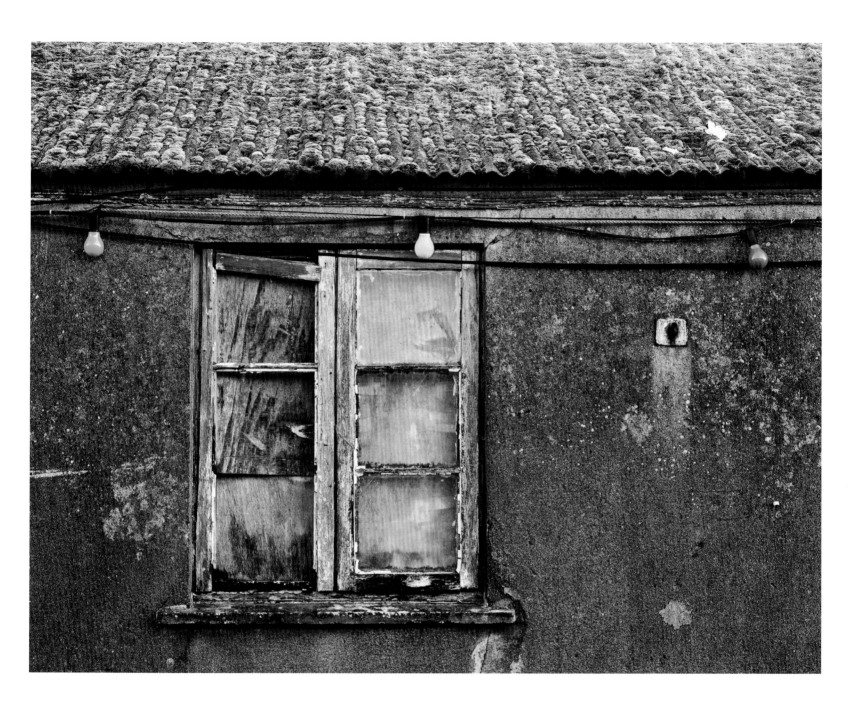

Camera: Mamiya 645 AFD II with Phase One digital back

Lens: Mamiya 80mm standard

Filter: None

Exposure: 1sec at f/22, ISO 100

Waiting for the light: Immediate

Post-processing: No adjustments

72 CONSIDER THE SKY AS A SUBJECT

When the sky appears in a photograph, it is perceived as being as solid and tangible as any other part of the picture and it is just as important. It is a powerful feature and can also be very beautiful, but despite this it is often overlooked because its potential is not always appreciated. To avoid missing opportunities, it therefore pays to maintain an awareness of what is happening above you.

The sky can play three roles. First, it is included as a secondary (but still important) element, in which case it will occupy a relatively small part of the composition. Secondly, it can be used to transform a mundane landscape into something worth photographing, in which case it becomes more dominant and often fills the majority of the frame, with the landscape playing a minor role and appearing as just a thin strip along the bottom of the picture. Then, very occasionally – if it is truly spectacular – it can play its third role, standing on its own and acting as the only feature.

The sky's appearance is constantly changing and the possibilities are endless. The most promising times are, of course, dawn and dusk. This is when the sky is at its most colourful, with a warm, glowing radiance that is unique to these hours. The rest of the day should not be dismissed, however, because intriguing cloud formations can appear at any time, particularly in stormy conditions. It is a fascinating subject, so keep looking skywards and you might just be rewarded with a heaven-sent opportunity to capture a memorable image!

BRITTANY, FRANCE

FOCAL POINT
The sky is one of the easiest subjects to photograph. Composition is straightforward – you just capture the best part! – and no tripod is necessary because you can use a fairly wide aperture and a fast shutter speed. No filters are required, except perhaps a polarizer, so basically you just point and shoot. This was the case with this image. There had been no indication that the clouds would part the way they did to reveal the crescent moon, and I had to react quickly. Its presence is the essential feature: it acts as a focal point and elevates the sky to such an extent that it was worth capturing on its own account.

Camera: Mamiya 645 AFD II with Mamiya digital back

Lens: Mamiya 35mm wide-angle

Filter: None

Exposure: 1/30sec at f/11, ISO 100

Waiting for the light: 30 minutes

Post-processing: Color Balance adjustment (warming)

AIM FOR QUALITY, NOT QUANTITY

Does 'E6' mean anything to you? No, it's not a vitamin or food additive, it is, in fact, a photographic process for developing colour reversal film, and it is a process with which I am very familiar because my conversion to digital photography has been relatively recent. Prior to that, I used 5 x 4in sheet film; it was slow and cumbersome and expensive, each sheet of processed film costing the equivalent of a medium-capacity memory card. The result was that film wasn't wasted: every exposure was carefully considered and the shutter released only when I was absolutely certain that everything was right and there was definitely a picture worth taking. My output was low – often I would make no more than ten exposures in a week – but I was never disappointed with the images. The objective was to achieve quality, not quantity – and I still adopt this approach, despite my switch to digital.

The digital capture of pictures requires a different technique, and making several exposures of the same subject is now the norm; but quantity should never be allowed to replace quality. No photographer has ever gained a reputation or won any accolades by creating a high volume of work, because it is quality that matters. Make this your priority.

CORREIAS, ESTREMADURA, PORTUGAL

OBSERVATION

I can spend hours strolling around medieval towns and villages. Potential subjects can always be found in the streets and alleyways, and it can be tempting to embark on a picture-taking spree. I have in the past succumbed to this temptation and have ended up with countless images, none of which were particularly outstanding. To avoid this trap I now leave my camera locked in my car while I make an initial exploration of the town.

EXPOSURES

I limit myself to making only one or two exposures, and this concentrates the thought process. I look for perhaps just one picture that captures the essence and character of a town. Having made a thorough exploration of Correias, a small village in northern Portugal, I captured this colourful wall after considering other possibilities. It seemed to fit the bill perfectly.

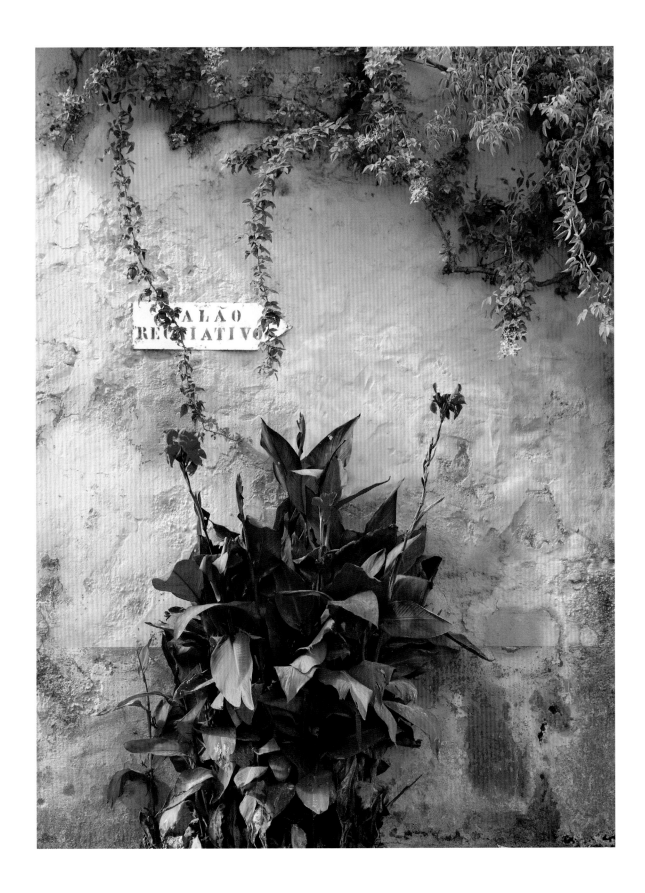

Camera: Mamiya 645 AFD II with Mamiya digital back

Lens: Mamiya 35mm wide-angle

Filter: None

Exposure: 1/10sec at f/18, ISO 100

Waiting for the light: Immediate

Post-processing: No adjustments

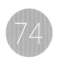

SEEK INSPIRATION

I have been a photographer for many years, and have been fortunate because I have never lacked the motivation to venture into the landscape and search for new images. I, like many photographers, find the pursuit of creating new pictures compelling. Perhaps it is the thrill of the chase, the challenge, and the euphoria that follows the capture of that fleeting, unexpected moment when nature's elements combine to absolute perfection (it does happen occasionally!). However, despite all this I still seek inspiration. Without it, I think there is a risk of lapsing into complacency and settling into a comfortable routine. There should always be something to strive for, and I find it helps to look at the work of other artists – both photographers and painters – and make comparisons with my own efforts. I like to be objective, but sometimes emotion takes over and I see an image that makes an impact and acts as a stimulus; and that, to my mind, is one of the great attractions of visual art.

Pictures of all types can be inspiring and act as a catalyst to creativity. Seek inspiration by visiting art galleries and exhibitions and viewing the images of other photographers and artists – it can only help your photography.

KILKIERAN BAY, GALWAY, IRELAND

COLOUR
Colour, as discussed earlier, is a powerful force in photography. It can form the basis of distinctive pictures, but its ubiquity can cause it to be overlooked. Surrounded by colour, we become immune to it; it fails to register, and opportunities for creative image-making are lost. I was reminded of this at the time this exposure was made, because I had been studying a book on minimalist art. My senses had been sharpened by some of the book's images, and the result was that potential photographs, which I might have previously overlooked, began to manifest themselves. This picture was, therefore, the result of inspiration gained by viewing other artists' work.

MINIMAL PALETTE
A restricted colour palette paired with minimalism is potentially a very effective combination. Together they allow elements such as patterns, shape and texture to become prominent, and the result can be original and memorable images.

Camera: Mamiya 645 AFD II with Mamiya digital back

Lens: Mamiya 35mm wide-angle

Filter: None

Exposure: 1/6sec at f/22, ISO 100

Waiting for the light: Immediate

Post-processing: Curves adjustment

IMPROVING THE CAPTURED IMAGE

LESSONS

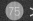 >>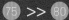

The capture of landscape images as Raw files means that a greater or lesser degree of post-processing is going to be necessary. How far you take the processing is a personal decision, but whatever the magnitude of the enhancements you make, a basic knowledge of the techniques for adjusting colour, exposure and contrast is an essential requirement. This chapter covers, in simple, non-technical terms, some of the basic post-processing tools for making these adjustments.

MAGHERAMORE BEACH,
CO. WICKLOW, IRELAND

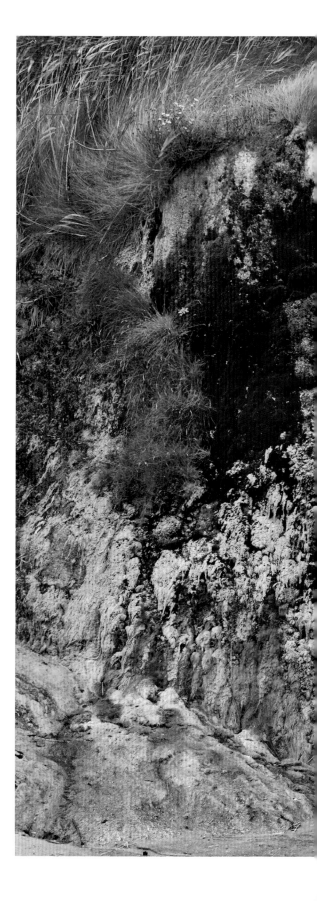

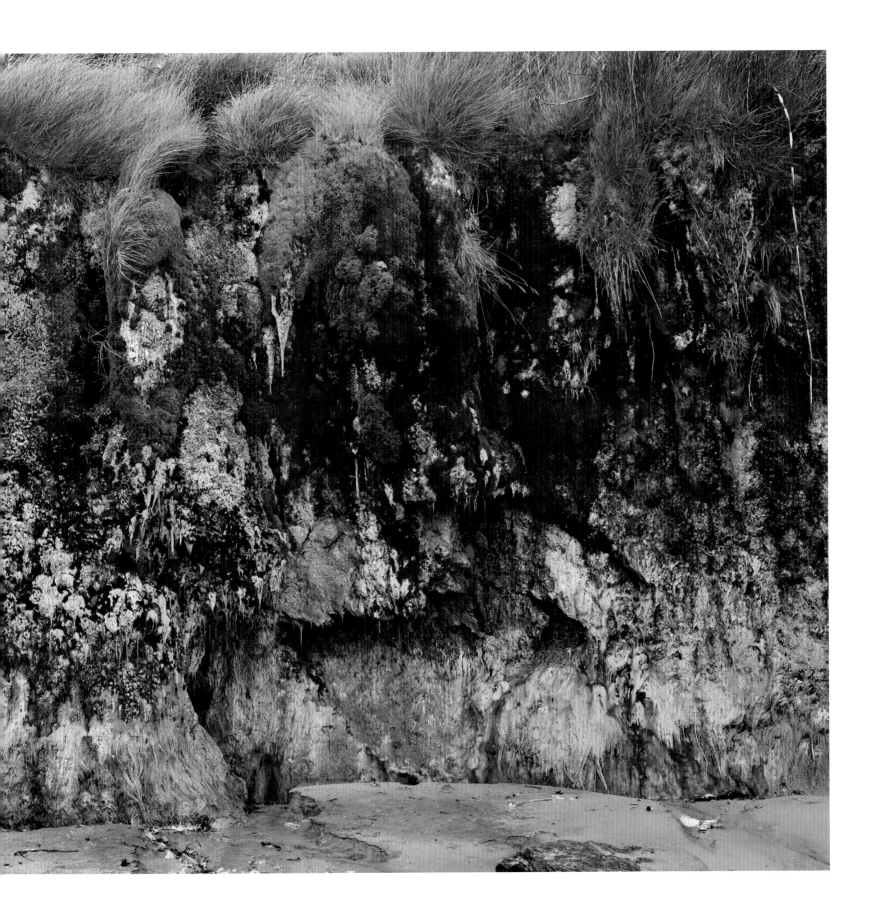

ENHANCE HIGHLIGHTS AND SHADOWS

To avoid detail being lost in the darkest and brightest parts of an image, it is sometimes necessary to adjust these areas in post-processing. Digital sensors have gradually improved and they are now capable of recording a brightness range of up to 14 stops (at the time of writing – they are continually advancing). This is more than adequate for most situations, but occasionally a little fine-tuning can produce a noticeable improvement in the extreme areas which, in a landscape environment, are likely to be the sky and any dark, shaded areas.

In Photoshop the Curves or Brightness/Contrast tools can be used, but personally I prefer the Shadows/Highlights tool. (In this chapter I have referred to tools available in Photoshop, but other photo-editing and Raw conversion software have similar functions.) It is perfect for making subtle adjustments, and with a little practice quite remarkable results can be achieved. When you open the tool, tick the 'Show more options' box and you will then be able to adjust the amount (strength), tonal width (range of tones affected) and radius (how pixels blend). Further refinements can be made with the Midtone Contrast slider. Experiment with different permutations; you can see the effect in the image as you make the changes. This is not something that can be rushed, as it is preferable to make only small adjustments at a time. To restrict the changes to specific parts of the photograph, the Lasso tool (with softly feathered edges) can be used to isolate the areas that you want to adjust.

The Shadows/Highlights tool is very effective and there are many excellent tutorials available online. Become familiar with it and learn its nuances, and you will be able to produce images that retain detail across a wide tonal range, even in high-contrast lighting.

UPPER ANTELOPE CANYON, ARIZONA, USA

CONTRAST
The Antelope Slot Canyons are among the world's greatest photographic locations. In different lighting conditions they display a breathtaking range of tones, but high contrast makes them difficult to capture. In this picture a degree of adjustment to the highlights and shadows was necessary to enable the detail to be shown in both the brightest and darkest parts of the image. This was achieved by using a combination of Curves and the Shadows/Highlights tool.

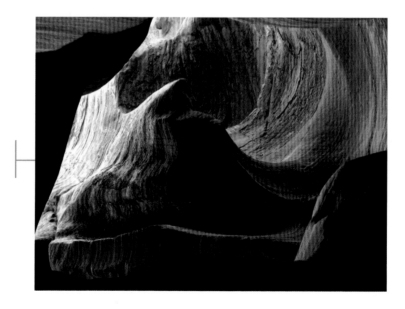

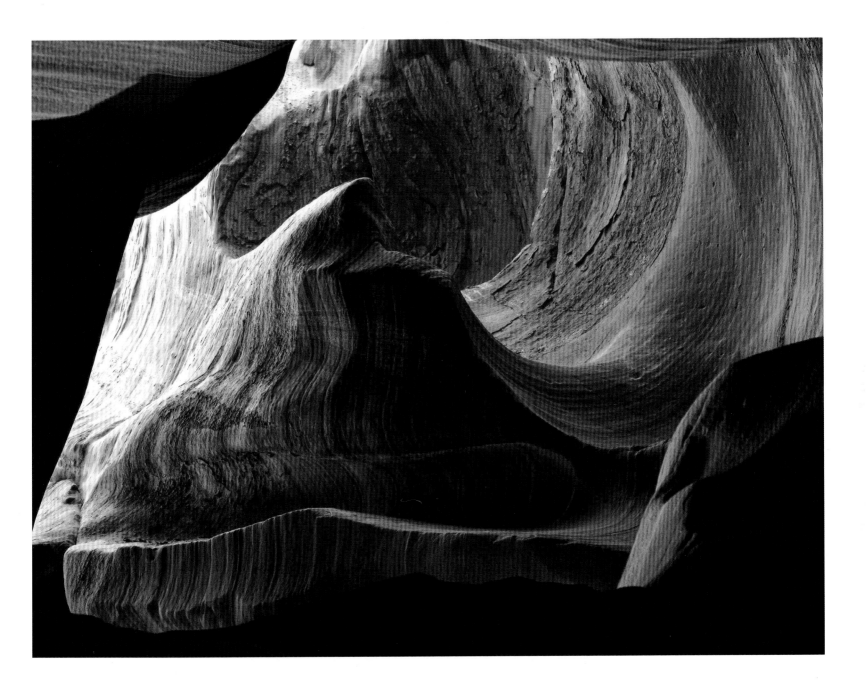

Camera: Canon EOS 7D

Lens: Canon 24–105mm L IS

Filter: None

Exposure: 1sec at f/13, ISO 100

Waiting for the light: Immediate

Post-processing: Curves and Shadows/Highlights adjustment

ADJUST CONTRAST

Contrast has a noticeable effect on the appearance of an image, but it is sometimes overlooked in the rush to adjust exposure and colour saturation. If there is too little contrast the picture will look flat and lack impact, while too much will, as was discussed on the previous page, cause detail to be lost in the highlights and shadows. A photograph can fail because of contrast, so it is important to get it right but, as with all adjustments, a little fine-tuning might be all that it is necessary – so it should be changed gradually, one small step at a time.

In Photoshop there are various tools that can be used, the obvious one being the Brightness/Contrast tool. Personally I like a combination of Curves and the Midtone Contrast slider in the Shadows/Highlights tool;

this enables fine adjustments to be made without having a great effect on the brightest and darkest areas. The method you employ is a personal choice; practice and experiment with different techniques until you find one that suits you and gives you the results you require.

Finally, a few words of caution: ensure you have saved a copy of the original picture before you make any adjustments. Once you have saved your changes they cannot be undone, so always keep a back-up copy. You might never need it, but anything can happen and it's better to be safe than sorry!

LLANTYSILIO, DENBIGHSHIRE, WALES

CONTRAST
Although the floor of the valley is brightly lit, the surrounding hills were, at the time of capture of this image, rather subdued. The picture lacked contrast and looked flat. I used the Midtone Contrast slider in Photoshop's Shadows/Highlights tool to increase contrast slightly. It was a minor adjustment only, as I was anxious to avoid it impacting on the tonal range of the image. There is a fine balance between too much and too little contrast, and a delicate touch was all that was required.

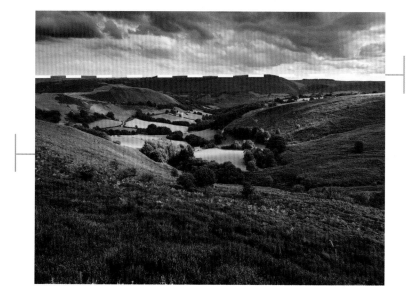

2–STOP (0.6) ND GRAD
A 2-stop ND graduated filter was used to darken the sky. It had no effect on image contrast or the brightness of the landscape.

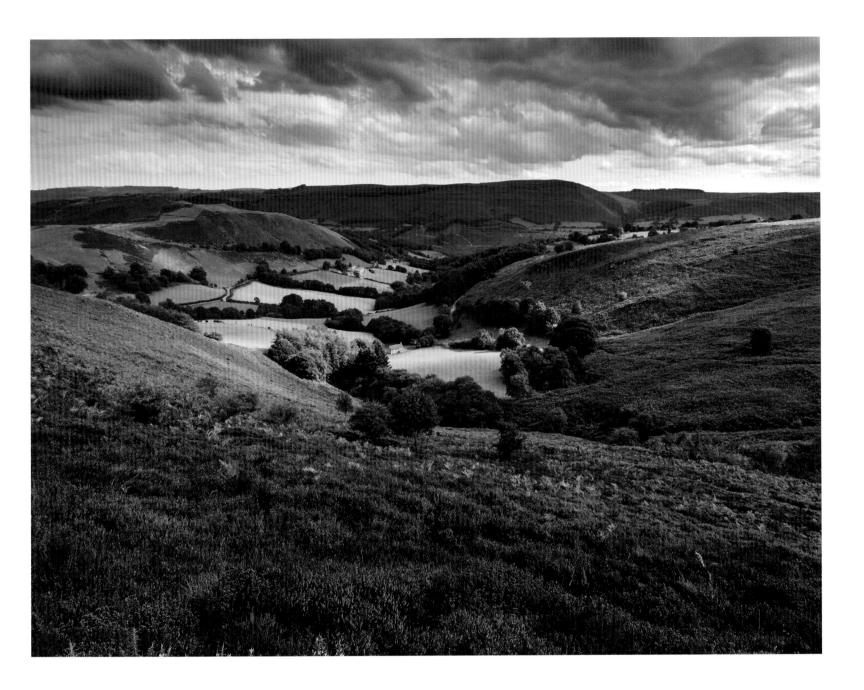

Camera: Mamiya 645 AFD II with Mamiya digital back

Lens: Mamiya 35mm wide-angle

Filter: 2-stop ND grad

Exposure: 1/10sec at f/22, ISO 100

Waiting for the light: 1 hour 20 minutes

Post-processing: Shadows/Highlights adjustment

77 ENHANCE COLOUR SATURATION

The birth of digital imaging has brought with it the ability to adjust (which is usually interpreted as 'increase') colour saturation – and, judging by some of the photographs I now see, it seems to be an adjustment many people find hard to resist. For some types of subject a boost in colour can be an improvement, but landscape images have to be handled with care. There is a threshold which, if crossed, will cause a photograph to look garish and unnatural. Applied correctly, however, a small increase in saturation can give a picture a dynamic quality and great impact.

If you feel a photograph looks flat, then experiment first with exposure and/or contrast. This may be all that is necessary; but if that fails, then colour saturation is the next option. A general increase might be required, or it may just be a specific colour that might benefit from

a little strengthening. There are, as you might expect, different methods of enhancing colour in post-processing. I like to start by trying the Vibrance tool, which ignores colours that are already sufficiently saturated and only intensifies the weaker tones. This can produce excellent, natural-looking results and is often all that is necessary. On the rare occasions when I want a little more, another option is the Selective Color tool. It is more commonly used for adjusting hues and colour balance, but can also be employed as a means of making small, very specific adjustments to saturation. Finally, if all else fails there is, of course, the Saturation tool. If used with restraint it can breathe life into an ailing image, but beware: it is a powerful tool, and too heavy a touch on its slider can lead to the picture's demise – albeit a colourful one!

ZION NATIONAL PARK, UTAH, USA

INTENSITY
Colour is the theme of this photograph of autumn foliage in the Zion National Park. The processed image lacked balance, however, because the vibrant bush in the foreground was too dominant. There was too much green against a background of rather muted warmer tones. I therefore strengthened the intensity of the red and orange by selecting just yellow and red in the Photoshop Saturation tool.

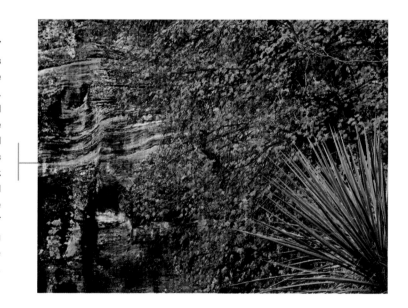

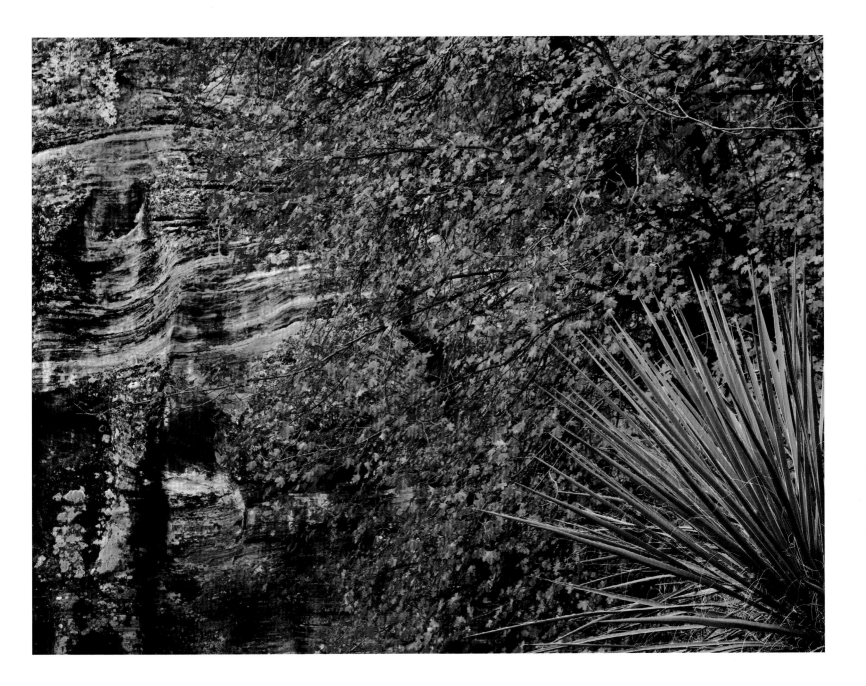

Camera: Mamiya 645 AFD II with Phase One digital back

Lens: Mamiya 80mm standard

Filter: None

Exposure: 1/5sec at f/22, ISO 100

Waiting for the light: Immediate

Post-processing: Selective Color Saturation adjustment

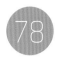 ADJUST COLOUR BALANCE

Depending on the time of day and the weather conditions, the colour temperature of daylight can vary from very warm to cool blue. In the days of film photography, filters were used to compensate for colour casts, but the auto white balance setting on digital cameras makes these filters unnecessary. The camera now adjusts colour balance automatically – but it is not foolproof and cannot guess your creative intentions. Fortunately it is very simple to adjust colour balance in post-processing, and even a small change can improve many landscape images.

The most commonly used filter was the 81B, which is slightly yellow/orange and was designed to warm landscapes by compensating for a blue cast in daylight. This and many other filters can be replicated in Photoshop by selecting the Photo Filter tool. Alternatively there is the Color Balance tool. You can adjust the strength of each selection you make, and many permutations and colour combinations are possible. As is always the case with landscape images, small, minor adjustments are likely to be more successful than making dramatic changes. I also find it useful to keep a copy of the original picture open while I make any changes, and compare the effect as I proceed.

ZION NATIONAL PARK, UTAH, USA

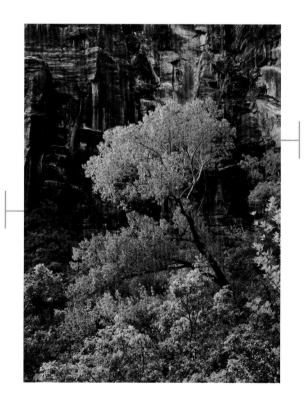

WARMING
There was a blue cast to the daylight at the time this picture of the Zion National Park was captured. Rather than use a warming filter, I compensated for it by adding a combination of a small amount of red and yellow in the Color Balance tool. It was a minor adjustment, as I was keen to avoid affecting the green hue of the lower leaves. The warming was, however, sufficient to strengthen the warm tones of the golden bush and background mountain.

POLARIZER, FULLY POLARIZED
A polarizer was used to reduce reflections on the damp foliage. The effect of this was a small increase in colour saturation and contrast. It boosted the appearance of the image and very little further adjustment was necessary.

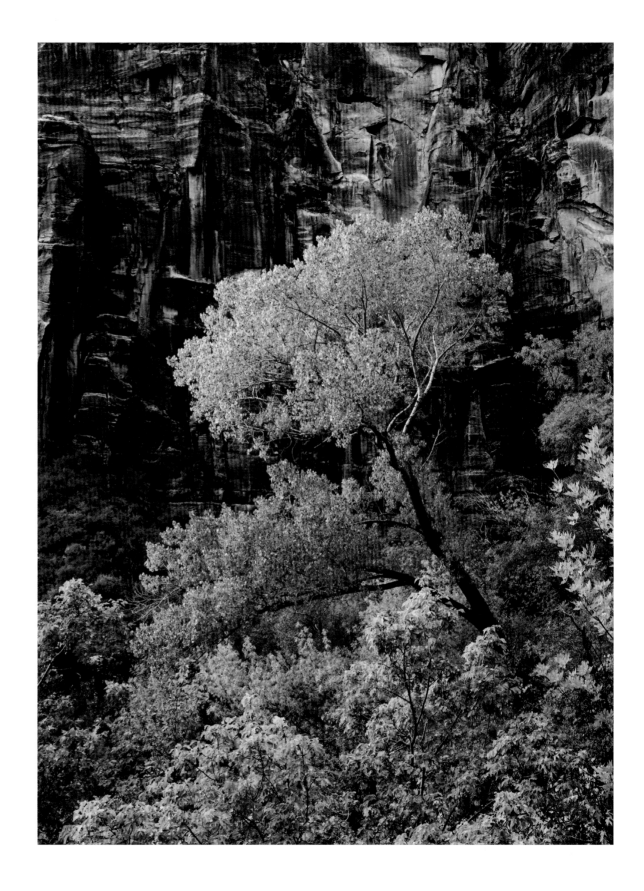

Camera: Mamiya 645 AFD II with Mamiya
digital back

Lens: Mamiya 150mm telephoto

Filter: Polarizer

Exposure: 1/4sec at f/22, ISO 100

Waiting for the light: Immediate

Post-processing: Color Balance
adjustment (warming)

 # MAKE SELECTIVE ADJUSTMENTS

The ability to make adjustments to specific parts of a picture is an important factor in the pursuit of the perfect image. It might be contrast, exposure, colour balance or saturation; whatever it is, often it is required in only a small part of the photograph and there are, as always, various methods of making selective adjustments. I like to use the Lasso tool, with softly feathered edges, as it enables a seamless transition to be created between two or more areas.

In landscape images an area which often requires enhancing is the sky. It is always brighter than the land beneath it, and in pre-digital days the solution was to use a graduated neutral-density filter. Now, post-processing tools

have provided an alternative method of darkening a bright sky – but there is a limit to what can be achieved. To adopt an approach of 'shoot now, fix later' is not the way forward, because in post-processing the smaller the adjustment made, the better the result. An unfiltered sky is likely to require a lot of darkening, and for this reason graduated ND filters are still relevant. Even with their use, though, further enhancements are sometimes required. Using the Lasso tool, or an alternative method, to isolate the sky or other areas is an important step in improving an image, and I would encourage you to familiarize yourself with this aspect of post-processing.

PARIA CANYON WILDERNESS, UTAH, USA

ENHANCEMENTS
Two selective adjustments were made to this image of the Paria Canyon. The sky, despite the addition of a 2-stop ND grad, required further darkening in the brightest areas. The foreground area was also selected and the deepest shadows were lightened. The Shadows/Highlights tool was used to make the enhancements. Both of these areas were isolated from the rest of the picture by using the feather-edged Lasso tool, as indicated in the small photograph.

2-STOP (0.6) ND GRAD

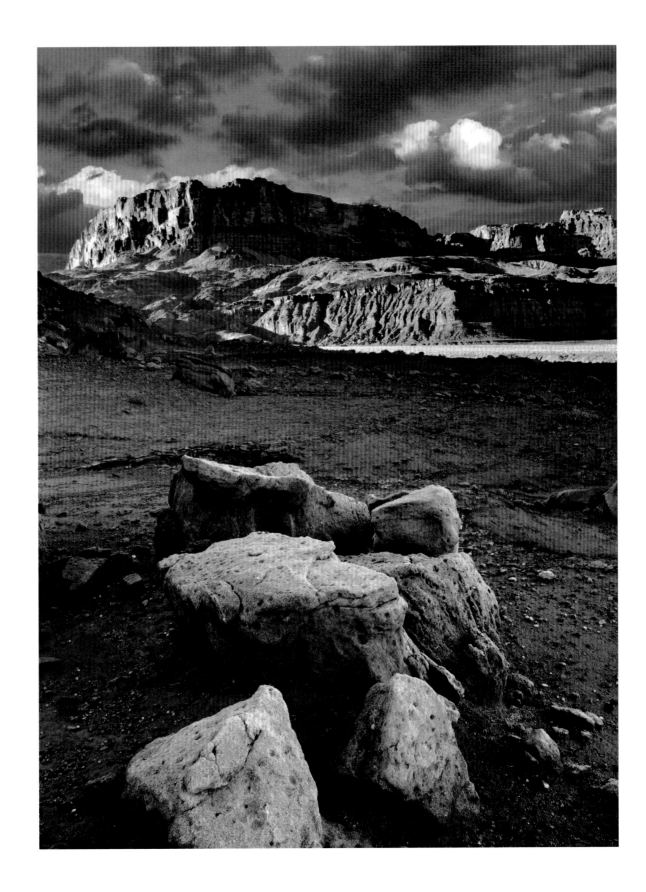

Camera: Mamiya 645 AFD II with Mamiya digital back

Lens: Mamiya 35mm wide-angle

Filter: 2-stop ND grad

Exposure: 1sec at f/22, ISO 100

Waiting for the light: 50 minutes

Post-processing: Selective Shadows/ Highlights adjustment

80 CROP THE IMAGE

Cropping an image is one of the quickest and simplest adjustments that can be made, but despite this it is sometimes overlooked. Although zoom lenses, because of the flexibility and compositional options they provide, have to a certain extent reduced the need for cropping, there are still occasions when a picture can be improved by removing part of it.

To gain and maintain a viewer's attention, a photograph should contain no dead space; every part of it should make a contribution and give the eye something to dwell upon. This is particularly important if the composition contains no specific focal point. Eliminating weaker areas and tightening composition produces a more cohesive image, and the result is likely to be

an increase in visual impact. The improvement is often dramatic, and a photograph can, by the simple act of cutting out unnecessary space, be transformed.

Cropping can be effective. I say that from my own experience, because photographs that I initially considered to be failures have been reborn as new, dynamic images. Look through your pictures and experiment. Be creative – a change in format from portrait to landscape or vice versa, for example, might be all that is necessary. It is very satisfying to discover the potential in discarded photographs; spend time scrutinizing them, and with any luck your efforts will be well rewarded.

LLANDDULAS, CONWY, WALES

COMPOSITION
This picture of Llanddulas Beach was captured on an APS-C sensor, which produces images with an aspect ratio of 3:2. I prefer the 4:3 ratio of my Mamiya, and therefore crop many of my APS-C images to this size. It doesn't suit all subjects and sometimes a panoramic format is preferable, but often, as is the case with the photograph opposite, cropping the sides to produce a squarer format strengthens the composition. Here the extreme left and right areas contained nothing of particular interest and made no contribution to the composition. They were not important and their removal tightens the image, which, I believe, is to its benefit.

2-STOP (0.6) ND GRAD

CROP
The sides were cropped to change the aspect ratio from 3:2 to 4:3.

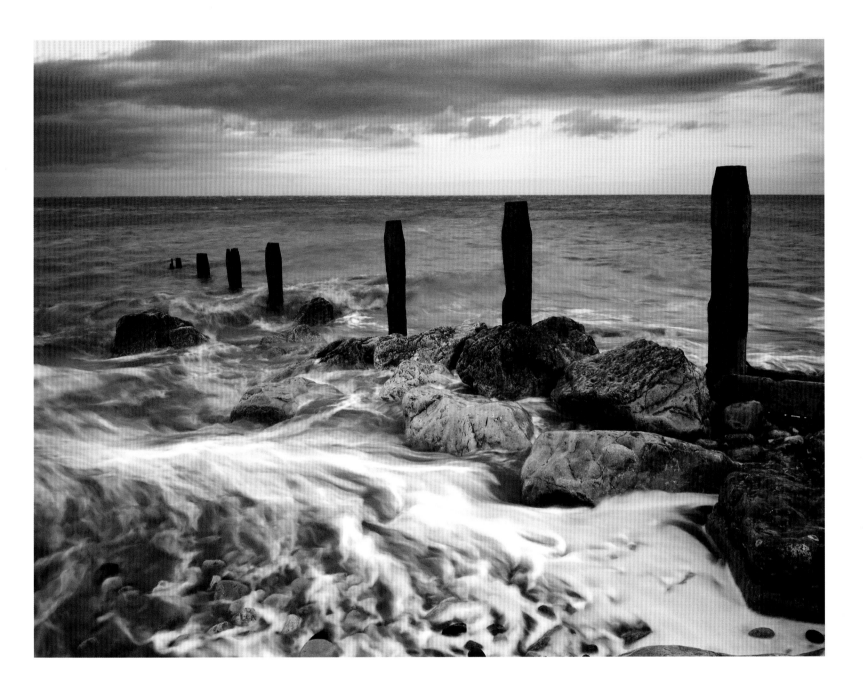

Camera: Nikon D7200

Lens: Nikon 16–35mm VR

Filter: 2-stop ND grad

Exposure: 1/4sec at f/14, ISO 100

Waiting for the light: Immediate

Post-processing: Cropping and Curves adjustment

IMAGE GALLERY

NEAR KOLOB CANYONS, UTAH, USA **1**

PARIA CANYON WILDERNESS, UTAH, USA **2**

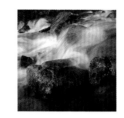

NEAR CONISTON, CUMBRIA, ENGLAND **5**

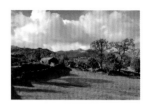

COT VALLEY, CORNWALL, ENGLAND **9**

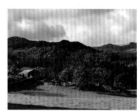

NEAR SKELWITH BRIDGE, CUMBRIA, ENGLAND **10**

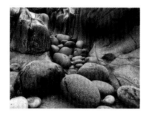

PORTH NANVEN, CORNWALL, ENGLAND **12**

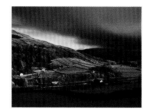

WHITE POCKET, ARIZONA, USA **14**

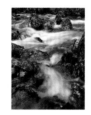

FISHER GILL, CUMBRIA, ENGLAND **16**

NEAR THWAITE, SWALEDALE, NORTH YORKSHIRE, ENGLAND **18**

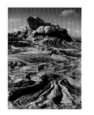

NEAR SKELWITH BRIDGE, CUMBRIA, ENGLAND **20**

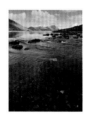

LOUGH FEE, CONNEMARA, IRELAND **22**

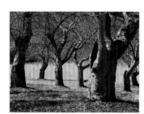

NEAR PHOENICIA, NEW YORK STATE, USA **24**

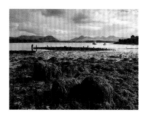

BALLYNAKILL HARBOUR, GALWAY, IRELAND **26**

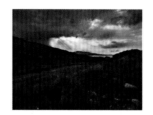

SHEEFFRY HILLS, CONNEMARA, IRELAND **28**

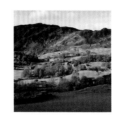

UPPER ANTELOPE CANYON, ARIZONA, USA **30**

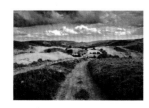

LLANTYSILIO, DENBIGHSHIRE, WALES **32**

ZION NATIONAL PARK, UTAH, USA **34**

LANGDALE VALLEY, CUMBRIA, ENGLAND **36**

NEAR AMBLESIDE, CUMBRIA, ENGLAND **38**

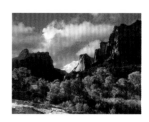

ZION NATIONAL PARK, UTAH, USA **40**

PORTO DE BARCAS,
PORTUGAL **42**

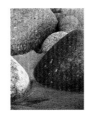

PORTH NANVEN,
CORNWALL, ENGLAND **44**

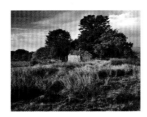

PONT MELIN-FACH, POWYS,
WALES **46**

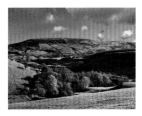

WHITE POCKET, ARIZONA,
USA **48**

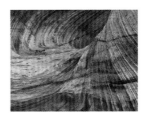

NEAR KELD, SWALEDALE,
NORTH YORKSHIRE,
ENGLAND **50**

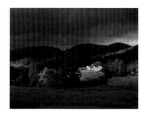

NEAR SKELWITH BRIDGE,
CUMBRIA, ENGLAND **52**

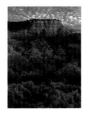

JOHNSON CANYON, UTAH,
USA **54**

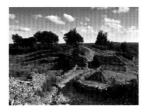

SILVEIRA, ALTO ALENTEJO,
PORTUGAL **56**

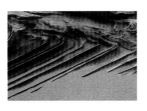

SOUTH COYOTE BUTTES,
UTAH, USA **58**

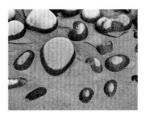

LETTERGESH BEACH,
CONNEMARA, IRELAND **60**

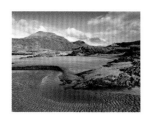

GLASSILAUN BEACH,
CONNEMARA, IRELAND **62**

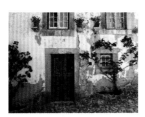

ÓBIDOS, CENTRO,
PORTUGAL **64**

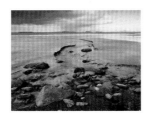

LETTERGESH BEACH,
CONNEMARA, IRELAND **66**

EGREMONT, WIRRAL
PENINSULA, ENGLAND **68**

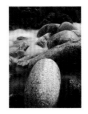

COT VALLEY, CORNWALL,
ENGLAND **70**

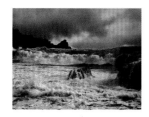

LAMORNA COVE,
CORNWALL, ENGLAND **72**

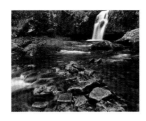

DENTDALE, NORTH
YORKSHIRE, ENGLAND **74**

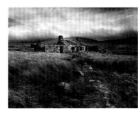

NEAR LLANLLYFNI,
SNOWDONIA, WALES **76**

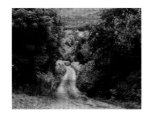

NEAR TINAHELY, CO.
WICKLOW, IRELAND **78**

NEAR LARAGH, WICKLOW
MOUNTAINS, IRELAND **80**

VILA VELHA DE RÓDÃO,
CENTRO, PORTUGAL **82**

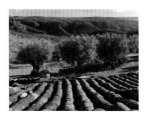

SILVEIRA, CASTELO
BRANCO, PORTUGAL **84**

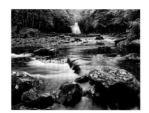

HELVELLYN GILL, CUMBRIA,
ENGLAND **86**

WEST BURTON FALLS,
YORKSHIRE DALES,
ENGLAND **88**

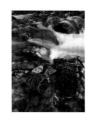

GREAT LANGDALE,
CUMBRIA, ENGLAND **90**

GREAT LANGDALE,
CUMBRIA, ENGLAND **92**

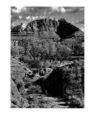

SPRINGDALE, ZION
NATIONAL PARK, UTAH,
USA **94**

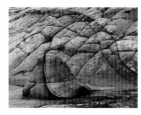

SOUTH COYOTE BUTTES,
UTAH, USA **96**

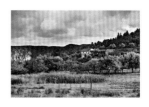

VILA VELHA DE RÓDÃO,
CENTRO, PORTUGAL **98**

NEAR HESWALL, WIRRAL
PENINSULA, ENGLAND **100**

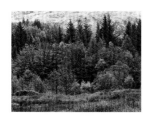

LANGDALE FELLS,
CUMBRIA, ENGLAND **102**

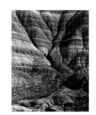

PARIA MOUNTAINS,
ARIZONA, USA **104**

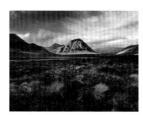

GLEN ETIVE, RANNOCH
MOOR, SCOTLAND **106**

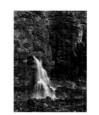

CHURCH COVE, CORNWALL,
ENGLAND **108**

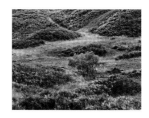

TILBERTHWAITE FELLS,
CUMBRIA, ENGLAND **110**

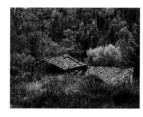

ABOBOREIRA, SANTARÉM,
PORTUGAL **112**

TREE BARK, BRITTANY,
FRANCE **114**

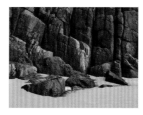

PORTHCURNO, CORNWALL,
ENGLAND **116**

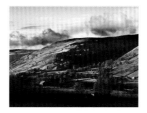

SWALEDALE, NORTH
YORKSHIRE, ENGLAND **118**

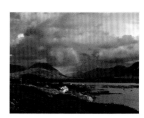

BALLYNAKILL HARBOUR,
CONNEMARA, IRELAND **120**

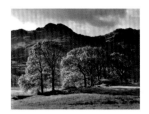

GREAT LANGDALE,
CUMBRIA, ENGLAND **122**

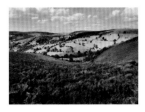

LLANTYSILIO,
DENBIGHSHIRE, WALES **124**

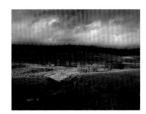

WIDDALE FELL, NORTH
YORKSHIRE, ENGLAND **126**

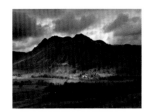

GREAT LANGDALE,
CUMBRIA, ENGLAND **128**

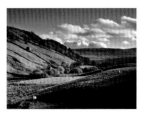

UPPER SWALEDALE, NORTH
YORKSHIRE, ENGLAND **130**

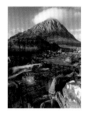

BUACHAILLE ETIVE
MÖR, RANNOCH MOOR,
SCOTLAND **132**

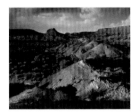

PARIA CANYON
WILDERNESS, UTAH,
USA **134**

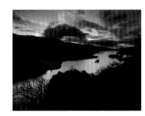

LOCH TUMMEL,
PERTHSHIRE,
SCOTLAND **136**

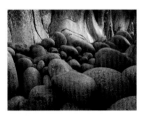

PORTH NANVEN,
CORNWALL, ENGLAND **138**

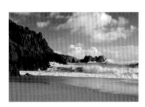

PORTHCURNO, CORNWALL,
ENGLAND **140**

PORTH NANVEN,
CORNWALL, ENGLAND **142**

KINGSTOWN BAY, GALWAY,
IRELAND **144**

PARIA CANYON
WILDERNESS, UTAH,
USA **146**

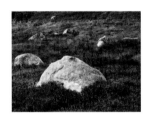

NEAR LARAGH, WICKLOW
MOUNTAINS, IRELAND **148**

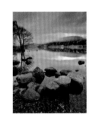

LOCH TUMMEL,
PERTHSHIRE,
SCOTLAND **150**

WEST BURTON, NORTH
YORKSHIRE, ENGLAND **152**

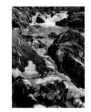

PITLOCHRY, PERTHSHIRE,
SCOTLAND **154**

AFON COLWYN,
SNOWDONIA, WALES **156**

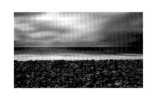

ABERDESACH, GWYNEDD,
WALES **158**

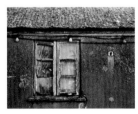

NEWLYN HARBOUR,
CORNWALL, ENGLAND **160**

BRITTANY, FRANCE **162**

CORREIAS, ESTREMADURA, PORTUGAL **164**

KILKIERAN BAY, GALWAY, IRELAND **166**

MAGHERAMORE BEACH, CO. WICKLOW, IRELAND **168**

UPPER ANTELOPE CANYON, ARIZONA, USA **170**

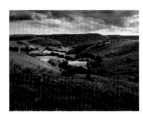
LLANTYSILIO, DENBIGHSHIRE, WALES **172**

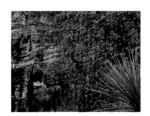
ZION NATIONAL PARK, UTAH, USA **174**

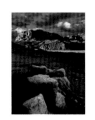
ZION NATIONAL PARK, UTAH, USA **176**

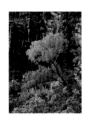
PARIA CANYON WILDERNESS, UTAH, USA **178**

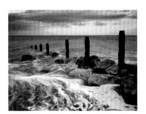
LLANDDULAS, CONWY, WALES **180**

EQUIPMENT USED

CAMERAS

Mamiya 645 AFD II with Mamiya and Phase One digital backs

Nikon D7100 and D7200

Canon EOS 7D

LENSES

Mamiya 35mm, 80mm, 150mm

Nikon 16–35mm VR

Canon 24–105mm L IS

Canon 100–400mm L

FILTERS

Lee hard graduated neutral density

Lee neutral density

Lee circular polarizer

TRIPODS

Benbo Mini Trekker

Uni-Loc Major 2300 and 1600

Velbon Ultra Rexi L

BALL-AND-SOCKET HEADS

Manfrotto 054

Uni-Loc 60RBH

VIEWFINDER

Linhof Multifocus

GLOSSARY

Angle of view The angle 'seen' by a given lens. The shorter the focal length, the wider the angle of view. Together with the subject-to-camera distance, this determines the field of view.

Aperture The hole or opening, formed by the leaf diaphragm inside the lens, through which light passes to expose the film or sensor. The size of the aperture relative to the focal length is denoted by f-numbers (f-stops).

Aperture priority Automatic in-camera metering of exposure in which the aperture is preselected by the user and the camera determines the shutter speed.

APS-C A sensor format for digital cameras, which has an aspect ratio of 3:2.

Aspect ratio The ratio of the width to the height of the image frame.

Autoexposure (AE) The ability of a camera to recommend the correct exposure for a particular scene.

Autofocus (AF) An in-camera system for automatically focusing the image.

Automatic white balance (AWB) A setting on digital cameras that prevents colour casts occurring in any type of light.

Backlighting Light coming from behind the subject, shining towards the camera.

Bracketing Making a series of exposures of the same subject at different exposure settings, typically in steps of 1/2- or 1/3-stops, as a precaution against inaccurate exposure.

Cable release A flexible cable attached to the camera to enable remote release of the shutter, to minimize the risk of camera shake.

Camera Raw A file format offered by most digital cameras. It records the picture as an unprocessed, uncompressed image. It can be considered the digital equivalent of an unprocessed film negative.

Camera shake Blurring of images caused by movement of the camera during exposure.

Centre-weighted metering A metering system that takes the majority of its reading from the centre portion of the frame. Suitable for portraits, or scenes where the main subject occupies the centre of the frame.

Colour cast A variation of the colour of light, which causes distortion of the colours in a photograph.

Colour-correction filter A filter that is used to compensate for a colour cast, the most common example being the 81 series of warming filters. *see Warm filter.*

Colour saturation A measure of the strength and intensity of colours in an image.

Colour temperature The colour of light on a scale between blue (cool) and red (warm). This depends on a number of factors, including the light source and the time of day. It is measured on the Kelvin scale: lower temperatures produce 'warmer' colours and vice versa.

Contrast The range between the highlight and shadow areas of a negative, print, transparency or digital image. Also refers to the difference in illumination between adjacent areas.

Converging parallels The distortion of parallel lines, which appear in the image as angled lines converging in the distance. This commonly occurs when a building is photographed with the camera pointing upwards.

Cropping Printing only part of the available image from the negative, transparency or digital image, usually to improve the composition.

Definition The clarity of an image in terms of both its sharpness and contrast.

Depth of field (DOF) The zone of acceptable sharpness in front of and behind the point at which the lens is focused. This zone is controlled by three elements: aperture – the smaller the aperture, the greater the DOF; the camera-to-subject distance – the further away the subject, the greater the DOF; and the focal length of the lens – the shorter the focal length, the longer the DOF.

Diffraction The softening of an image caused by the spreading out of light rays as they pass through the lens. The smaller the aperture, the more noticeable it becomes.

Diffuse lighting Lighting that is low or moderate in contrast, such as the light on an overcast day.

Digital SLR (digital single-lens reflex) *see* SLR (single-lens reflex).

Dynamic range *see Tonal range.*

Exposure The amount of light reaching the film or sensor. This is controlled by a combination of aperture and shutter speed. Also, the act of taking a photograph, as in 'making an exposure'.

Exposure compensation A level of adjustment which is applied manually to autoexposure settings. Generally it is used to compensate for known inadequacies in the response of a camera's exposure meter, which may result, for example, in underexposure in snow scenes.

Exposure latitude The extent to which exposure can be reduced or increased without causing an unacceptable under- or overexposure of the image.

Exposure meter A device, either built into the camera or separate, incorporating a light-sensitive cell. It is used for measuring light levels, as an aid to selecting the best exposure setting.

Exposure value A single value indicating the amount of light required to expose an image correctly at a particular ISO setting. This overall value can be reached by various combinations of shutter speed and aperture.

Field of view The extent of the scene that can be captured on film or sensor. This depends on the film/sensor format, the angle of the lens, and the camera-to-subject distance.

File format The type of digital file used to capture or store the image, e.g. Tiff, Jpeg, Raw.

Fixed focal length *see Prime lens.*

Flare Unwanted, non-image-forming light reflected inside a lens or camera. It can create multicoloured circles or loss of contrast, and can be reduced by multiple lens coatings, low-dispersion lens elements or a lens hood.

F-numbers A series of numbers on the lens aperture ring and/or the camera's LCD panel that indicate the size of the lens aperture relative to its focal length. The higher the number, the smaller the aperture.

Focal length The distance between the film or sensor and the optical centre of the lens when focused at infinity.

Frontal lighting Light shining on the surface of the subject facing the camera.

Highlights The brightest parts of an image.

Histogram A digital graph indicating the light values in an image.

Hot shoe A connector on the top of a camera that enables flashguns and other accessories to be attached.

Hyperfocal distance The closest distance at which a lens records details sharply when focused at infinity. Focusing on the hyperfocal distance produces maximum depth of field, which extends from half the hyperfocal distance to infinity.

Image resolution *see Resolution.*

Image sensor The digital equivalent of film. The sensor converts an optical image to an electrical charge that is captured and stored.

Image stabilization An in-camera feature that compensates for any movement of the camera during exposure.

ISO rating A measure of the degree of sensitivity to light of a film or sensor, as determined by the International Standards Organization. As the ISO number doubles, the amount of light required to correctly expose the film or sensor is halved.

Jpeg A common file format used by digital cameras. It compresses the image, and over time this may result in a degradation of image quality.

Landscape format An image format which is wider than it is tall.

Large-format camera A camera that uses sheet film of 5 x 4in or larger.

LCD Stands for 'liquid crystal display'. It is used in the display screen included on most digital cameras.

Matrix Metering Exposure metering based on light-value readings taken from multiple segments across the entire image frame.

Medium-format camera A camera using rollfilm (normally 120 or 220 film), or a digital sensor of equivalent size, that measures approximately 2¼in (6cm) wide.

Megapixel One million pixels.

Mid-tones Parts of an image with tones of an intermediate value; i.e. the tonal values between the highlights and shadows.

Neutral-density (ND) filter A filter that reduces the brightness of an image without affecting its colour.

Neutral-density graduated (ND grad) filter A neutral-density filter that is graduated to allow different amounts of light to pass through it in different parts. These filters are used to balance naturally occurring bright and dark tones. In landscape photography they are commonly used to balance the exposure values of sky and landscape.

Noise A coarse texture in a digital image (resembling the grain of a film image) that becomes apparent during long exposures and when using high ISO settings.

Panoramic camera A camera with a frame of which the aspect ratio of width to height is greater than 3:2.

Pixel Short for 'picture element', this is the basic building block of every digital image.

Polarizing filter A filter that absorbs light vibrating in a single plane while transmitting light vibrating in multiple planes. When placed in front of a camera lens, it can eliminate undesirable reflections from a subject such as water, glass or other objects with a shiny surface, but not metal. It is also used to increase colour saturation.

Portrait format An image format that is taller than it is wide.

Prime lens A lens that has a fixed focal length, as opposed to a zoom lens.

Raw *see Camera Raw.*

Reflected light Light reflected from the surface of a subject; the type of light that is measured by through-the-lens meters and handheld reflected-light meters such as spot meters.

Resolution The amount of detail in an image. The higher the resolution, the larger the potential maximum size of the printed image.

Shutter A mechanism that can be opened and closed to control the length of exposure.

Shutter release The button or lever on a camera that causes the shutter to open.

Shutter speed The length of time light is allowed to pass through the open shutter of the camera. Together, the aperture and shutter speed determine the exposure.

Sidelighting Light shining across the subject, illuminating one side of it. The preferred light of most photographers, it gives shape, depth and texture to a landscape, particularly when the sun is low in the sky.

SLR (single-lens reflex) A type of camera that allows you to see the view through the camera's lens as you look in the viewfinder.

Soft-focus filter A filter used to soften an image by introducing an optical effect called spherical aberration. It is not the same as an out-of-focus image; a sharp image is necessary in order for the effect to succeed.

Spot meter An exposure meter that measures a small, precise area. It enables a number of exposure readings to be taken of different parts of a subject and therefore provides a very accurate method of metering.

Standard lens A lens with a focal length approximately equal to the diagonal measurement of the film format. It produces an image approximately equivalent to that seen by the human eye, and equates to the following focal lengths: 35mm for digital APS-C cameras, 50mm for 35mm film or digital cameras, 80mm for 6 x 4.5 or 6 x 6cm, 90mm for 6 x 7cm, and 150mm for 5 x 4in cameras.

Telephoto lens A lens with a long focal length and narrow angle of view. When used at a long distance from the subject, a telephoto lens can help create the impression of compressed distance, with subjects appearing to be closer to the camera than they actually are.

Through-the-lens (TTL) metering A meter built into a camera that determines exposure for the scene by reading light that passes through the lens as the picture is taken.

Tiff Stands for 'tagged image file format'. It is a common image format supported by most types of photo-editing software.

Tonal range The range between the darkest and lightest areas of an image.

UV filter A filter that reduces ultraviolet interference in the final image. This is particularly useful for reducing haze in landscape photographs.

Vignetting The cropping or darkening of the corners of an image. This can be caused by a lens hood, filter holder or the lens itself. Many lenses do vignette, but to a minor extent. This can be more of a problem with zoom lenses than prime lenses.

Warm filter A filter designed to bring a warm tone to an image, to compensate for the blue cast which can sometimes be present in daylight, particularly with an overcast sky. The filters are known as the 81 series, 81A being the weakest and 81E the strongest.

White balance A function of a digital camera that allows the correct colour balance to be recorded for any given lighting situation.

Wide-angle lens A lens with a short focal length and a wide angle of view.

Zoom lens A lens whose focal length can be varied.

INDEX

AMMONITE
PRESS

To place an order, or request a catalogue, contact:
Ammonite Press
AE Publications Ltd, 166 High Street, Lewes,
East Sussex, BN7 1XU, United Kingdom
Tel: +44 (0)1273 488006
www.ammonitepress.com